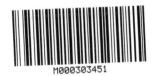

# The Mural Artist's Handbook
Morgan Bricca

*For Lucas and Allie, my brightest stars.*

Book design by Adam Hay Studio

Printed and bound by IngramSpark

ISBN: 978-0-578-78478-6
www.TheMuralArtistsHandbook.com

Morgan Bricca

# The MURAL ARTIST'S HANDBOOK

Making the world a more beautiful place,
one wall at a time.

**Let the beauty of
what you love be
what you do.**

Rumi

# Contents

# 1

# A New Era for Mural Art

Mural art has traditionally sustained a circumspect reputation, far outside the boundaries of the "art establishment." Twenty years ago, the word "mural" brought to mind grapevine stencils in kitchens, elementary school class projects, and amateur political images painted in alleyways. Most communities have struggled to create cohesive policies or plans for integrating mural art into public spaces, resulting in murals which swing wildly between amateur efforts and "pseudo advertising" for commercial interests.[1]

Today, murals are experiencing a renaissance. The most recent evolution is rooted in the trifecta of increasing grassroots political activism, photo sharing on social media, and the re-defining of community space through intentional placemaking. Instagram, and the corollary demand for the perfect "selfie moment," is also driving mural design. We want our personal spaces to reflect who we are and how we want to feel. The handmade, "one-of-a-kind"*ness* inherent to mural art defies commodification; it is more akin to a *site specific event* than a product.

**Opposite:**
*Refuge* by Joshua Mays at 143 SE Yamhill St. in Portland, OR.

9

The sudden enthusiasm for the art form has resulted in more public attention to the medium, more walls being offered up, and more money invested in mural art—resulting in more professional artists being drawn into the art form. A quick scroll through @TopStreetArt on Instagram is both humbling and mind-blowing. A dozen years ago, mural art was definitely *not* a hot commodity. Trader Joe's and Fry's Electronics were the best gigs a mural artist could hope for, and it was kitschy work at that. Today, it seems everyone wants a mural. Truly exceptional large-scale works of art are being created worldwide on a daily basis. The image that pops into someone else's head when you say the word "mural" is changing—for the better. Mural art is finally having its moment, and it is well-deserved.

Mural art has a lot of things going for it. It is inexpensive, relative to other beautification and capital improvement projects. It is eco-friendly; non-toxic materials can be used, and there is no "thing" to ship or send to a landfill, as it is all handmade on-site. Cities are discovering that mural art deters unwanted tagging. Most importantly, mural art can influence whether an environment is perceived as neglected or welcoming, and cue behaviors that correlate with feeling safe—like walking slower and taking in the environment, making eye contact, or smiling at strangers.

By bringing high-caliber art into our public spaces, outside of paid venues and glass doors, art becomes knit into the fabric of everyday life. Creatively imagined spaces invite the broader community into an *experience* with art—changing culture, igniting us to imagine new possibilities for ourselves and our world. Public murals tell a story about a particular place: who lives there, what they love, and also what is

**Speak softly, but carry a big can of paint.**

Banksy

possible—activating shared imagination and civic pride. Public art is answering the question, "Who are we, and where do we want to go?" and "How can our public spaces become more vital, more inviting, and more relevant to the people who live in our community?"

Our increasingly urbanized lives have resulted in an overabundance of walls, hordes of blank canvases ripe for artistic reinvention. The windowless, oppressive walls of cheaply constructed multistory buildings of the sixties and seventies as well as the neighborhood side of freeway walls are ideal canvases for mural art. In schools, the utilitarian physical structures reflect the didactic institutional approach towards education embraced by prior generations and are ripe for transformation. Mural art not only introduces color to a typically beige school campus but also aligns the built environment with updated educational pedagogy that embraces social-emotional learning and psychological safety. Interior design is embracing holistically integrated, calming spaces. The boundless, frameless, wabi-sabi nature of a hand-painted mural dovetails perfectly with this trend.

While it is an exciting time to be both a mural artist and a mural art advocate, mural art is still in the Wild West phase. Mural contests and festivals are transforming the façades of communities, sometimes for the better…and sometimes not. City commissioners, wanting to join the mural bandwagon, underwrite projects without a clear sense of how the artwork will tie into their vision for the city, or what an adequate budget or artist selection process might be. Meanwhile, most of our schools still look like prisons from the outside, and the cost-effective beautification of mural art remains underutilized by school districts, whose interests lean towards efficiency and minimizing legal exposure over taking creative risks.

In this handbook, I share what I have learned working on over 500 mural projects, including residential, school, commercial and public projects, each project with its own unique requirements, challenges, and metrics for success. I begin with my own story and best practices for painting a mural. In chapters 4-6, I address considerations specific to the clients who are most likely to commission you for a mural. In chapters 7 and 8, I share the inside workings of what, for me, has been a fun and profitable small business. My hope is to empower you to make the desired impact  with your art by making it a sustainable endeavor, creatively and financially, over the long haul.

Yes, the mural art world is still its own Wild West. However, by pointing out pitfalls as well as helpful protocols common to the collaborative mural creation process, my hope is that more great mural art can be made. By sharing the opportunities and risks inherent in a variety of projects I have encountered, I hope to help you navigate this Wild West successfully so that you can make your own unique contribution to the art form.

An infinite number of blank walls lie dormant, ready for your creativity to bring them to life. What are you waiting for? Let's get started...

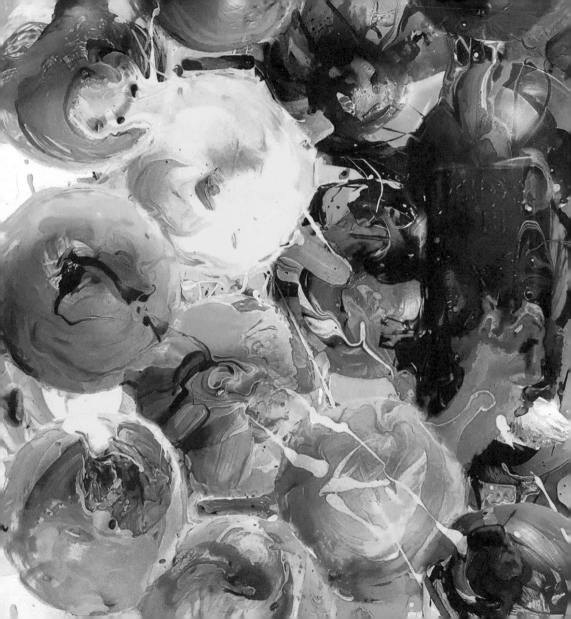

# 2
# Switching Gears in Life

One summer evening in 1999, I was speeding down the highway, headed home after a long day at the office. I worked as an information technology manager, keeping the software, servers, and computers of a startup biotech company running smoothly. On this particular day, I had managed to slip out of work "early,", around 5:00 p.m. I was anxious to get home, so I could start "enjoying my day." The irony is no longer lost on me.

Racing home that day, I came upon the rattletrap station wagon with a ladder strapped on top going 55 MPH in the middle lane. I switched lanes to get around the impedance, but a sideways glance to see who would dare drive at such a pokey pace gave me pause. The windows were rolled down, the longish hair of a middle-aged guy blowing in the wind. He looked so relaxed. At that moment, I had one clear thought: I want that. Not in the literal sense of that car or that human, but that vibe in general. I read the sign painted on the side of his wagon: Mural Magic Guy. Huh. That's a funny thing to do for work.

Over the course of the next few years, I moved myself into the slow lane. I quit my job and started walking on the beach near my house daily. I adopted a puppy. As I paid more attention to what made me happy, I discovered that I loved working with my hands, specifically on home improvement projects. I started spending my weekends working on one beautification project after the next. Scraping popcorn off the ceilings, laying mosaic patterns over linoleum countertops, plastering and painting—I loved losing myself in the creative process of the labor. At some point, probably inspired by Mural Magic Guy, I painted a floor-to-ceiling mural on the wall of a windowless stairwell in my condo. I would sip my morning coffee on the top stair, marvelling at how the mural had transformed a dark and neglected pass-through area to my favorite spot in the house.

Fast-forward three years. Painting commissioned murals had become my primary source of income. I had not magically transformed into the chilled-out person I'd envisioned, although shifting from a high-stress job to painting nature scenes to peaceful music by myself was a welcome change for my nervous system. What I came to understand is that the look I saw in the car next to me wasn't relaxation as much as a "satisfied fatigue" after a workday that was both physically and creatively demanding. I was now spending my days engaged in work I relished; I didn't have to wait until I got home to start enjoying my day.

I called up *Mural Magic Guy* from the phone book to thank him for inspiring me in my newfound career. He was grateful I called, but said while he had loved painting murals, he just wasn't making enough money doing it. He was currently looking for full-time employment in a previous line of work. I was crestfallen. It was like my own dream had met an unfortunate ending.

Wherever your skills
are at now, the most
efficient way to develop
your creative voice going
forward is to spend
the best hours of your
day, month after month,
elbows deep in making art.

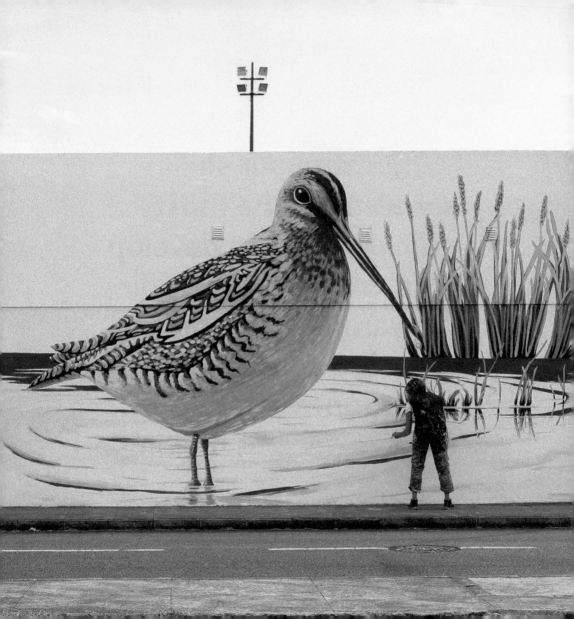

Sadly, this scenario repeated itself many times over my 20-year mural career: I've met many talented mural artists who love the work but are unable to make it sustainable as a business in the long run. This outcome breaks my heart. I imagine a world full of blank walls in need of a creative hand, and a diverse army of talented artists who love the work. I suffer from both extreme stubbornness and chronic idealism. I can't change my personality, but I can strategically direct my efforts. I took it upon myself to channel my stubborn idealism into figuring out financial sustainability for myself as an artist. Determination to make money was, ironically, an act of rebellion against the status quo. The status quo for artists, at least.

## Is Your Art Good Enough?

A common refrain I hear from artists interested in making money from their art is that they feel they are not yet "good enough." They believe if their art was just a *little bit better*, their art business would take off. I did not go to art school, so I would be the last one to suggest that you should take another art class. Art classes provide accountability, camaraderie, and constructive feedback. However, the core of improving our skills as artists is simply *time spent* working on our craft.

Is there a way you might be able to put in the hours needed to hone your creative voice without taking another painting class? One way to be accountable to your creative practice is to find clients who will pay you to paint for them. In this scenario there are no class fees, your art is of service, and you earn money that can sustain your creative adventure.

**Opposite:**
Morgan, painting a *Wilson's Snipe* on the Island of Flores in the Azores, Portugal.

People who watch me paint sometimes assume I must have been "artistically talented" from birth. My earliest memory related to art is climbing into my mom's station wagon after kindergarten, sobbing over the painting I held in my hands. I felt ashamed because while  the other kids in my class had figured out the mechanics of drawing a sun, a house, and stick figures and I could only manage "scribble scrabble." Growing up, I loved theater, singing, and sports. I was not inclined towards spending my free time in seated activities, creative or not. The first time I picked up a paintbrush in earnest was when I was 26 years old, when I attempted my first mural.

My first paintings were (no surprise) awful. However, in painting I discovered something that tickled a part of my brain that had previously laid dormant, and I was captivated by the challenge. I learned by simply painting—mural after mural. My first two were in my house, then two at my sister's house, then my grandma's house, then at a friend's house, and so on. Word of mouth slowly expanded the circle of individuals willing to pay me to paint their walls. Within a year, I was consistently finding paid work as a mural artist, despite my work being definitively amateur.

Amateur mural art is not the goal; it is a starting point. The goal is work that is both remarkable and demonstrates mastery of the craft. This is accomplished when the artist can spend the *best* hours of her days, *most* days of the week, year after year, working on her craft. The improvement in my skill as an artist over the past twenty years has been dramatic.

Whether you went to art school or not, the most efficient way to develop your creative voice going forward is to spend the majority of

your time elbows deep in making art. In this book, I propose that wherever you are on your path to mastery, you can find an audience and paid work commensurate with the skills you offer. I'm sure you know at least one incredibly talented artist who struggles to make a living from their art. Making a *business* out of your creative efforts, becoming an art professional, requires appreciably different skills than making art privately. The skills you bring to your business are not limited to what you can do with a paintbrush. Previous work and life experience will give you a boost, whether that is strong communication and people skills, marketing, or technical skills. These can all be put to use to find clients who will pay you to paint.

As you gain fluency in running your mural business, the busier you will be painting. The more you paint, the more your skill at both painting and project management improve. This positive feedback loop will cycle you up into a full schedule of creatively challenging projects with better clients and better pay.

## Why Murals?

For starters, it's what I know. I've never licensed my work on mugs or T-shirts, never started an Etsy store, nor sold paintings through a gallery. The commission-based model for mural painting works well for me. I enjoy the variety of types of projects and subjects I get asked to paint, I don't need a big studio or storefront, and I don't have to share my profits with a gallery or middleman.

Most importantly, it is super fun. There is something both exhilarating and completely forgiving about painting a wall. It engages me both

# My Credentials

- ☐ Art School
- ☐ Gallery Representation
- ☐ Popular on Instagram
- ☑ Making money making art

physically and creatively. When I attempted my first mural, I reasoned, "This blank wall is just sitting there anyway. Something is better than nothing. Besides, I can always just paint over it if it doesn't turn out right." I set the bar so low that success came easily.

The temporality of mural art, knowing you can't take it with you, that it lives outside the traditional sphere of "art world" scrutiny, is liberating. I recommend starting out with residential murals because the stakes are the lowest; the artwork only needs to satisfy one person for one particular room, and only for as long as it pleases them.

On the other hand, a blank canvas sitting on an easel in my studio can inexplicably feel consequential, as if one could be unworthy of a fabric-wrapped, wood frame. It offers me no clues as to whom it is for, where it will live, or why it will matter.

When you paint a mural on a wall, the clues for what to paint are offered by the immediate environment. Who uses this space, and how is it used? What does this space need for its function or aspirations, and how could I play with color and subject in a way that would support that purpose? How could I make the space more useful, engaging, or beautiful through paint? Emancipated from the confines of the rectangular boundaries of a traditional canvas frame—where floors, ceilings, and adjacent walls are all part of the creative conversation—the possibilities for impact expand exponentially.

## Mural Artist: It's a Real Job

I love my job. I love the physicality of working big, the smell of paint as I mix up glossy potions of limitless color, the flow that emerges when

I let intuition lead. And the reactions! When I'm painting, I hear the word "wow" so often, if I were a dog, I might think it was my first name. Painting for other people is a delightful way to show up and be of service.

There are a lot of ways to define success, especially as an artist. I have never won any art awards or had my work shown in a gallery. You won't see my artwork printed on the T-shirt of anyone famous. To me, success includes the "ooooohhs" and "aaaaahhs" of a group of fourth-graders rounding the corner to see the mural going up for the first time. Success is being able to match my work schedule to my kids' school schedule, so I can be around for them. Success is tears of gratitude from a client who is touched by the transformation of a previously neglected space. Success for me is getting paid for a job well done, supporting my family with work I truly enjoy doing.

What will success look like for you?

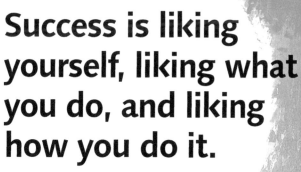

**Success is liking yourself, liking what you do, and liking how you do it.**

Maya Angelou

The mindset and metrics for success are appreciably different between studio work and painting in someone else's home or business.

# 3

# Painting a Mural: Best Practices

Whether you are just starting out as an artist, or you are a skilled artist who wants to move toward public mural projects, I recommend that you paint your first five or so murals in "low stakes" environments before charging for your work or painting in public spaces. Start out on a wall in your bedroom, at your grandmother's house, or the garage door at a friend's house. Better yet: all three. Start with walls where you can take your time experimenting and developing your style without pressure for a certain outcome. Your learning curve will be steep on your first couple projects. You will learn how to organize yourself, which materials work best for you, and how to use them in a way that best matches your creative intention. You will also get exponentially faster after each project, and this will help you figure out the right price and pace for your work, which will help you figure out if you want to turn it into a business.

# The Hidden Skill of Mural Painting

Murals reside at the intersection between art, design, and the house painting trade. When I was still working in tech, I had a friend, Ted, who was a professional house painter. Faux and specialty finishes were booming, and Ted was frequently looking for walls to practice new techniques on. I owned the condo I lived in and spent most of my weekends on home improvement projects anyway. I would work alongside Ted, taping and plastering with stencils or ventian plaster, or mixing up homemade "milk-paint" recipes using slack lime and whey, or whatever faux finish technique he planned to try on his next job. I had no idea that within a few years, I would quit my job and start painting murals, and that what I had learned those many hours working alongside a professional house painter would provide me with a solid foundation for a future career in mural painting.

The benefit of my experience became clear to me when I started hiring assistants to help me on mural projects. Most fine artists are used to working at a snail's pace in the controlled environment of an art studio, with smaller tools and smaller scale of traditional paint mediums. An art studio is set up for making messes, with plenty of counter space where light and surface angles can be adjusted to suit the artist. Errant paint splatters or showing up at 11:00 a.m. is not a problem for someone buying framed art, but it might be when you are working in some else's home. The experienced house painters I hired to help me wouldn't bat an eye at an 8:00 a.m. start time and were lightning-fast at taping, cutting in corners, and covering large areas with paint. They were careful to keep a light footprint, kept their work

area organized and clean, and were careful to avoid dripping paint down the wall or on the floor. I discovered my ideal assistants had both fine art and house painting skill sets.

Most aspiring mural artists have fine art and design backgrounds already. I recommend rounding out your skills by working alongside professional house painters. The tricks you will learn on the job related to wall prep, onsite organization, and clean-up will save you a lot of time and headaches in the long run.

# Materials

I painted my first mural as a weekend warrior fixing up my house, without a fine art or street art background. Because of this, my primary medium continues to be house paint, and I am still a big fan. I currently favor Benjamin Moore Aura, which does not contain volatile organic compounds (VOCs), is self-priming, and has a lifetime guarantee against chipping, peeling, or wearing off. Unless they are in full sun, the exterior murals I paint will last a minimum of 30 years. Buying top-of-the-line paint saves me time, because I can achieve solid color coverage in fewer coats. The thickness of best quality paint also helps bridge surface imperfections, like hairline cracks, on the wall. Though I don't expect art schools to start touting the benefits of house paint any time soon, it is ideal for covering large areas while being made to withstand the wear and tear of real life, including weathering outdoors.

House paints colors are created by a mix of tints, typically including black, to make the colors deeper. Because of this, when mixed together, they trend away from vibrancy, towards the colors of mud. I use that

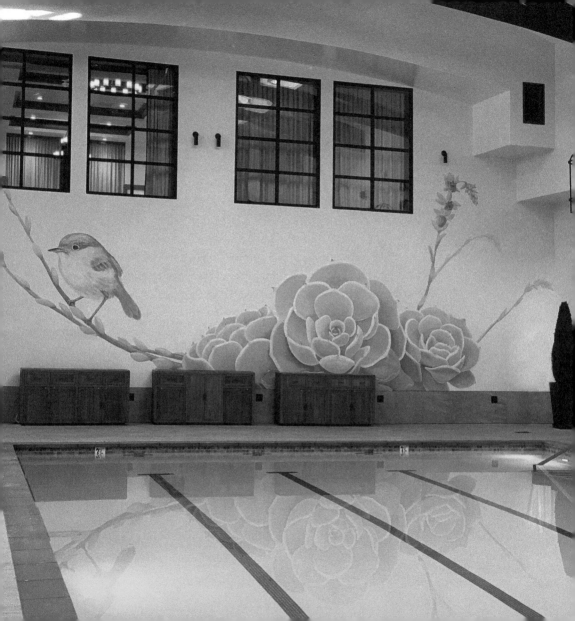

to my advantage to create soft effects in my murals. Tertiary grey and grey-influenced calming colors are popular right now, particularly in interiors, so this limitation in house paint can also mitigate color, especially when achieving subtle color transitions over a large area.

With house paint, I can work wet-on-wet for about a half hour for blended effects on interior projects. On exterior projects, the dry time depends on the weather and time of day. I arrive early to the jobsite and take advantage of cloud cover or morning dew when I want a long working time with the paints. In the early morning, house paint can take up to a few hours to dry. Where I live, the California sun can reduce dry time to under 10 minutes by midday. I use the fast dry time to my advantage on areas that need sharp edges or multiple coats.

Once I have the *base* coat applied, which includes the major color blocks of the composition, I refine the subject and foreground elements for the mural in brighter artist's acrylics. My favorite is Golden brand heavy-body acrylics, because they have high pigment ratio and durability, so a little bit goes a long way. I add retarder (to slow down drying time) or extender (to thin the paints) as needed. The toxicity of the products you use matters when you spend the bulk of your days using them. This is why using water based paints makes good sense. All but the cadmium colors of the Golden line of paints are non-toxic and have very little odor, making them ideal for indoor projects. I've worked with cheaper brands of acrylics, but they don't make my heart sing. The rich pigments of quality acrylic paints set the artwork apart with a vibrancy and immediacy that is lacking in mass-produced art prints or wallpaper. .

**Opposite:**

Morgan painted this mural, *Echeveria and Gnatcatcher*, for a community center in San Diego, CA with latex house paint.

## NOVA COLOR PAINT

Nova Color is a paint company based out of Los Angeles, and it gets honorable mention here because they specialize in mural paints. I have used them but do not use them regularly for the following reasons:

- There are no local retail outlets that sell it, so I have to plan what I will need in advance and order online.

- Nova paints contain VOCs. They have a strong odor and make my eyes water while I work.

- The coverage is not as opaque as the Aura house paints or Golden acrylics; more layers are needed for solid color coverage.

A benefit to using Nova Color paints is that you can purchase them in smaller quantities than gallons of house paint. I paint a lot of murals, so I will eventually use up my full gallon of red or bright green house paints over the course of several murals. However, if you are planning on painting only one or a few murals, you will save money by buying the smaller quantities of Nova Color to avoid leftover paint. Additionally, the strong odor of Nova Color paints might not bother you if you are only painting occasionally.

## SPRAY PAINT

Most mural artists who started out with street art prefer spray. If you are working on an exterior mural project and longevity is not the goal, then spray is fast and gets the message up. If spray is core to your creative

voice, go with it. The main reason I prefer traditional paints is that they are a better match for my creative style. Here are a few more reasons why I prefer brush instead of spray application:

- Toxicity: In recent years, spray paint has become somewhat less toxic than it used to be, but even CFC-free aerosol sprays emit VOCs.

- Prep: Spray requires significantly more preparation effort and materials, particularly for interior jobs, than roll-on paint—in the form of taping and covering everything in plastic tarps to protect against overspray. Paint is relatively efficient: you walk up to a wall, throw down a tarp, tape the bottom edge, and get to painting.

- Masks: Wearing the heavy-duty respirator required for spray deters exchanges of smiles and engagement. After a few hours of your face being pinched and sweaty (and with a better understanding of the pain of Darth Vader), the joy of wearing a respirator wears off.

- Color: With spray paint, you are limited to working in one color at a time, a color somebody else has mixed and chosen. I love the unlimited color possibilities and nuance enabled by mixing colors myself.

- Stock and availability: With paint, I only need to stock 7 to 10 basic colors, and can mix every color I need from there. With spray paint, you might need a range of 30-plus cans of color.

Unless you are working in a city with a good art store, you have to plan out all the colors and purchase everything (and more than you think you will need) in advance.

- More trash is generated: You might have 30 empty spray cans after a mural, compared with 3 to 4 empty gallons of paint.

- Durability: Spray paint applies a very thin layer of paint over a wall. It cannot compete with the durability and UV resistance of a quality, thick house paint applied in layers that are engineered to last 25-plus years on full exposure walls.

- Cost – This will vary from artist to artist, depending on their style and how much paint they put into each piece, but I spend more on materials when I use spray paint in a project.

Whether you decide to work with spray or brush, select the best quality materials. Your hand-painted efforts will never compete on price with mass-produced wallpaper prints. Don't cut corners on the small cost of using the best quality paints available.

## Setting Up

You will spill paint. Possibly all over the place. (Even though you are certain you will be careful.) Once I get absorbed in painting, I tune out the details of the environment—which becomes a hazard if the environment isn't set up right. Cover the floor, wall fixtures, and furniture around the wall with plastic or paper, so you can focus on making art

and not scrubbing paint out of the carpet. Never use a sheet (paint goes right through it); instead use a rubberized drop cloth. The weight of the heavy material keeps the drop cloth in place. Tape the drop cloth down, so that flipped-up edges don't become a trip hazard. *Anything* on the floor (open paint containers in particular) are prone to getting kicked over once you will get absorbed in your painting process. The last thing you want is to be negotiating with clients over paint drips on the carpet at the end of a project, when you should be basking in the beautiful artwork.

Once the area is taped off and protected against errant paint drips, inspect the wall. Patch cracks and holes, and sand the patched areas smooth. If the wall is in bad shape, for example with a lot of greasy or sticky areas, wipe the wall first with diluted trisodium phosphate (TSP), and roll on a primer. If the wall was previously painted in gloss or semi-gloss, then lightly sand the whole wall. Most walls you encounter will have a low sheen finish, so you can just spot-sand any wall irregularities and start painting straight away with your self-priming house paints.

I like to keep all my supplies on a rolling cart. There are two reasons for this. First, keeping everything at waist height will save your hamstrings and back from having to stoop over to pick up supplies off the ground. Bending over works for about half an hour, but not for a full day of painting. Secondly, I can roll the cart along the length of the wall as I work, so all my supplies are close at hand. Make sure you have everything you will need close at hand before you start, so that you won't have to leave the paint space until you are ready to take a break. Once you start painting, you might step in a drip, or have paint on the edge of your glove. If you have to leave the area, that drip on your foot travels to a

clean surface, and the doorknob will get a smear from the dab on your glove. Each drip and smear will add 10 minutes of detective work and housekeeping at the end of a project.

On the top of the rolling cart, I assemble my water bucket, paints, brushes, wiping cloths, and paint tray. I reuse the shallow-sided but sturdy fruit and vegetable boxes from Costco to keep everything together, so nothing falls out (yikes!), and to provide maximum mobility as I paint. My favorite paint mixing trays are the plastic clamshell trays that Costco sells apples in. The size of each "cup" is just the right amount of paint for mural painting. Although, if your life looks anything like mine, you are already awash in plastic containers, all of which can be repurposed for holding and mixing paint. If you tell two friends to pass along their clean, used plastic containers to you, you will soon be overrun with options for the day's painting trays. The important thing here is to keep everything contained in one "tray" (in my case, a box) so that you can keep all your paints together, ready to mix as you work along the wall.

## Blocking in the Artwork

How you approach the painting will depend on the subject and whether you are painting a single, dynamic element on the wall or a "corner-to-corner" wall mural. For corner-to-corner, I recommend beginning by rolling on a base coat of house paint in colors with a slightly deeper tint than the final color palette desired. Use a roller both for efficiency, to decrease the total number of layers needed to achieve good color coverage, and also so that white from the wall does not peek through the rich colors of your painting. On small murals—under 120 square

A mural art business has minimal inventory: Everything you will need will fit on a rolling cart.

feet—a small "weenie" roller is sufficient for rolling on the base coat. On larger murals, use a full-size roller. By using a roller, I have a rich tapestry of overlapping colors on the wall in short order, following the general shapes of the composition.

Once the base coat is dry, refine the shapes in brighter colors with a 3- to 4-inch chip brush, the kind you can find at any hardware store. For most designs, you can get a fairly clean line with the edge of a chip brush that is well loaded with paint. In general, on smooth surfaces, I use soft bristled brushes, and on rougher surfaces like brick or stucco, stiffer bristles help achieve a straight line. I paint most of the details in my murals with a size 10 or 12 artist's brush and move to smaller brush sizes only for the final details.

If you are painting artwork that does not go corner-to-corner but is a dynamic element on the wall, then a roller might be overkill. If the wall has been recently painted and is the desired color, use chalk or a watercolor pencil to block in your composition, and then move right to your fine art brushes and artist's acrylic paints to paint in the foreground element. Acrylic paint is opaque; each layer obfuscates the outlines (and effort) of a detailed drawing that might be underneath, so don't spend too much time getting the sketch perfect. I mark exact distances (if needed) or general anchor points with chalk, but otherwise I get right to refining the design with paint.

I frequently adjust the scale of the elements onsite, so that the composition works perfectly in the space. In my experience, what looks good on a piece of paper might not be the right composition on a wall. Based on viewing obstacles, angles, and opportunities, I may change the scale or rearrange elements. If I am painting a landscape, I generally

put the horizon about eye level, because it feels most natural, as if one were looking out a window.

As you migrate towards smaller brushes and artist's acrylics, don't get stuck for too long on any single element. Water-based paint dries quickly. If the area you are working on starts heading in an unfavorable direction, just move to a new area and come back 30 minutes later to start fresh. With a mural, there is lots of surface area to cover, and developing the composition as a whole helps develop consistency and cohesion across the piece. If—no, when—you drip paint down the wall, wipe the paint before it dries so it doesn't show through as a bump under future layers.

A mural takes many painting sessions to complete. When you start to slow down or get grumpy, employ the same strategy every great artist falls back on at some point: take a lunch break. My most productive work days are when I can take a midday nap in my van. Every work of art goes through an ugly phase. With a mural, your process is on full display to your client or the public. Be patient with yourself and the process. Self-flagellation doesn't improve the work. On the other hand, a heavy dose of self-compassion to let it be ugly when you go home for the night will make it easier to bounce back and improve the work the next day when you are fresh.

## Using a Projector

Projectors have progressed light years forward since I started painting murals. Previously, the price, primitive interface, low quality, and advanced planning required meant projectors were more headache and

expense than they were worth. In the past five years, I have started to use a projector more often, because it saves me time, especially for lettering or if I am blocking in a human figure. I use a wireless Bluetooth connection to share my phone screen with the projector. I can search images and manipulate them onsite, flipping the image, or zooming in or out to get the scale right, which is much easier than physically moving the projector around the room to get the optics right. I like the mobility of the lightweight "pico" projectors. I currently use a ViewSonic M1 that can go without an A/C adapter for a couple of hours, in case I am not near an outlet. It has a "short throw"—meaning it can project a wide picture even when fairly close to the wall—which is great for situations where you can't back up very far from the wall, for example in a hallway or on a narrow sidewalk. High lumens add to the versatility, so that you can see what is being projected even if you can't make the room completely dark.

Every projector works best in low light, but this adds additional logistical and weather-related challenges when working out-of-doors. For example, it's best to apply paint above a temperature of 60 degrees, but it is often colder than this outside before the sun comes up; so painting with a projector in the early morning is usually not a viable option. In the evenings, there are also changes in weather (cold or wind) and light conditions; you can't mix colors in the dark. Basically, on outdoor projects, depending on a projector to complete the work can be problematic.

Although I have come around to the benefits of a projector, most of the time I prefer to paint from a printed image held in my hand. Not only is it faster, but also I am working holistically and intuitively with

the shape, instead of getting distracted by the technicalities of setting up of the projector (tripod, lighting, image projection, power source, etc) and tracing the design, which is an entirely different creative process. If an element in the composition of the painting has exacting proportions, but the space isn't right for a projector, a quick solution is to print out the image of what you want to paint, then fold the image in half or up to eighths, and measure and chalk in a correlating grid onto the wall. This will chart out the basic proportions and negative space around an object, so you can orient the work on the wall.

## Color Volume

In traditional studio art making, an artist typically makes creative choices that are unrelated to the space where the artwork might eventually live. I take the reverse approach in my work: the mural has a specific function for a particular space. My creative choices are driven by that shift in perspective.

The color volume that is appropriate for each environment will vary wildly. The relatively large size of the canvas you are working on with a mural is all the reason to be more, not less, nuanced with color, particularly with interior murals. For exterior projects, a bold composition with clean lines and illustrative style offers visual "pop" for attracting attention, but a work of art doesn't have to project at the loudest volume to create a profound impact. I love mural art that emerges almost unexpectedly and invites you into a quieter moment in the public space, instead of shouting at you. I will never forget wandering around downtown Portland when I turned the corner to see a mural by one of

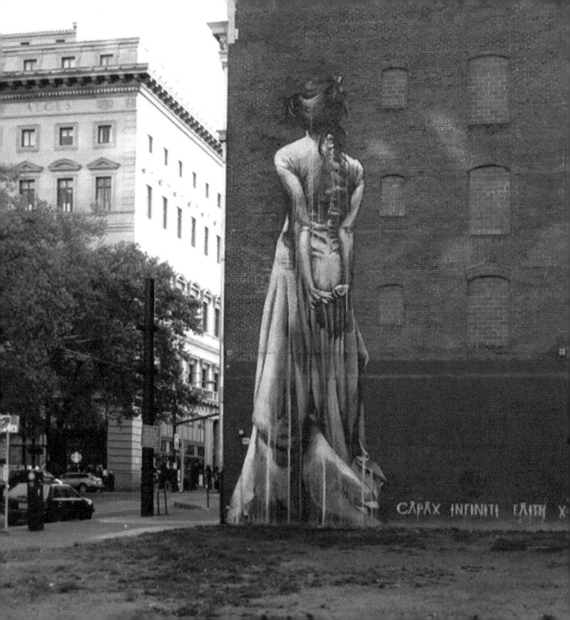

CAPAX INFINITI FAITH X

**Opposite:**

*Capax Infiniti* by Faith XLVII at 1156 SW Washington St. in Portland, OR.

my favorite artists, Faith XLVII: a three-story mural of a bride on the side of an old brick building. It was a full-length, beautifully-rendered portrait with the subject's back towards the viewer. Rather than looking "stuck on" the side of the building, it was integrated into the urban landscape, executed with a transparency and artfulness that evoked a fading but cherished memory elegantly imprinted on the massive (and mostly windowless) brick building.

# Painted Ceilings

Painted ceilings capture our collective imaginations. We picture Michelangelo, straining in the cold and damp Sistine Chapel by candlelight, suffering over his ceiling project for four years. We know he was under mental and physical duress and did not enjoy the work one bit. Still, the fascination in having one's ceiling painted like the pope's persists.

My advice on ceiling projects: Don't be cavalier about the physicality of the endeavor. Here are my suggestions for staying healthy while painting a ceiling:

1. Careful planning. Create sample boards and mock-ups, and the details agreed upon with the client, in order to save time on puttering, false starts, or re-dos. With ceilings, I aim to get feedback from my clients at least daily so I know the work is on track with their expectations.

2. Work short days. I never quite figured out the "*Four-Hour*

*Work Week*", but on ceilings, the four-hour workday is key. Don't let guilt or your workaholic tendencies keep you on the jobsite. Go home early and take good care of yourself, so you can work many days in a row without strain.

3. Take frequent breaks. I set a timer every 45 minutes to take a 15-minute break. I am never ready to put down my brushes; but as soon as you can take a break, do. I haven't fully mastered this one. As my mother used to say, "Do as I say and not as I do."

4. Wear neck support. Yes, people will look terribly worried and ask if you were in a car accident, but a medical neck stabilizer is great. Even less attractive but more supportive is the Neck Aid. Instead of wrapping around your neck, it provides a shelf for the back of your head to rest on. It hooks onto your pants and behaves like a pair of over-ambitious suspenders. You might be mistaken for a relative of Mr. Bean.

5. Reward yourself with a massage or chiropractic adjustment. This will speed up recovery and make sure you get your hunched shoulders out of your ears. On the bright side, my chiropractor pointed out that painting ceilings might be the perfect therapeutic counter-stretch to chronic hunching over my smartphone.

**Opposite:**
Morgan painting *putti* on the ceiling of a private residence in San Jose, CA.

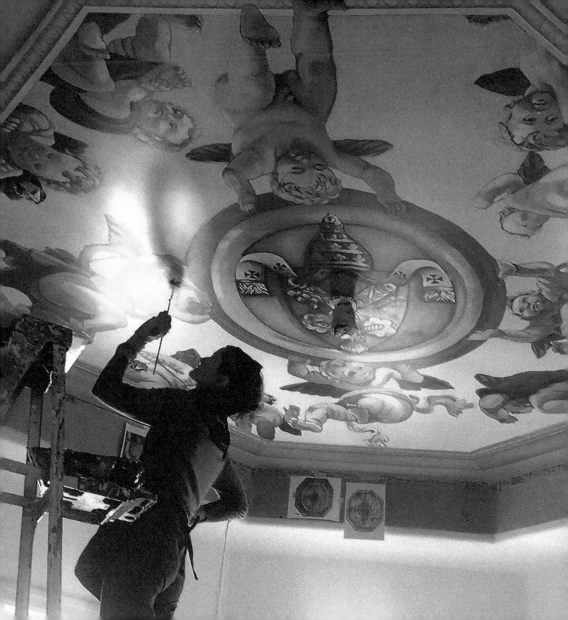

# 4

# Residential Murals

## (The Best Place to Start.)

While public mural projects hold the promise of fame and longevity, residential murals are fabulous bread and butter jobs for a mural artist. I know of a couple of internationally recognized mural artists who continue to take on residential mural projects because the international opportunities often don't pay much more than the cost of airfare and materials. Residential projects are scalable: from beginner artists to accomplished masters, there is a residential client that will be interested in your offering.

Residential projects are the perfect playground for developing your mural painting skills. The stakes feel lower on residential projects than public-facing walls, since the only judges are you and your client. Each project is an opportunity to develop fluency in a new surface, technique, or environment that offers a unique challenge. Relative to public or commercial murals, the design and approval process zips along. The client might be ready to have you start as soon as possible, and most residential projects can be completed in less than a week. Residential work can be a great way to churn through a wide variety of projects and make a living

**Opposite:**
Another happy residential client in Los Altos, CA.

47

at your art while developing a pipeline of larger (and typically slower) commercial and public mural projects. Through residential projects, you will learn how to organize yourself on a job site while gaining confidence with the materials and scale before you work on murals in public spaces. You will learn the dance of the collaborative creative process, and how to set that up for success.

Commissioning a work of art is a leap of faith between both parties, with the client shouldering most of the risk. The client is not only committing to funding their wild idea, they are doing it sometimes against the advice of their risk-averse spouse or interior decorator. Time and again, I have enjoyed the satisfying impact of success that has come from our creative leap. Clients cry tears of gratitude for their trasnformed space. Every happy client reminds me that I am providing a meaningful service through my creative efforts. The highlight of residential projects is often the clients themselves. The relaxed work environment, including petting their dogs when you show up to work, having lunch in someone else's well-tended garden, or being offered the occasional cappuccino or baked offering, also makes residential projects a delight.

Taking on a commissioned project can be a terrifying proposition for artists who don't want input or feedback on their creative efforts. One of the most common questions I get from artists and non-artists alike is, "Don't things ever go 'off the rails'?" They want to hear horror stories. It's true, there are many things that can go wrong when someone commissions a work of art. There have been a handful of royal "fails" in my career, including getting fired and clients that refused to pay. While they caused a lot of drama at the time, they were rare; and in retrospect, the "fails" were the projects in which I learned the most. Each bump in

# Tips for Successful Private Commissions

1. Respond within 24 hours to all mural inquiries. This rule extends through the life of the project; be responsive to your clients.

2. The first interaction with a client is a mutual interview. Do they have the budget for professional art? What is their timeframe? Does the project appeal to you creatively? Is this person someone you look forward to working with? Whatever they tell you about the project, listen to what they are saying (and not saying) carefully. If your gut says no, don't take the project. Not every client will be a good fit for your services.

3. Be clear with your process and let clients know what to expect each step of the way. For example, "I will send you a proposal by the end of the week. Both the deposit invoice and contract for the work are included in the proposal. If you would like to move forward with the work, please mail a deposit check and signed contract back to me and then I will begin working on a custom design."

4. Don't begin any work without a contract and deposit in place.

5. Keep your agreements. When it comes to timing or pricing, unpredictability is unprofessional.

the road points to a shortcoming in my process, which I am then aware of and able to fix.

For example, I had a client that held the belief that the value of an artist's work should be judged on how much time it takes to create the piece. It made perfect sense then that they were upset when a project only took me two days, when I had verbally estimated "about a week." I learned from this experience to include my wildly optimistic as well as my most conservative estimates on timing. In almost every instance I can think of, if a project runs into trouble, it is an issue around poor communication of boundaries, process, or the setting of expectations. Don't oversell the brightness of glow in the dark paint or use examples of other artists' work to a client. Speak candidly from your experience, and use only previous examples of your own work to set realistic expectations for your clients. I adjust my process after each bump and "fail" so that, on balance, about 98 percent of my projects end with happy clients and a paid artist.

## The Design Process

Clients are hiring you based on your body of work and whether your style is a match with what they are looking for. Similar to an architect or interior designer, the design is a big chunk of the creative work and should be paid for. Having said that, pitching ideas including creating digital mockups of their space using examples from your portfolio, creating rough sketches of ideas, and sharing images that might inspire the design or "mood board" might all be part of the pitch you make to the client to communicate what you are proposing and bidding on.

If your proposal is accepted, the first step is to sign a contract and collect a design deposit. I begin the design process with a phone call or in-person meeting. Establish a clear description with the client of how the finished work should feel and a wish list for what might be included. Ask the client to share images of artwork that inspired them to commission a mural.

Based on the style and possible subjects discussed in our initial meeting(s), I create between one and three distinct designs that would work in their space and within their budget. If any of the designs offered changes the scope and therefore the cost relative to my initial proposal, I let the client know upfront, so they can consider that information in their decision. I sometimes create my designs on paper with watercolor and ink, especially for the first stages of noodling ideas, but more often these days I use Procreate on the iPad with an Apple Pencil.

Whichever medium I use to create the design, I want to convey the general composition to the client. I do not try to fill in every detail or get the colors exact. I leave that for the painting. I let the client know what level of detail they *do* need to pay attention to in the design, and what types of details don't get decided until the painting is underway. I will include a written checklist of elements that will definitely be included as well as a written description of the final piece. Beyond that, I want to maximize leeway for my own creative expression during the painting process. This is in the client's best interest, as the ideas I come up with onsite, "elbow deep" in paint, are what make the artwork truly site-specific and integrated with the immediate environment.

If a client decides not to move forward with the project after receiving the designs, the contract should be clear that the creative copyright stays with the artist.

*Who* I work with has become my most important job selection criteria.

If it's not both a creative and temperamental match, it won't be an easy project for either artist or client.

# Painting *In Situ*

Once the client and I have a shared understanding of what the final product will look and feel like, it's time to get the paint on the wall. I communicate along the way with my clients, especially if I need confirmation on the color or any deviations I make from our agreed upon composition. When I am working in the space where the artwork will be, interacting with the people who use the space, I have more sources of inspiration than I do when I am coming up with a design in my isolated studio. I might adjust the color palette or change the composition relative to the immediate environment based on visual obstacles or opportunities.

I let my clients know what time I will arrive and how long I expect to work each day. I bring everything I need with me for the day: water, food, supplies. I take my shoes off if they have carpets. I pet their dog, shake hands with their children, don't blast my music, and in general keep good manners. I cover everything in tarps or plastic, taping any edges that need to stay clean. I take my brushes home at the end of the day and wash them in my own sink. Remember, clients will treat you with the same care and professionalism with which you treat your work.

I invite clients to stop in whenever they like to check on progress. I had one woman pull up a chair and watch me paint her mural start to finish. (We had a great day together.) Inviting feedback includes the client in the creative process—and also ensures the artwork is on track with their expectations. If the client cannot be there to see it in person, I send daily photo updates. Doing so will save you from any misundertandings that might result from waiting until the end for the "big reveal." Surprises

can be problematic: re-doing finished work is particularly disheartening for an artist. By inviting the client into the process, you can best manage the project for a positive outcome for both parties.

# Incorporating Client Feedback

With a commissioned work of art, you and your client are on the same team; you both want beautiful art and happy endings. The client has worked hard to fund the project and will be living with the artwork for the next decade or more. You want them to *love* it. Navigating client feedback requires a curious and creative mindset, and will get easier with practice.

Whenever possible, do not take creative feedback personally. All feedback contains information, whether it is articulated well or not. This is your area of expertise, and it is up to you to translate their concerns, knowing they may not have the right vocabulary, or understand what is involved to create the outcome they are looking for. Just because they didn't go to art school doesn't mean they can't have an opinion about what you are painting. Unlike commercial projects, where you might be working alongside other creative professionals, with residential projects, you are the creative expert in the room. Share your expertise without being disrespectful.

Remember, you can always (tactfully) say no! You are, after all, the one holding the paintbrush. For example, "That's a cool idea! However, I don't think that will work in this situation because…" Is it outside the established scope or will it detract from the composition? Would the idea be better incorporated into the surrounding decor? Most of

**Practice is the best of all instructors.**

Publilius Syrus

the time, an extra set of eyes and fresh perspective improves my work. I frequently find myself saying, "My clients have the best ideas."

## Wrapping Up: Avoid Surprises

Keep your client apprised on timing as you progress, and let them know at least one day in advance when you plan to finish. I prefer when the clients are home on the day I finish the mural, to minimize the possibility of having to return for touch-ups. I let a client know when I am on my final touches, and I will ask them, "Please let me know if there is anything that catches your eye, so I can fix it as I finish up the piece." If payment is due upon completion, I want to make sure they are home, satisfied with the artwork, and not surprised when I say, "All done." Bring a printed copy of the final invoice with you on the final day of painting. Typically, for residential clients, you should be paid the same day you finish the work.

Within a day or two of completion and payment, send a "thank you" note, noting any specific kindnesses received during the project. If you have done your job well, you won't need to ask for referrals. Your clients can't wait to show off their new mural to everyone they know, post it to social media, and tell their friends about the amazing artist they hired. No matter what your goals are with your artwork, private clients will play a critical role in your success. Make sure they feel seen and appreciated.

**Opposite:**
Morgan transformed this residential basement in Palo Alto, CA with a *trompe l'oeil* mural inspired by a formal French garden.

← Before
&
After ↓

# 5

# School Murals

Over the years, traditional educational priorities like order and consistency in schools have evolved towards an increasing emphasis on critical thinking, collaboration, and creativity. Teaching pedagogy has come to embrace a diversity of learning styles, and it is now understood that children learn best when they feel emotionally safe. It turns out that incorporating play is one of the most effective ways to learn anything. Unfortunately, most school campuses still resemble correctional facilities. Heavy, functional buildings and universally beige walls don't echo the 21st-century approach to education. Mural art is the most cost-effective campus improvement project and can indicate a vibrant and healthy school culture.

I am passionate about the value that mural art can bring to a school campus. Good teachers instinctively know they need to engage their students' hearts first before they can teach them anything. It turns out we think better, learn better, and behave better when we feel safe and seen. The spaces we create provide cues for expected behavior. Whether we are six or sixty, spaces that feel kind and welcoming put us at ease, and we are more likely to find a kind or positive response in a relaxed state than when we are stressed.

School mural projects are the perfect bridge between residential and public murals for an artist. The scope of a school mural is typically larger than residential projects and the artist gains experience with an increasingly collaborative design process—including gathering community input, common on public mural projects. On the whole, a school community is a receptive audience. While working on a school mural, you might be the toughest art critic on the project.

# Funding School Murals

Tight budgets are a reality for school mural projects. At the core of the debate around whether a school should invest in mural art is this question: *Does the physical environment matter?* and "*If so, how much?*" School budgets are stretched thin over many worthwhile competing priorities. However, if it is agreed that the physical environment matters, is that reflected in the budget, at least as a percentage? Schools sometimes solve a funding gap by opting for permanent art to be created by volunteers and students. While mural art painted by students is fun and builds engagement in the arts, the results will be a far cry from what a professional artist will be able to create and won't have the longevity of skillfully executed mural art.

Funding for school mural projects can come from a variety of sources, including a PTA (Parent Teacher Association), principal's discretionary budget, campus maintenance budget, or from the curriculum budget. For example, some schools fund a "character education," social/ emotional, or diversity and inclusion learning curriculum—and a mural that celebrates or supports an aspect of that curriculum is eligible to

When efficiency
trumps care,
it creates more
problems than
it solves.

receive funds from that program. Another example is that in California, all fourth graders study California history. Every school has an annual budget to support that unit, which might include field trips to the capital or to visit one of the early Spanish missions. One less field trip for one year would pay for a large mural that celebrates California history and would last 30 years in the heart of campus, benefiting the entire school community on a daily basis. Another source of funding is from a graduating class gift. I have heard more than once, "We initially planned to gift a bench to the school. However, when you include the cost of engraving a dedication and installing the bench, it would be about the same cost as a wall mural, which is way more fun."

Mural art is a relatively inexpensive solution to beautify school environments, especially relative to other capital improvement upgrades, and requires little if any investment in ongoing maintenance. "Relatively inexpensive" should take into consideration paying the artist a professional wage for their work. I never recommend an artist paint for free, and schools are no exception. It is better to let the school community make the artwork a priority for themselves, and unite around a shared value of caring for their campus. As for exposure, in the dozens of school mural projects I have painted, a school mural has never led to a private commission from a family, despite the large number of families who encounter the artwork.

I do offer schools (and other non-profit organizations) a discount over my regular pricing. The waves of "oohhs" and "aahhs" I hear when a class comes around the corner and sees the mural progress reminds me that I am making a difference in how a generation of kids will feel on campus. It's a good feeling. Whenever possible, I schedule

my school murals for times when school is in session, so teachers can bring their classes by, and the parents can see progress at drop-off and pick-up. The interactions are precious. "Are you a real artist?" and "Aren't you finished yet? It looks done already!" It is also encouraging for the many self-identified student artists at the school to see an artist getting paid for their work so they can consider that being an artist is a "real job" they might one day pursue.

While painting a school mural does not typically lead to getting hired for residential or commercial projects, word of the success of one school mural project can ripple through to other schools, and lead to more mural projects, especially within the same school district. Principals share information with each other. Make sure you set up each project so that you can earn a living wage. When the district does call you back to paint another mural, you are still a full-time artist who can help them out. Every project that keeps you in business allows you to hone your craft and improve your offering for the next project.

## School Mural Design

In the case of schools, a mural design that prioritizes "kid-friendly" aesthetics communicates to kids and adults that making kids feel welcome (a component of feeling safe) is a priority. Kid-friendly doesn't have to be represented with teddy bears and primary colors. Artwork should strike a balance so that it is also appealing to staff as well as the broader community who likely share the facilities on the weekends and during the summers. School murals can incorporate wayfinding, school values, and educational elements from the curriculum. The mural art

will become part of the school "brand." For example, schools where I have painted murals in the past often use the mural as the backdrop for their website banner, weekly newsletter, or annual school photos. Some of my murals are designed to encourage "selfie moments," so students can share their school pride on social media. The mural frequently becomes the backdrop for school events—transforming them into more vibrant, colorful affairs. The benefits of art on a school campus amplify far beyond the requisite "art appreciation"; the art enhances a sense of pride and belonging for an entire school community.[2]

# Case Study: Springer Elementary School

## ... Or, How to Transform a School in Under $15,000

**Quick Quiz:** Where would you prefer to send your child to school? Does one of the photos on the facing page seem more kid-friendly than another? More playful? More inviting?

When I first met with Christy Flahavan at Springer Elementary, we agreed that the school had seriously neglected their curb appeal. For the previous 40 years, "putty on putty" was the color palette, and portable classrooms (putty-colored, of course) dominated the school entrance. Christy had attended Springer as a child, so she had a special affinity for the campus and was dismayed by the impression of stale

**Opposite:**
Morgan painted a wall mural and pavement elements at Springer Elementary School in Los Altos, CA.

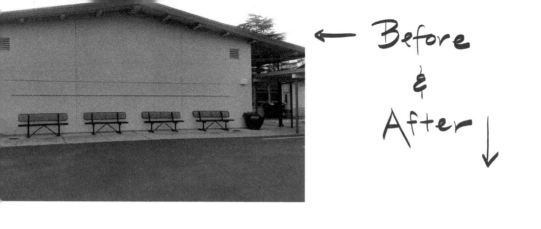

← Before
&
After ↓

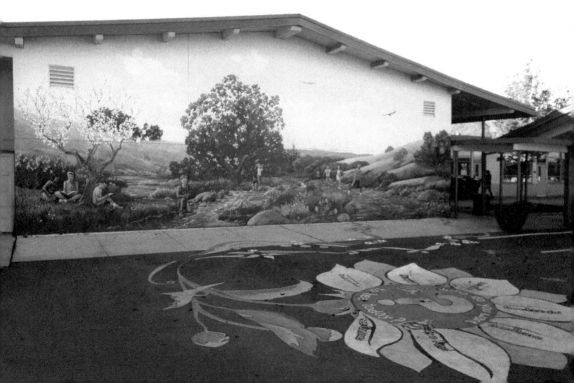

neglect. Despite transition in the school administration and only lukewarm interest from the PTA, Christy, who was PTA president, had a bold vision for mural art on campus. She was able to earmark a small amount of PTA funds to commission a pavement painting project for the kindergarten play yard. The scope was buffered by including a Saturday "volunteer day" where I directed a self-selected group of parent volunteers to help execute the design. (The cost for this project was $3,000, including design and materials, and was executed over one weekend.)

Monday morning, as the kindergartners poured into the colorful play yard, it was a revelation. No one questioned the expense as the kids squealed with delight and engaged with the colorful flowers, animals, and educational elements painted on the ground. The cared-for, kid-friendly environment helped the teachers feel supported in their work and also gave parents confidence that their children were being educated in a school environment that cared about the well-being of their students.

The success of the kindergarten blacktop mural enabled Christy to gather broader support and solicit donations from the school community for a large mural at the center of school on the back of the multi-purpose wall the following year. The 40-foot long windowless wall at the center of campus was a hub for school activities: drop off, pick up, lining up for class each morning, and school-wide assemblies. We chose an expansive landscape as the subject of the mural—a scene that celebrated the local wildlife and natural habitat. We incorporated a legend on the side of the landscape mural to identify species the fourth graders learned about in their California history unit, including quail, California poppy, and a

**Opposite:**
The kindergarten playground at Springer Elementary School in Los Altos, CA painted by Morgan with the help of parent volunteers.

← Before
&
After ↓

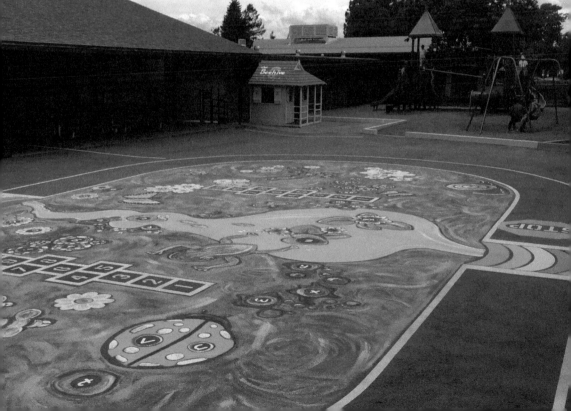

red-tailed hawk. Again, the artwork was a hit not only with the students who watched the painting unfold throughout their school day over several weeks, but it also was enjoyed by the entire school community.

The following year, the new principal used part of her discretionary funds to continue the artwork onto the pavement below the large wall mural. She wanted to highlight the growth mindset and citizenship curriculum that Springer school had adopted. Using a pun on the school mascot, which is a bee, we came up with a "Who do you want to Bee today?" art campaign including seven character traits that support a positive learning environment (and are simple enough for the youngest students to understand): bee kind, bee brave, bee playful, bee persistent, bee confident, bee helpful and bee curious. Sign me up!

After we completed the pavement painting, the principal added again to the project to include wall vignettes featuring native pollinator species throughout the campus, which tied into the school's garden-based science curriculum. Each vignette featured one of the seven "Springer Bee Qualities" as well as a native plant in bloom and a pollinator. In the game of finding all the vignettes throughout the campus, students learned to identify key pollinator flowers like hummingbird sage and showy milkweed flowers, the primary food source of Monarch caterpillars.

In the span of three years, Christy's determination to breathe fresh life into the campus created a cascade of beautification projects that transformed the Springer campus. If you visit the school today, you would have an entirely different first impression than you would have had just a few years prior: many of the bare, putty-colored walls now feature colorful artwork that celebrates aspects of the campus culture, history, and curriculum. All of the foot traffic entering the campus passes

over one of the two pavement murals, either through the kindergarten yard or by the administration building, so the entire school community is greeted with art when they come onto the campus. What I have witnessed across most of my school mural projects is that once the school community experiences the positive impact from the artwork firsthand, building broad-based support for future mural projects at that school is much easier. The first leap is the biggest hurdle.

# Artist's Rights

In general, school district administrators prioritize fiscal prudence, legal caution, and risk management. Mural art introduces a wild card typically outside of a district's or principal's core expertise. Successful project management for school mural projects requires addressing the seemingly competing interests that school administration faces. On school projects, I frequently provide an up-front design, so it is easier for the project champion to win over support. My district-friendly contract includes a clause that allows the district unconditional rights to paint over the artwork at any time, for any reason. It also includes a clause that allows the school unlimited use of photos of the artwork for print or digital purposes.[3]

I recommend that artists maintain creative copyright on every project. Creative copyright protects the artist's right to claim they created the work and use images of their work however they choose. These rights are outlined in the Visual Artists Rights Act of 1990 (VARA).

I recently worked on a relatively small mural project for a school within the Los Angeles Unified School District (LAUSD). In order for

the principal to gain approval for the mural, I was required to sign a liability waiver, special event waiver, facilities use contract, as well as two separate contracts for the artwork, one of which included my contract as an addendum. In the LAUSD district contract, a clause stipulated that the artist released any claim on creative copyright. This type of clause is a "nuclear" solution to resolve concern over the remote chance of lawsuits from the artist regarding damage or destruction of the mural. A plain English paragraph that specifically releases the district of liability for damage or destruction of the artwork for any reason, and also allows the district to paint over it "at any time, for any reason," is the cleanest way to delineate both the district's and artist's rights. Since this was a small project, and the principal was at her wits' end with the difficulty of getting district approval for the project, it did not seem worth the effort to protest the clause. However, retaining creative copyright is something I have successfully negotiated with other school and commercial projects in the past, despite the client initially requesting I waive my VARA rights.

## Painting a Mural on Panels

Sometimes a district will require the mural to be painted on panels. Panels add expense and liability to a project, but if the artwork is painted on temporary structures (for example, portables), or if it is intended as a temporary piece, panels make good sense. For example, a mural painted by a graduating class would lose contextual relevance to the school community in just a few years, so that would be a good candidate for painting on panels.

Whenever possible, I prefer to paint directly on the wall. Painting directly on the concrete or stucco saves money in the form of additional materials and installation, as well as increases liability for the artist and the district. A mural painted on panels could theoretically be pulled off and cause injury. Districts that require panels eliminate the possibility for the creative integration of the artwork into the surrounding environment, by wrapping the artwork around the corner of a wall or onto the ground. For example, if the mural design includes a tree, I might pull the roots or foreground flowers out onto the pavement or turn the corner with the branches, giving the artwork a dynamic edge that extends the impact of the artwork.

## Mural Longevity

Over time, as a mural becomes knit into the fabric of a community, the art takes on new meaning for both historic and sentimental reasons. Murals rarely generate lawsuits, but when they do, they reliably make headlines. For example, George Washington High School in San Francisco was sued to paint over the racially divisive artwork created in the 1930s that covered its walls. The school then faced countersuits by preservationists who wanted to protect the artwork's historic value and artistic merit. This kind of situation is a legal nightmare for a school district, whose core interests lie closer to following legal compliance than to advocate for the merit or impact that art might have on their campus. A handful of rare, high-profile legal cases can negatively impact the reputation of mural art and create hesitation when districts consider commissioning mural art.

**Murals are not forever, and that's okay.**

In the long run, it is in the artist's interests to ensure that more mural projects can happen rather than to battle preservation lawsuits. I advocate embracing the temporal nature of the art form and adopting a contract that clarifies artist and district roles for the entire lifecycle of the artwork. A mural, particularly with full sun exposure, has a limited physical lifespan. A mural will not hold the same relevancy or vibrancy 30 years later. In the case of the George Washington High School murals, some of the artwork includes visual depictions of abuse of non-white populations. Is that still the most relevant story to tell to a school student body that is 92 percent non-white? The vital question as to whether a mural continues to serve the space is to ask, "What is the purpose of that space, and does the artwork support that purpose?" If the artwork is offensive, amateurish, or physically degraded, the answer would likely be "no."

From personal experience and years of feedback from clients, I know firsthand the impact art can have on a space. Mural art at a school with a diverse student body should not undermine a culture of inclusion and safety for students. As we recognize that mural art does not have a neutral impact, we have a responsibility to not preserve a mural just for preservation's sake. In the case of George Washington High, the original mural might best be preserved through photographs and archived in the school office.

# Student Engagement

Schools often ask me if the students can participate in the painting process. I respond that it depends on the goals for the artwork. If the goal is to create a quality work of art that will become part of the school identity for decades to come, then I would leave the painting to the professional artists. Painting, like playing the violin, tap dancing, or cooking is a skill developed with years of dedication and practice. A school might hire professional musicians to perform as an educational experience. In a similar way, exposing students to professional quality mural art can be a form of art education.

If the purpose of the artwork is that the students are learning to paint, and their participation is the goal, then the project can be structured around that goal. If this is the case, paint the murals on temporary panels that can be removed. Both the coordination to include students and the materials and labor to install panels will add to the cost of the mural, and the product will be substantially different than if the painting was left to a professional mural artist. The coordination and painting time (and proportionately, the cost) will double or triple, not to mention the cleanup time from the paint drips and spills. Finally, there is the short attention span to contend with. Kids at schools will ask me after just a few hours, "Aren't you done yet?" and the next day, "I thought you were done already! Are you STILL painting?" Most young students can't imagine focusing on a work of art for more than 30 minutes, let alone a *whole week*.

Is there a way for the students to participate in the mural other than participating in the actual painting? Absolutely. Soliciting input from

either a self-selected group of students, student leadership, or the senior class is a great way to make sure the mural is relevant to students. I engage the student groups with questions like, "What is unique about your school? What are your favorite traditions? What do you love about school? What images do you think are important to include in the mural?" I invite them to draw their ideas on paper, or up on the whiteboard. While I am painting the mural, I invite teachers to bring their classes by to watch the painting process, ask questions, and offer feedback.

A wall mural is a visual legacy that will define the school campus for decades to come. Schools should consider investing in professional art that is on par with the skill, care, and professionalism that the teachers and administration bring to their work with students each day.

# Case Study: Blach Middle School

The principal invited all seventh and eighth graders who were interested in helping design a school mural to meet in the art room at lunch. Only a dozen students were willing to give up their lunch hour, but they were all active participants in our brainstorming session with the campus art teacher. Together, we looked through design ideas the regular art classes had created during their class time. We considered the merit of various themes and concepts, discussed our favorite elements, and explored new ideas that the designs inspired us to consider.

The group was unanimous on the following design features:

- The artwork should feature a "selfie moment."

- The mural should feel "happy."

- The mural should include their school mascot, the falcon, and the falcon should look "friendly."

- It should include glitter.

- It should be made holographic.

**Opposite:**
Morgan, in front of the *Rainbow Falcon* mural she painted at Blach Middle School in Los Altos, CA.

Except for the last item on the list, which I haven't quite figured out how to execute in paint, I checked the boxes on all the requirements. As the final protective coat was drying, I blew rainbows of glitter over the mural, so it would sparkle. The principal polled the student body to find out which words they felt best embodied their school culture. I incorporated those words into the artwork on the ground, in front of the mural. The qualities included: Enthusiastic, Creative, Curious, Inclusive, and Kind. I also painted footprints on the ground under the falcon, to prompt students on where to stand for the optimal "selfie moments."

The colorful mural lives at the heart of the campus, where the students congregate before school, and during recess and lunch. The wall also serves as the backdrop for outdoor, school-wide assemblies. The color, vibrancy, and meaning of the words fit their age and class culture, because the piece was designed by *them*.

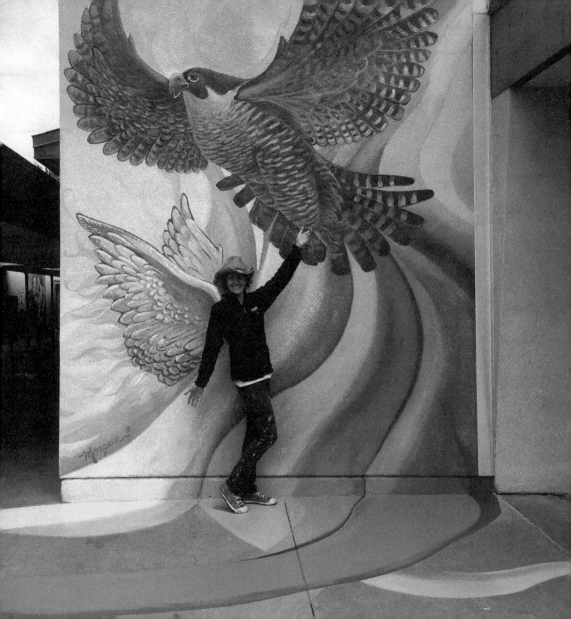

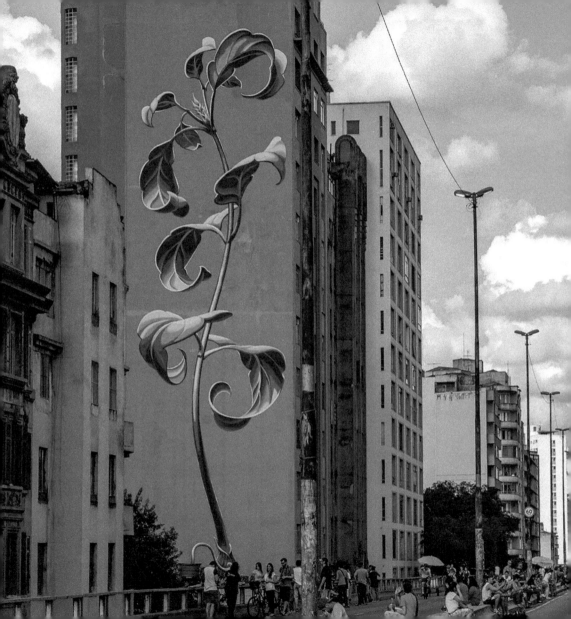

# 6

# Public Mural Projects

When it comes to publicly-funded art, each community varies widely in terms of policy, budget, and citizen enthusiasm. The rules change from town to town—how things get done, who gets "picked" and why. If you drive through a town and see a lot of beautiful murals there, it's because there is a vibrant arts ecosystem in that community, including arts and community beautification organizations that put in countless hours of work to make those projects happen. Art advocates in that community may have spent years arranging meetings with public officials and engaging with the community in direct fundraising efforts or in getting a "percent for art" policy passed. Either way, a publicly-funded mural art project involves significant coordination and cooperation between citizens, city management, and elected officials.

As you evolve outward in your mural work towards commercial, and eventually public murals, the level of cooperation with other stakeholders, whether they are professional creatives like designers and architects, or public art committees, also increases. As a creative professional, it will

79

become increasingly important to have a distinct, creative voice and know what story you want to tell; but also be willing to incorporate feedback to ensure the work is as site- and context-specific as possible.

Artists that support themselves with public art projects typically run larger art studios that include someone on staff dedicated to managing submissions to open calls for artists, or "Request for Proposals"(RFPs) sent out by city governments. Cities tend to be conservative, so if they decide to hire an artist that doesn't live in their city, they are typically looking for an artist with an impressive portfolio of "knocked it out of the park" successes on other public art projects. Some cities are required to issue an RFP for transparency when they spend public funds, even if they already have a shortlist of artists they are interested in working with. Publicly-funded projects typically entail extended approval processes and long timeframes, which can take years before coming to fruition. While I don't want to discourage you from applying for publicly-funded mural projects, it is a slow and competitive arena that probably won't support you reliably until you are well established in your mural career.

If you broaden your definition of public murals to include all mural art that is public-*facing*, including commissions from building owners and businesses, opportunities abound to get paid while sharing your creative voice in the public sphere. This type of work does not necessarily mean that the subject or style of the artwork is less creative or confined to narrow commercial interests. Overtly commercial mural art is not in the best interest of a community, and any community backlash against a mural is not in the best interest of a commercial brand or business.

# Art Advocacy

Public mural art, both publicly and privately funded, is a direct result of the effort of art advocates. Mural artists are in a symbiotic relationship with the art advocates who play a critical role in bringing mural art into spaces they care about. Art advocates are the instigators of a process that will transform and positively impact their communities for decades to come.

Engaging in art advocacy in your own community is a great way to contribute to the art ecosystem where you live. For residential projects, advocating the benefits of mural art is a natural extension of your business interests, and your enthusiasm for your product will help you find clients. However, in the public sphere, the optics are unfavorable for a freelance artist to put together their own mural project. Don't use your public mural advocacy efforts simply to find yourself work.

I get super excited when I discover a community that is vibrant with art. While I believe that supporting the arts and artists is a noble cause, there are many practical and economic reasons for public mural art, including:

- Mural art deters graffiti, saving cities and building owners money on graffiti remediation.

- Communities with mural art are more desirable places to live and work. Communities that embrace public art typically see a correlating bump in real estate prices. (Depriving a community of beautification projects is not the best way to solve the challenge of affordable housing.)

- Commercial districts with murals invite engagement. Visitors are more likely to walk rather than drive through an artsy business district, and pedestrians are more likely to shop or stop for coffee, giving local businesses a boost.

- Mural art is an inexpensive capital improvement project, relative to landscaping, hardscaping, or building renovations.

- Upcycling: Windowless, multi-story buildings lacking architectural interest—the "community eyesores"—make the best canvases for murals.

- Murals require minimal maintenance and last between 25 to 40 years.

When it comes to art advocacy, there is no magic formula for winning over the mural skeptics. Every project I have worked on has happened because one individual saw an opportunity to put together something beautiful for their community and then figured out how to make it happen, one call, one meeting, one step at a time over the course of many years. The best resource for art advocacy including research with regards to the benefits of public art can be found at AmericansfortheArts.org.

**A successful public art program is a community-wide effort.**

# Case Study: "Beautility"

The Fontana Parks Neighborhood Association was formed 20 years ago by a group of neighbors who wanted to have trees planted along a local greenbelt owned by the water district. The greenbelt grew into a well-used park with walking paths that snaked through several neighborhoods. A dozen ugly concrete water vaults were visible along the paths. The Fontana Parks Neighborhood Association spent three years lobbying their local council representative to earmark funds to have the vaults painted with art. I was one of six artists selected by the City of San Jose to paint the vaults in Fontana Park.

To give you an idea of the effort and coordination involved in what might seem a fairly straightforward project, Michael Ogilvie, the Director of Public Art for the City of San Jose, shared with me his records related to the effort involved in bringing this project to fruition:

- 693 emails

- 77 phone conversations

- 42 in-person and group meetings

- 3 community events

- A cumulative 600 hours of artist time creating designs and painting the murals

- 250 hours of staff time for project management and coordinating logistics

**Opposite:**
A "Beautility" water vault Morgan painted in Fontana Park in San Jose, CA. The box includes a poem by Rumi:

*I will be waiting here...*
*For your silence to break,*
*For your soul to shake,*
*For your love to wake!*

← Before
&
After ↓

These figures do not include all the volunteer hours that community stakeholders spent on the project.

This may seem like a crazy amount of effort for a wee bit of art. It's worth noting here that Michael is an efficient person. We have worked on two projects together, and he gets to the point quickly and keeps all the cats (artists, government agencies, etc.) herded in the same direction without fuss. In Michael's words: "By comparison, this project was a pretty small project, as it did not require engineering (soils, structural, electric), off-site fabrication, transportation of large-scale objects, road closures, complex installation processes, or excessive inter-departmental or inter-agency coordination, though water district approvals had to go through an extensive evaluation process."

Part of the reason this project took so much coordination is the utility boxes were the property of the city water district. Public utilities and transportation departments have jurisdiction over a lot of public real estate but are generally "art ambivalent." Prime canvases for mural artists, such as neighborhood-facing freeway walls and underpasses, are held in trust by government agencies who care little about art and the communities that would benefit from mural art. My hope is that each successful mural project will build awareness of what is possible, and through effective art advocacy, more public walls held by government agencies will be made available for community art projects.

## Finding Public Mural Projects

CaFÉ (CallforEntry.org) is the most popular site for posting open calls for artists. Some cities have their own portals for applying to projects.

Sometimes a city will put out a Request for Qualifications and create a pre-approved pool of artists they will select from for any projects that come about during a defined period, typically two years. More cities are getting up to speed on what is a reasonable budget and selection process, but consider each project you apply to on its own merit. I regularly see RFPs asking for original designs without a stipend, or a lower price-per-square-foot than a house painter would charge to paint the wall a solid color. Not every project will help you stay gainfully employed as an artist. Art commissioners are not typically intentionally trying to exploit artists. If I take the time to respond respectfully to contests or RFPs with inappropriately low budgets with information about how the project might be structured to optimize the best outcome for the artist, client, and community, I have seen those RFPs revised.

Contests and other "exposure gigs" are not typically not geared towards professional artists. If I receive an email or see a Facebook post for a potential mural project that includes the words "contest," "exposure," "vote," or "win," I skip it. Don't bite if a mural project doesn't pay professional wages. If you have a business, getting a mural on your storefront is like getting a tattoo—it's going to be part of your brand for a long time to come. The tattoo artist matters. A lot. Running a contest open to all artists to put a free tattoo on my body in return for "exposure" probably won't garner me the best artist or tattoo out there. A mural contest is intended to garner attention for the business but it will not ensure the artist earns a living wage or that the business ends up with a professional work of art that elevates their brand in the community.

# Creating a Design

Remember how I said all design work should be paid work? It's true, but in the Wild West, rules are made to be broken. The best way for an art advocate to find funding for a mural project in their community is to be as clear with their idea as possible, including presenting a visual mock-up when approaching potential supporters and donors. The word "mural" is ambiguous; many people have seen lots of ugly murals in their lives and fewer beautiful, transformative murals. A picture says a thousand words and can win over allies with a glance. If an art advocate is making an earnest effort to coordinate a public mural in their community, I am happy to help the fundraising effort by creating a mock-up of the site with sample artwork, whether they plan to hire me for the project or not. On the other hand, if the funding is secured, for example with commercial or private clients, or a city RFP has been issued, the budget should include a stipend for original design work by the artist.

During the design process for a public mural, don't invite everyone to the party. A "kitchen sink" style mural that aims to please everyone and incorporates a laundry list of themes is a lost opportunity to tell one story very well. Ideally, the artist was selected based on a body of work that is already creatively aligned and compelling to the community. However, accepting input from select key stakeholders like an art commissioner is good business, and ensures your art will be received well in the community.

When I consider a design for a public space, I begin by thinking about who lives there. Is it a quaint, family-oriented community or more

urban? What is the speed and angle from which the artwork will be seen? What energy or style would serve the space, and how might the space be used differently after the mural is painted?

Once the mural painting is underway, invite the community into the process whenever possible. Invite the local paper to cover the project. Offer "office hours," so people can ask questions about the project and engage with the artist. Collect first-hand testimonials from the community about the artwork.

It takes a while for a new mural to work its way into the fabric of daily life, but the benefits of a mural have a "long tail." The mural might become a favorite backdrop for quinceanera photo shoots. People may start to use it as a reference point in local geography; for example, "the restaurant next to the _____ mural" or "to get to my house, turn right at the big _____." Someday, when the farmers market needs a second location, they will choose the parking lot next to the mural because of the beautiful backdrop. Children who used to point out details with their tiny fingers from their stroller will whiz past the landmark on their bikes on their way to middle school. Visitors from out of town will stop and park once they see the mural. They will explore the area to see what other unique things they might discover, and they will share their positive experiences in your town on social media.

The first mural project in a community faces the most resistance. After one or two murals go up on other walls, and the success is experienced firsthand, more walls magically become available and other businesses in the area will want a mural of their own. One success breeds more success.

# Painting in Public Spaces

Putting out a creative idea, especially in the form of a public mural, exposes us to the fickle company of other people's opinions. Mostly, people are thrilled and supportive of new art in the community. People love to be helpful and frequently offer feedback when I am painting. Since I typically work alone, it is reassuring to know that if the nose looks too big or if there is a typo, someone will speak up. If it is useful feedback, offered with good intention, I try to incorporate the suggestions. The day flows better when I don't take anything personally.

Once I had an octogenarian set me straight about a watering truck I had depicted inaccurately in the mural. (I had assumed the vintage lorry I was painting was for watering the crops, when in reality it was used to keep the dust down on the roads.) Every project is an opportunity to learn something new—or improve my accuracy in visual translation. Once when I was painting a *trompe l'oeil* ("trick the eye") scene of a walk-in vault along a public street, someone stopped to ask why there were cookies stored in the vault. It is possible the comment came from someone who was hungry, but it was also super helpful to know the stacked gold bars in the vault were looking edible. The comment was an invitation for me to consider how I could render them to look more angular and metallic.

I typically don't wear earbuds when I am painting in a public space so that I am accessible to hear comments. The vast majority of people offer positive encouragement, and that makes life sweet for everybody. If anyone is outright rude, I simply direct them to contact the city. There is always the option of noise-canceling headphones.

**Opposite:**
*Love Letter to Oakland* at 4th and Oak St. in Oakland, CA, by David Burke, Joevic Yeban, Dorias Brannon, Kee Romano, and Zach Cotham.

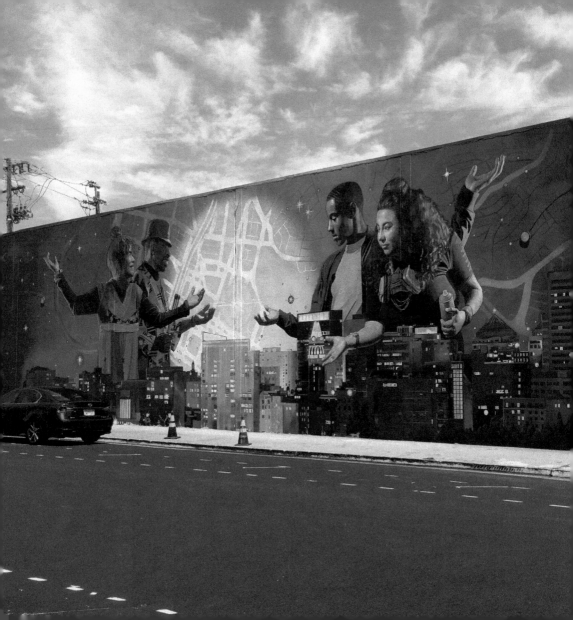

Pedestrians are sometimes oblivious to their surroundings. Be sure to block off your work area on the sidewalk with orange cones and caution tape. The most frequent hazard is pedestrians looking down at their cell phones, so use chalk and cones—visual cues on the ground to prepare them for what is ahead.

Remember when you are out painting on the street, you are an ambassador for mural art in that community. People love to meet the artist, take photos with you, tell you about their mother/brother/cousin who is also an artist. Making connections with strangers is a highlight of the work for me, but it can also add context and meaning for the people who will enjoy your artwork in their community for years to come.

## When to Varnish

Most of my clients assume that every mural should be varnished. Not at all. Mural art deters tagging and graffiti. Murals rarely get tagged because of a culture of respect for the work of other artists among street artists—and also because, in general, taggers would prefer to have a blank wall all to themselves. The paints I suggest are durable; accidental or incidental marks from crayon to sharpie can be removed with warm soapy water or a mild degreaser. Varnish is expensive and significantly increases the total cost of a project in materials and labor hours to apply it. On projects with a tight budget, I think it is better to put the money towards better artwork than protecting a low-budget piece with varnish. Unvarnished murals also are easier to touch up, since the artist can just walk up and paint on the wall without first

having to remove the protective varnish. The only thing more toxic than varnish is varnish remover.

There are two situations in which I recommend varnishing a mural. The first is if a mural is painted on a public wall that has been a long-time target of tagging and graffiti. A good anti-graffiti varnish that I would recommend in this situation is TSW (This Stuff Works) made by Graffiti Masters. For a public mural, the client (building owner, city, or school district) should be in charge of purchasing and applying the graffiti varnish, since they are the most invested in the long-term maintenance of the mural.

The second situation in which I recommend a varnish is on walls that receive more than eight hours a day of full sun exposure. In this case, I recommend a UV varnish. I use a product made by Marabu, called Clear Shield, in the matte finish. (It dries to an eggshell finish.) Some anti-graffiti varnishes offer UV protection, but most UV varnishes are not categorized as graffiti-resistant.

When I paint murals on south- and west-facing walls, I exaggerate the warm tones during the painting process to anticipate a bit of fading, and then apply extra coats of the UV varnish over the warm-colored areas of the mural (red, orange, yellow), as those colors are most vulnerable to UV rays. Murals with south-facing sun exposure should have a UV varnish reapplied every five years or so. East- and west-facing murals should have a UV varnish re-applied about every 10 years. North facing walls do not need a UV varnish.

# Case Study: The California Avenue Underpass

The California Avenue Pedestrian Underpass in Palo Alto has historically been a frequent target for taggers. The tunnel was poorly lit and long enough that anyone inside the tunnel was not visible from either entrance. A "community participation" mural painted 25 years prior covered both walls and the ceiling, but it had substantially deteriorated from both water damage (the paint was peeling and bubbling off) and also from regular graffiti removal efforts over many years. The poor state of the walls contributed to the steady contributions of taggers.

After the restoration of the underpass mural was completed in 2017, it was tagged only a few months later. The next tag came six months later. Each time, I came out and touched it up right away. It took less than a half hour to remove or paint over the tags. Since then, over the past two years, it has not been tagged again. This transition from a tagging "hot spot" to not being tagged at all in the last two years provides one data point that beautiful artwork on a wall does deter tagging, even in former "hot spots." The city chose not to put anti-graffiti varnish on the tunnel, primarily because of budget constraints; in retrospect, this was the right decision. It was much easier for me to touch it up without a varnish covering the artwork. The mural renovation was commissioned as a short-term, stopgap measure until the underpass can be rebuilt with proper drainage. In the meantime, the upgraded artwork makes the tunnel feel safer—and the mural once again brings delight to commuters, students heading to school, and anyone out for a stroll.

**Above:** Before
**Opposite:** After

THE YEAR OF THE OCEAN
1998 Palo Alto, California
Design by USCART

WALK
YOUR
BIKE

When bankers get together for dinner, they discuss Art. When artists get together for dinner, they discuss Money.

Oscar Wilde

# 7

# Making Money Making Art

There is no one-size-fits-all in art or business. Lifestyle and job flexibility have always been part of my personal metric of success. When I started painting murals, success meant not spending all day in front of a computer. When I had kids, success meant being able to earn income in the limited hours I wanted to devote to work. My work schedule matched the school schedule of my two kids. That is to say, every long weekend, winter break, ski week, spring break, sick day, school play, and sporting event, I was "supermom" to my kids. My kids think my main job is to do their dishes, but regardless, those are the teaching moments I want to be around for. Now that my kids are grown, I am again redefining success. This time it includes helping other artists find their own success.

I encourage you to fit the advice I offer in this section into the unique framework of your life, so that the work is not only financially rewarding and creatively satisfying but sustainable. And fun! If you want drudgery, take a shortcut and get a job at the DMV. Maintaining joy in your

workday is vital to staying "in the game" as a mural artist for the long haul. Meaning and purpose will also start to weave into your work as you master the dance steps of honing your creative voice and finding great clients.

I have a secret that makes me unpopular in most artists' circles: I love money. I love learning about it, talking about it, making it. Paying attention to money supports my freedom and autonomy. In my twenties, I engineered a lifestyle that kept my expenses low. I saved up enough to provide wiggle room, so I could quit a corporate job I no longer enjoyed and pursue a non-traditional career path. Today, by keeping my expenses low, I can be selective with the projects I take on and avoid burnout.

I continue to prioritize my autonomy and personal freedom over anything money could buy. Painting murals is not the most lucrative career path I could have chosen, and profit is only one of the criteria I use when I decide to take on a project. I have no "exit strategy" with my business; it's just a woman, a wall, and a paintbrush. Everything I create is custom and hand-painted. I don't leverage my creative efforts into licensing or products. It is certainly not the only way to run a mural art business, but for the past 20 years, the "art as service" model has worked well for me.

However skillful we are with budgeting our money and however much we love our work, we still need to earn a living wage. Starving artists don't last long as full-time artists. I want your efforts to be financially sustainable from the start, so you can keep painting while honing your craft and creative voice over the long haul.

Before I launch into the details of monetizing your creative talent, let me point out the obvious, which is that not everyone who loves to

cook should become a chef. Commercializing your art requires a willingness to learn skills outside of your core art form. Whether you have a business partner or not, you will spend a substantial portion of your work life taking care of the details necessary to run a business. None of the tasks are inherently good or bad; they can all be integrated into your path of true creative mastery. If you really just want to make art and not worry about money or the business side, I wouldn't recommend depending on your artmaking for a steady income.

## How Much Should I Charge for a Mural?

In deciding how much to charge for a mural project, consider:

- What is your level of experience? How many projects of similar scope and theme have you painted? Cities and businesses, in particular, will pay a premium for an artist with a strong track record.

- Where do you live? Wages of other skilled trades in your community, like an electrician or carpenter with similar years of experience as you have, would be a useful reference point.

- What is the overall scale of the project? On large projects, there are economies of scale, reducing the price per square foot.

- How accessible is the wall? How far do you have to travel to get there? Do you have to work on a ladder (which will slow

you down), or can you use a scissor lift (which will speed you up and add to the total cost of the project)? Is it on a ceiling?

- How involved will the planning and design be? Community murals typically involve more meetings and extended permit timelines relative to residential projects.

- What level of detail is the client looking for? How long will it take to execute the painting? Figures and lettering typically take longer than landscapes or abstract paintings.

## SET A MINIMUM

Whichever method you use to calculate how much you charge, maintain a minimum project fee. Every project has minimum fixed time inputs that include client meetings, creating a design and proposal, travel, setup, and cleanup. A minimum project fee ensures that you will earn enough from that project to keep you in business. Set your minimum a little higher than you are comfortable with. The results will surprise you.

Budget constraints are a reality for most clients. If the budget is set, and that amount meets your minimum project fee, you can reverse engineer a design to fit the client's budget. Find the middle ground: an elegant design that you are proud of but also one that won't take you so many hours to execute that you can't make a living wage with that project.

**I'm not a businessman.
I'm a business, man.**

Jay-Z

### ESTABLISH A PRICING METRIC

When artists price their own work, they usually price it too low. I am susceptible to pricing my projects by how I feel: How hungry for work am I? How easy or difficult does this project seem? What does my bank account look like? This "reactive pricing" will keep you always bidding your lowest viable wage, not creating a thriving business. I suggest creating a "per square foot" metric that guides your pricing. Once you have painted your first dozen murals, you will get a sense of how long it takes you to cover a given area with a certain level of detail. I no longer share my pricing metric on my website, but I still refer to it when I am bidding on a project, to quickly establish a baseline price.

# How Much Will I Earn?

Your income will correlate not only with your artistic skills, but also with your marketing, communication, and digital skills. Your income will also track with your geographic location, years of experience, and internal financial thermometer. A freelancer typically charges double per hour what a company would pay for an employee, because the freelancer is responsible for their own supplies, health care, retirement plan, business taxes, and office expenses—as well as finding their own clients and collecting payment.

A reasonable starting wage for a freelance mural artist managing their own project is between $50 to $80 per hour. If you take on a project that will require 4 hours of design time and 20 hours of onsite painting, you should charge at least $1,200 ($50 per hour x 24 hours

of work time)—in addition to a materials fee, which is maybe $200 for a small project. If you live in a big metropolis like New York or the San Francisco Bay Area, you would bid around $2,100 for the same project.

Another way to calculate how much you need to charge is by working backward. Ask yourself: How much do I need to earn in a month to cover my basic living expenses? Even better, how much do I want to earn? How many projects can I take on each month? About how many hours total will each project take?

Be sure to factor in taxes and business expenses, which will take a substantial chunk out of your revenues. For example, if you want to earn (NET) $5,000 a month, you will need to bill about $9,000 in project fees. If each project takes you about a week, and you spend the equivalent of one week each month on your business, you will need to earn around $3,000 per project. If you average 30 hours per week on painting, your hourly estimate would be about $100 per hour.

I want to be crystal clear here: Do not communicate or agree upon an hourly wage with your clients. It encourages all the wrong metrics for a creative endeavor, including a client who is micromanaging your time and productivity. Estimating how much time a project will take, and how much you need to be earning during your limited working hours, is for your internal business calculations. Establish a pricing metric for yourself, so you have clarity around how much you need to charge to stay in business. By working backwards to calculate your monthly income requirements, you can sort out when it makes sense to take on worthwhile but low paying projects, only if you can offset them with other more lucrative projects that month.

I provide my clients with a fixed-price bid. I also provide my clients with a general time estimate, for courtesy. For example, "I estimate this project will take between three and five days to complete." I don't increase my price if it takes me longer than I expected. Likewise, I don't reduce my price if I finish up faster than I anticipated. After each project, I tally up my hours invested in the project and project fee to see how accurately I estimated the job and determine any adjustments I should make on future projects. If you are chronically undercharging for your time, you will not stay in business for very long. This is why, especially at the beginning, it is important to track your hours and income carefully.

When I am not working on designs or in the field painting, I spend my time on business development tasks like writing proposals, accounting, website management, project management, as well as project follow-up—including photographing my work and sharing it on my website and social media. Every task you do, whether you do the work or hire someone else to do it, should be accounted for as paid hours by the business. Even if some of the tasks are "lower value" (errands!), your time shouldn't have a value of zero. Calculating your time and effort in this way sets up your business to eventually pay a professional to take care of the tasks you don't want to do—or that someone else can do better.

# 5 Things to Do This Week

**1.** Write down your perfect job. What do you paint? Where? Who are you working with? How will your artwork add value to the lives of others? Clarity begets enthusiasm and results.

**2.** Paint your best mural yet—in your house, or on a friend's wall or non-profit organization you support. Paint in the style you want to be best known for.

**3.** Create a website with the mural you create as the centerpiece and share only pieces that are aligned with the work you want to be hired to create.

**4.** Decide one form of ongoing marketing that you are willing to do on a regular basis, start anywhere. Commit to spending a few hours each week on this effort for at least one year.

**5.** Subscribe to Seth Godin's daily blog.

# Setting up Your Business

## Business Type

If you are just starting out, you likely will form your business as a sole proprietor. Many successful artists today have a life partner who helps them with some aspect of business and marketing—or they partner with another artist with complementary skills. If you find a good match and want to form a partnership, that's wonderful. If you don't, don't worry! There is a lot of freedom in forming your business as a "sole proprietor." Your imperfect efforts as a solo-preneur will far exceed any results you will get by sitting around waiting to be "discovered" by someone else.

## Register Your Business Name

Download a Fictitious Business Name Statement form from your county, also known as a "DBA" (doing business as). Each county has a different form and process. With your "DBA," you can open up a bank account with the business name, so you can keep your business and personal accounting separate.

## Insurance

School, commercial, and city projects require liability insurance, but even on residential projects, insurance provides peace of mind for both you and your client should any mishaps happen on the job.

If you start to get overwhelmed with all the tasks you need to manage in getting your business set up, remember this: The world is conspiring to make it as easy as possible for you. Whether it is accounting, a website,

or online marketing campaigns, there is a product out there that wants to get you up and running in an afternoon. I spent weeks hand-coding my first five-page website in 2001. Today, web development software like Wix or Wordpress is built for beginners and guides you right along to a professional looking site within a few hours. Hiring freelancers is also easier than ever. I used LogoTournament to find a logo designer, and found freelancers through Upwork for website support, to compile videos, and to design business stationery. It is relatively easy to assemble a virtual team that will help you bridge any gaps in your skills. I don't have any employees, but I do get plenty of help.

## The Proposal and Contract

Consider including in your mural proposal a cover letter, description of their project (including size and brief description of the design direction), a sample design, examples of work that are relevant to this project, a cost estimate, a sample contract, the invoice for design deposit if they would like to move forward, client testimonials and/or references, and proof of liability insurance.

Your contract does not have to be complicated, but you do need one for every project you get paid for. My contract has seven sections written (by a lawyer) in straightforward, non-legal language. The sections cover who, what, where, when, how much, a copyright clause, and an artwork guarantee.

What's an artwork guarantee? I'm so glad you asked! Here is the content I include in this section:

Instead of Sunday night dread, I look forward to Mondays. I love vacation, and I love getting back to work. I want that for you, too.

*Some Things that I Guarantee; Some Things that I Don't: You are hiring me because you have seen some of my other work, either in person or on my website. While I am working on your Mural, I guarantee you that I will give it my full artistic attention and effort. However, as much as I want you to be happy with the Mural that I paint for you, I cannot and do not guarantee that this will be the case. Once I am finished with the Mural, as described above, you will owe me the balance due, without reduction or contingencies in case it does not turn out exactly as you anticipated.*

This clause communicates a critical point to clients up front: Art is subjective. The client is hiring me as a freelance professional artist to create custom artwork. This clause alerts the client of the inherent risk they are assuming, perceived or real, in commissioning an original work of art. Once you have a successful track record and sufficient representative examples of your work, I suggest adding a similar clause to your mural contract.

## The Evolution of Your Offering

What you earn during your first few years as a mural artist will be substantially lower than what you will earn after five or ten years of experience. As you gain fluency at screening for the right clients, the bidding process, and working efficiently onsite, everything takes less time overall. Your craft will also improve dramatically, creating a more valuable offering in less time while simultaneously attracting clients with bigger budgets.

I recently painted a ceiling mural in one day and charged my minimum project fee of $5,000. That's a great outcome for one day of painting. So why was the client so happy as she handed me the check? For one, I wasn't the first artist she'd worked with on this project. John, the first artist, bid $5,400 for the work and spent five days painting the ceiling with an assistant. He was showing up at 11:00 a.m. each day and not paying attention to smeared paint lines and drips—or to the concerns the client had regarding his color palette. After a week of work, John informed the client he needed to increase the price, because the project was taking longer than expected. The client, who was sleeping in another bedroom while the project disrupted her space, could see the project was not headed in a productive direction. My bid was ultimately lower than John's, and she was thrilled with what I painted. She didn't care how long it took me; she considered sleeping in her own bed that very night a bonus. I am always wary of stepping into another artist's project, but since the client assured me she would pay John the daily wages he was requesting, I felt comfortable that the client was behaving ethically. John was probably as frustrated as the client and relieved to be off the project.

A key point I want to make here is that there is room for both me and John to make a living as artists. I was on the other side of an identical situation when I was only a few years into my career. The client wanted soft clouds, and I was making bold clouds that I fell in love with, and I just couldn't understand or incorporate the concern the client was expressing about the color palette. I didn't have the maturity to understand commissioned artwork wasn't about my vision alone. I was paid fairly for the days I worked (I was happily earning around $300

Have patience.
All things are difficult
before they become easy.

Saadi

per day at the time), but I was fired from the project. It hurt, for sure. Since then, I have painted upward of 50 ceilings, and what a difference a bit of experience makes. All the mistakes I've made and techniques I've mastered have accumulated so that I can make it look easy. I have no doubt that in a few years, if John continues finding steady work as a mural artist, he will improve his offering dramatically on all fronts. In the meantime, think of all the white ceilings in your city. Imagine the diversity of potential clients; each might have different expectations and preferences of what an awesome sky ceiling would look like. You are looking for clients who like your unique style and can afford wherever you are on the mastery continuum. There is no "best" or "worst," only plenty of room for many different types of creative offerings.

Can anything of quality be produced in a day? You might be familiar with the narrative that Michelangeo spent four years painting the ceiling of the Sistine Chapel. Michelangelo considered himself a sculptor, but had not yet mastered fresco. The work progressed very slowly—at first. His finished work sometimes peeled off the ceiling in chunks, because the plaster was too wet, and entire sections would have to be redone. Towards the end of the project, however, he skillfully managed the challenging conditions. Michelangelo painted the largest section of the ceiling, "The Creation of Adam,"—one of the most iconic and widely replicated images in the world—in a single day.

Granted, Michelangelo was in his own league. Comparisons are unnecessary. Over the years, you will develop your own vein of original genius. As you do, you will become increasingly efficient in your artmaking efforts. Efficiency - which is distinct from rushing - is a natural byproduct of repetition and experience.

# Finding Clients

Artmaking as a business includes mining your own terrain for what is vital for you to share, as well as being curious as to how your gifts might be of service to others. The best marketing tool you have is to make something remarkable. Easier said than done, I know. But if your artwork is not yet remarkable, is there something about your process, or how you share what you care about that delights other people? Your unique offering, the way you do your art, and how you articulate that in a meaningful way to others is how you will find clients.

Be realistic with what you most naturally create and who that might resonate with. Finding where what you care about intersects with what someone else cares about is the best terrain for finding clients who will enjoy and pay for your work. If someone outside your friends and family hires you for a mural, find out why they chose you. What were they looking for? Were they pleased with the outcome? Why? Who else might feel that way? This is the beginning of finding a market for your work. Start small when you answer these questions. I take on an average of two projects per month. I only need about 24 people each year to decide that what I make is what they are looking for. That is a pretty intimate number! It works against our innate human anxieties not to go after more, but you don't need or want to be the artist for everyone.

Most of my clients currently find me through my website. I know another artist who stays super busy through word of mouth from designers. Facebook or Instagram are built for connecting with potential clients. The medium you choose to promote your offering, however, is not as important as having a clear offering, presenting what you do

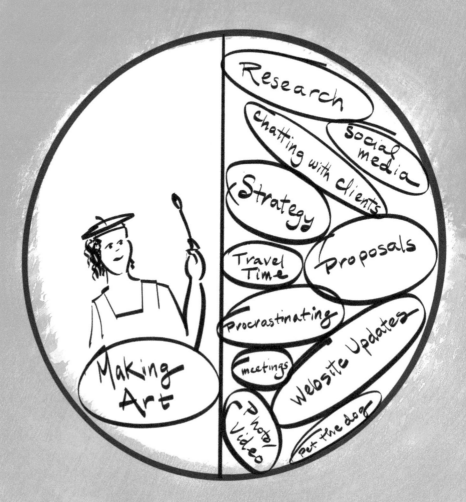

My worklife balance.

and how you do it in a clear and compelling way, and being consistent in showing up to the platform and clients you serve. Having clarity is like turning the lights of your business on, as if it were a lighthouse. Let the metaphorical boats come to you, instead of chasing every boat (and odd job) around the harbor.

The following story illustrates how defining myself clearly helped me find work early in my career.

*I had only painted a handful of murals and, in my head, was still exploring the audacity of calling myself an artist. I thought to myself, I will try it out and see how it sits with me.*

*The next time someone asked me what I did for a living, I said, "I am an artist."*

*"Oh! That's cool. What kind of art do you make?"*

*I replied, "I paint murals." In that moment, I repressed the urge to add, "Just saying that makes me feel like a fraud! Really, I am between jobs—doing painting, mosaics, and sculpture for fun. I'm also exploring an import-export business with handmade textiles..." Instead, I stuck to just three words: "I paint murals." I offered him clarity about me, despite lacking clarity myself.*

*A minute later, he asked, "Do you have a card?"*

*I had printed out a card on my printer that very morning, using the old-school Avery perforated cards. I had trimmed the edges so they looked slightly more legitimate. I pulled one out of my back pocket and proudly handed it over. Again, I didn't tell him I had just printed them out that morning, or that I was just starting out, etc. I simply said, "Here's my card."*

*It turns out he was a hotel consultant, and he passed my name to a few*

*local hotels. Three hotels called me to talk about murals from that key introduction.*

*My first meeting was with the manager of one of the most expensive hotels overlooking the beach in La Jolla, California. I bombed the interview. I was cavalier and gave a super low bid on the spot ($500!) right after the general manager had just shown off his French art collection to me. I never heard back from them.*

*I upped my game for the following interviews. I dressed better and carried a black leather folio tucked under my arm. I prepared a bid after our meeting with an extra zero at the end. The next two hotels hired me to paint a total of 10 murals, about $40,000 worth of work. This one chance encounter with the hotel consultant and the opportunities it created kickstarted my career. I am certain that if I had been mushy in my response to that first inquiry, he would not have risked his reputation to refer me to his business associates.*

The more specific you can be—even about the type of mural art you make, the exact kind of clients, setting, or subject that your mural art is a good fit for—the faster people can refer you to exactly the niche client who is looking for you.

This is a long-winded way of saying this: Take the pencil drawings you did in your studio art class in college off of your website. Your early pieces in different mediums are working against you. Take dog-walking and screen printing off your website also. Showcase your five most awesome murals, painted in the style where you shine, and that is enough.

Remember, you are starting a business, not a charity. Art may have inherent moral merit, but marketing yourself as a "noble cause" is lazy.

Do the work to develop the skill and offering that will delight your clients—an offering where they receive so much value from your work they think they got a steal even when they pay you the big bucks.

## Overbook Your Painting Schedule

I recommend booking 20 to 30 percent more projects than you have time for. Mural painting is highly susceptible to delays or cancellations. Maintaining an abundance of work in the pipeline means that you can keep painting even if one project hits a bump. A mural is a "nice to have," and clients have many competing priorities with their time and money. Don't take it personally if your project gets shuffled around; build it into your business model. Collect deposits in advance, communicate project milestones, and check in regularly with regards to start dates. Having a full schedule will also boost your confidence in negotiations with new clients.

One time, a school principal told me she was ready to move forward with a mural project. However, I had not received the deposit check or the contract. I checked in every 30 days, but after six months realized that while the principal said she was eager to start the project, it had not been approved by the district. I have a policy of not holding painting dates on my calendar if I have not received a contract and deposit at least 30 days in advance. I moved projects up in my queue to keep my painting schedule full. If I had started the school project before the deposit or contract was in place, final payment would likely have suffered the same disorganized fate. Protect your time and energy so that you can focus on paid work.

Keep in mind you don't want to work with everyone who calls you for a mural. If a project falls apart early on, sometimes it is for the best. Take care of your project pipeline, so there is always another wave to catch.

## Should I Work for Free?

There is a cultural assumption that because artists love their work, they should be willing to offer it for free. If a mural project genuinely adds value to a community, the artist should not be the largest financial donor on the project. Don't let anyone else convince you to accept little or no pay for a mural project on the grounds that "a lot of people will see it," especially if it mostly benefits the person inquiring. If the mural art is adding value for a building or business owner, the artist should be paid. Fame and pats on the back won't pay for your groceries. If that artist's phone is ringing after their free project, it will be for other "opportunities" to paint for free, not for clients who are ready to pay professional wages for the work.

On the other hand, passion projects are awesome. If the "where," "what," and "why" is defined by you—not the owner of the taqueria—and you are donating your expertise not for fame, but because it is a message that is vital to you: do it. If you can afford to take time out of your paid projects and understand that the work will not lead to more paid work, but it is important enough for you to do anyway: do it. In 2019 I hustled to find a wall where I could paint a mural of Greta Thunberg in advance of her U.S. visit. I spent the same amount of time painting the mural as I would have if I had stood on the street corner with a sign at a

**Opposite:**

Morgan painted her *Greta* mural on the corner of Third and State St. in downtown Los Altos, Ca.

119

#FridaysforFuture protest. It was an honor to put my talents to use towards climate change awareness. It didn't lead to paid work, and I didn't expect it to.

Another approach is that instead of donating art, why not donate money? Most professionals share their money as well as their professional expertise. Money has tremendous psychological power in our lives, and sharing it is ironically the best way to combat feelings of scarcity. From 2005 to 2012, I donated 10 percent of profits from my mural painting business to TrickleUp, an organization that gives micro-grants to female entrepreneurs in developing countries. I had a tangle of psychological hang-ups around my work, including guilt for not being with my kids full time, guilt that perhaps painting murals was not a "serious career," and ambivalence about my abilities as an artist. Donating a percentage of my profits helped me to confront these demons. I came out victorious every time I wrote a check. Every 10 percent I donated moved another 10 families from one meal a day to three, kept their kids in school, and gave women the power in those families to influence positive outcomes. The commitment I felt towards the cause kept me focused on being profitable with my painting efforts. The process also made me a more careful accountant, which has helped me run my business better. I have since changed the focus of my donation efforts to include local causes, but the benefits continue. In addition to establishing a minimum project fee, committing to donate a percentage of my profits was the best financial decision I have made with my business.

Donating your art because you don't have confidence in its value devalues the donation for everyone. Donating the profits from selling your art (even though you may still lack confidence in your art making) feels amazing.

## CHARITY AUCTIONS

I occasionally receive requests for art donations to an auction for a worthwhile charity. Since I am an artist, I cannot write off any art I donate above the cost of the canvas. In my experience, giving my work away at a charity auction has not led to paid work. The attendees are fans of the charity, but typically unfamiliar with my work. Auctioning off my work will not net as much financial gain for the charity as would occur if I sold that artwork through my "warmed up" channels, then donated the proceeds to that charity.

## SCAMS

There are people who will prey on the still-too-common "starving artist" mentality. If you get an inquiry that sounds "too good to be true," it just might be. I have been asked to paint the backdrop for the next Taylor Swift concert, two children's rooms in Greece, or a painting for someone's wife, "for their anniversary, something in the $10,000 range." If you are ever in doubt, pick up the phone and call the person who inquired. Typically in these cases, it's not a working number. Don't pursue any inquiries that either don't seem legitimate or are not completely professional.

In order to charge substantial money for your work, you must believe in the value of what you create. Your business is not a scheme, charity, or lucky break. There is no shortcut; do the work to build your own platform, so that your phone is ringing steadily with solid offers. Wait for projects that are in your strike zone, so you stay in the best position to knock it out of the park.

Protecting the joy and primacy of artmaking is an ongoing balancing act in the life of a professional artist.

# 8

# Keeping the Artist Happy

I have a second confession, this time one that would alarm most psychologists: I navigate being both an artist and a business owner by accommodating a split personality. Dual narratives exist alongside each other in my head. My "inner artist" and "inner business owner" have different goals and concerns—all of which are legitimate. My inner artist has "inconvenient" impulses, like wanting to write a children's story instead of working on mural designs the client is waiting on. She doesn't want to be defined or corralled, but she can create volumes of creative output if skillfully channeled. My inner business owner is pragmatic and disciplined. She makes sure the queue is full of wonderful projects—and that my inner artist is taken care of with beautiful things like cashmere and fresh-pressed juices, and wild shopping sprees at the art store. Neither aspect of my personality is bad or "the problem." A "good life" has many components, some of which are seemingly at odds with each other—like eating donuts and being physically fit.

Embrace all of it. Instead of an either/or mindset, make room for all parts of yourself. You want to make money and make the world a more

beautiful place? Go for it. That is what creativity is for. Once you unhook your thinking from binary mode, every challenge reveals a multiplicity of opportunities. How can you be both disciplined *and* fluid with your creative process? How might you be both productive *and* relaxed? How can you stay on the same team with a client, when your ideas seem to be at odds? Is it possible to both make money *and* give a project away? The final question might seem an unsolvable koan, but this is exactly what I did in painting a bus for a non-profit after-school program.

# Case Study: Siena Youth Center Bus

The Siena Youth Center reached out to me to paint their all-white bus with landscape art. The plain white bus would be a target for taggers in the neighborhood and also didn't match its happy purpose: to bring the kids on nature-inspired field trips such as mountain biking treks in the Santa Cruz Mountains and visiting the Monterey Bay Aquarium and tide pools of Half Moon Bay. As a not-for-profit entity in an economically challenged neighborhood, they would have a hard time paying my rates even with my standard school discount of 30 percent. I was the sole provider for my family at the time, and I was not able to donate such a large chunk of my time and efforts to this worthwhile project, but I didn't want to pass on it either. Instead of donating the mural, I donated the time and effort required to raise the funds for the project through a Kickstarter campaign, on behalf of the youth center.

**Opposite:**
The Siena Youth Center Bus in Redwood City, CA.

The campaign raised $9,500 for the project. It was a win for the youth center and for the donors who were able to participate in this heartwarming cause, and it allowed me to both beautify their bus and support my family. I also loved sending out 150 handmade "You are Wonderful" banners to the donors of the campaign. It connected me with a supportive tribe of fans.

## Project Selection

I aim to meet three out of four of the following criteria with every project:

- Am I excited to work with this client?

- Is it creatively interesting?

- Does it pay well?

- Will it have a broad positive impact in the world?

As previously mentioned, the most important of the four criteria is who I will be collaborating with. Using a consistent metric when I am deciding whether or not I am a good fit for a project helps me to balance my pipeline with school mural projects that might not pay as much— and residential projects that are not a visible contribution in the community but pay well.

A few years ago, Minted approached me to paint another artist's design on the front of their company headquarters. I wouldn't be able

to sign the work; I would only be the hired hand. I wasn't sure if the project was the right fit for me, so I went to my four questions.

*Am I excited to work with this client?* Yes. Minted is a high-end art company, and I would be working with a team of experienced creative professionals.

*Is it creatively interesting?* Yes. The proposed design was elegant and original. Executing the design would expand my own painting skillset. I would work with the designer on-site, so that her digital art would be accurately translated through paint. Collaboration creates an opportunity to learn from other artists.

*Does it pay well?* Yes. I established a fair price-per-square-foot in my proposal.

*Will it have a broad positive impact?* Yes, in a handful of ways. The mural would cover the front of a prominent building in downtown San Francisco, a creative upgrade for the street and community. I invited the designer to paint alongside me, and it helped give her the confidence to take on a large mural commission on her own a few years later. Minted created an inspiring video about the mural collaboration, which had the potential to inspire more successful mural projects.

It turns out, the Minted project met all four of my criteria, so I happily took on the project.

## Protect the Fun

I spend about half my time painting and half my time working on my business, including marketing, project management, and finally sharing the work in a way that will, in turn, bring me more work.

minted. Yuke Li

I am binary with my days: it's either a painting day or a desk day. Either way, I work about six hours a day. I track my time to make sure that I am spending at least half my total work hours on painting and design, the part of my work that I enjoy the most.

For me, getting directly to work on the painting days is easy. Someone is expecting me, the wall is staring at me, the paints are quivering with excitement in the back of my van. I work by myself most of the time, taping and rolling on the base coat, even though doing it alone might not be efficient from a business standpoint. I love the fluidity and autonomy of solo work--managing what time I show up, what I listen to, what gets done, and how. As an introvert, not having to talk to anyone during my workday is one of life's sweetest luxuries. I keep my "inner artist," the craftsperson, in the equation as I plan my business efforts. Balancing business sustainability with the creative output your heart wants to make—at the pace it naturally creates—is an art, not a science.

Distinguishing between when to push and hold myself accountable—and when to take a break—requires a surgeon's precision. Inner resistance to creative or novel work with an uncertain outcome is normal. Don't assume that resistance means you are not meant to do that work. Decide for yourself how much time you are willing to spend on your business each week relative to your art-making. If you are just starting out, or juggling a family and other work, perhaps that is only five hours per week. Make sure you actually show up for those hours.

Particularly when you first start out, resistance will be strong. Implementing any of the business strategies you want to pursue will require a ninja productivity toolkit. I follow a daily routine, decide on

**Opposite:**
Yuke Li designed this mural for the Minted Headquarters in San Francisco, CA, in 2016.

my daily "critical inch," and accommodate a very short list of permissible distractions. (The list includes petting the dog, naps, and walks around the block.) Fear is wily. Without a plan, it will surface as distraction which quickly leads to scrolling through the daily news feed or Instagram. Embrace rituals, systems, and habits in your life that support your creative process and enable you to create at a steady rate.

In your efforts, especially the parts of the work that are hard for you, be kind to yourself. Self-compassion paves the way for radical honesty: Did I do the things I committed to doing today? Why not? Adjust the goalposts closer, as needed, so that success feels attainable. Being kind to yourself always yields the best results, and the other option is no fun anyway. If you notice you are not creating much of anything, give attention to why. It might be fear or lack of accountability, but sometimes what's needed is simply rest. I have learned over the years that a few days off between projects works wonders for my energy and enthusiasm.

Sharing your creative efforts with the rest of the world is not easy or particularly comfortable. This is the hard work of an artist. I hold tight to the network of support I have in the form of clients, friends, and family who have supported me along the way. I could not have done it—nor would it be much fun—without them.

## You're Next!

This book is a summary of what I wish I knew when I started out painting murals. I wish I could go back and tell my 27-year-old self who had no idea if she was crazy for trying to pursue a career as a mural

We can't take any credit for our talents. It's how we use them that counts.

Madeleine L'Engle

artist this: Do it. The difficult path of constructing a life with artmaking at its center? Worth it.

In the midst of my unexceptional credentials, I have stumbled into a fulfilling and sustainable career creating art. The variety of people and places my work brings me in contact with profoundly enriches and expands my life. "Mural Artist" is not only a *real* job, it's an awesome job. I love how color changes how a space feels. I love the physicality of working with my hands and staying in constant motion. I love the smell of paint, as it reminds me that transformation is underway. I love the scale of murals, whether a life-size humpback whale or a poppy that is ten feet across. I love that a mural is designed for a specific person and place. I love being of service with my creativity and winning over mural skeptics with creations that surprise and delight. I love my work so much that I want to make it possible for other artists—*for you*—to create your own version of mural-making awesomeness.

There are so many bare walls in the world, waiting for a creative hand. As we embrace this exciting art form as *professionals*, and all that this word embodies, we will contribute to the further expansion and popularity of mural art—beautifying walls and communities around the world through paint and creativity. I wish you the best of luck with your mural art endeavors—and many happy days of painting.

# Notes

## A NEW ERA FOR MURAL ART

1. In 2002, advertisers sued the city of Los Angeles on First Amendment grounds, because mural artists could create big, eye-catching displays that were banned for commercial enterprises. As a result, the city banned all public murals until they could figure out how to legally distinguish a work of art and a commercial advertisement. It took Los Angeles 11 years to articulate a policy and lift the ban.

## SCHOOL MURALS

2. To read more statistics on the myriad benefits of art in schools visit AmericansfortheArts.com and download their "Making the Case" art advocacy handbook for schools.

3. Schools are typically not-for-profit, so I don't mind giving them virtually unlimited usage rights with images of their mural.

# Recommended Reading

*The Artist's Way* by Julia Cameron
This book completely changed the trajectory of my life—from working in tech to full time artist.

*Your Money or Your Life*
by Vicki Robin and Joe Dominguez
I read this book the year I graduated from college. It taught me a mindset around money that inspired me to engineer an unconventional life for myself.

*Secrets of the Millionaire Mind* by T Harv Eker
From Harv, I learned about both/and thinking, and this one idea has changed how I look at money and everything else.

*The War of Art: Break Through the Blocks and Win Your Inner Creative Battles*
by Steven Pressfield
This book doles out razor-sharp truth about the daily labor of making art.

*Self-Compassion: The Proven Power of Being Kind to Yourself*
by Dr. Kristen Neff
This is the book I most often gift to others.

# About the Author

Twenty years ago, Morgan wanted to improve a narrow, windowless stairwell in her condo. She attempted to recreate through paint the view from her balcony where she had lived in Granada, Spain: a narrow, cobblestoned street lined with shops, stray dogs, and señoras carrying their daily provisions. While painting the mural, Morgan fell under a magical spell where time stood still and she forgot to eat lunch. By the time she finished the mural, the top of the stairs had become her favorite spot in the house.

Morgan has been painting murals around the world for the past 20 years. She is passionate about the dramatic transformation that mural art can have on a space, and its ability to inspire us to a more beautiful world. Morgan has painted over 500 murals, including 50 public murals in the San Francisco Bay Area alone. In 2017, she was invited to Jianxi, China to participate in the Miracle Mural project. She joined 100 other mural artists from 60 different countries, as each artist created a mural based on the theme of "Peace and Transformation."

**Opposite:**
Morgan in front of her *Nature is Home* mural at Hua Quan Village in Jianxi, China.

Morgan is the host of *If These Walls Could Talk*, a podcast about mural art. You can find her blog, workshop offerings, and which wall Morgan is working on now at www.MorganMurals.com.

CPSIA information can be obtained
at www.ICGtesting.com
Printed in the USA
LVHW072026270721
693876LV00005B/54

# CARS

# CARS

igloo

Published in 2011
by Igloo Books Ltd
Cottage Farm
Sywell
NN6 0BJ

Copyright © 2009 Igloo Books Ltd

M044 0311
10 9 8 7 6 5 4 3 2 1

ISBN: 978-0-85734-794-7

Cover Image © Tom Skinner

Printed and manufactured in China

# Contents

# Introduction

The world has had a passionate love affair with the car ever since Gottlieb Daimler and Karl Benz invented gasoline-powered vehicles, the event which started the age of the modern automobile. And nothing reflects this passion more than the dream cars and fast cars that make drivers stop and stare when one of these special cars pulls up next to them.

Clean lines, elegant designs, special finishing and exclusivity all help to make a dream car. These are the classic cars; the cars that never look dated. A car doesn't have to be old to be a classic. It's a combination of the way a car looks and the way it handles on the road, but if a car is sleek, graceful and has a touch of glamour, it will qualify as a dream car. If a car makes a pulse race, if buying one means a decision made by the heart instead of the head, it's a dream car.

Fast cars exude power. They're all about acceleration, engines, speed, transmission, grip, handling: the car that can do 200 mph (320 kph) - easily – and the car that can take the corners and bends.

Dream cars and fast cars – one of a kind, special, attention grabbing and head turning. Cars that set your heart racing. Cars worth the passion.

# DREAM CARS

# Alfa Romeo 8C Competizione

There's a Maserati chassis under the skin and a Maserati-designed engine under the bonnet, but the 8C Competizione sports Alfa Romeo badges – and it's arguably the most beautiful car ever to do so. It started life as a concept car, which was shown at the Frankfurt Motor Show in 2003, but in the three years it took to prepare the 8C for production, it lost none of its grace, elegance and sheer power. It's still got the gaping air intakes and the fared-in headlights at the front and it's still got the four exhaust pipes and twin circular tail lights at the rear.

The 8C shares its name with the eight-cylinder Alfa Romeo sports cars that dominated Europe's racetracks before World War II, and especially with the 8C 2900, which not only clocked up scores of victories but also became one of the great Grand Tourers of its age. It also draws inspiration from other past masters, including the Tipo 33 Stradale and Giulia TZ2, though the modern 8C's design – by Wolfgang Egger at Alfa's own Centro Stile – resists any temptation of falling into the retro trap.

Instead, it has a thoroughly modern supercar design, with a long bonnet and a short tail. There's a prominent horizontal furrow cut into the side above the wheel arch, which adds visual dynamism, while the massive wheels and muscular rear wings emphasize the performance potential of Alfa's latest supercar. Aerodynamic efficiency was a keystone of the body design, with all surfaces optimized for smooth airflow, though the clever bits are hidden underneath, where there's an aerodynamic undertray that ensures plenty of downforce at high speeds without the need for intrusive spoilers or wings on top.

Under the bonnet of the 8C Competizione is a 4,691 cc V8 producing 450 bhp at 7,000 rpm and 470 Nm of torque at 4,750 rpm. It drives the rear wheels via a six-speed electro-hydraulic manual transmission. Operated by paddles behind the steering wheel, the gearbox can be used in manual or automatic modes and in normal and sport modes. The all-independent suspension uses double wishbones, variable gas dampers, coil springs and an anti-roll bar front and rear, while stopping power is provided by massive cross-drilled discs.

Performance is electric: from a standstill, it reaches 60 mph in 4.1 seconds and 100 mph in 9.3 seconds, and has a top

| ALFA ROMEO 8C COMPETIZIONE 2006 | | |
|---|---|---|
| **ENGINE:** 4,691 cc V8 | | **WIDTH:** 74½ in / 1,894 mm |
| **MAXIMUM POWER:** 450 bhp at 7,000 rpm | | **HEIGHT:** 52¾ in / 1,341 mm |
| **MAXIMUM TORQUE:** 470 Nm at 4,750 rpm | | **WHEELBASE:** 104¼ in / 2,646 mm |
| **MAXIMUM SPEED:** 181 mph / 291 km/h | | **MANUFACTURE DATE:** 2006–present |
| **0–60 MPH ACCELERATION:** 4.1 secs | | **BRAKES:** disc (f and r) |
| **TRANSMISSION:** 6-speed electro-hydraulic manual | | **SUSPENSION:** double wishbone (f and r) |
| **LENGTH:** 168½ in / 4,381 mm | | **WHEELS:** alloy, 20 in |
| | | **TIRES:** 245/35 R-20 (f and r) |

speed of 181 mph / 291 km/h. That's quicker than the Maserati GranTurismo, from which it borrows the suspension, or the Maserati Coupé, from which it borrows elements of its structure. It's very nearly as fast as a Ferrari F430, thanks to its lightweight carbon-fibre body, which is 176 lb / 80 kg lighter than that of its Maserati cousins. On the road, the Alfa 8C is not just fast, it's also very noisy, with its rumbling exhaust note and crackling from the tail pipe on the overrun.

Inside the two-seater cabin, carbon fibre and the finest leathers abound. Owners can even specify special leather luggage to fit in the rear shelf behind the drive and passenger. In other respects, the interior is classically simple with large cowls over the speedometer and rev counter and a prominent starter button on the fascia.

Some may question whether it is a true Alfa Romeo, given that it has a Maserati chassis and suspension system, its engine is developed from an existing Maserati unit and built by Ferrari, and the car itself is put together not in an Alfa factory in Milan or

Turin but by Maserati in Modena. But does it really matter? The 8C Competizione is frankly so wonderful, so desirable, and so classically elegant that it's enough that it exists – albeit at a list price of some £111,000. Alfa announced in advance that it only intended to make 500 examples of the 8C coupé, and a further 500 examples of the 8C Competizione Spyder convertible, so this will forever remain a rare supercar.

# Aston Martin DB9

The DB9 was the model that was supposed to assure the future of Aston Martin. The company had been through a number of different owners, but now, as part of Ford's Premier Automotive Group (which also included Jaguar, Land Rover and Volvo), it had secured the investment to create an all-new manufacturing facility at Gaydon in Warwickshire to replace the antiquated sheds at Newport Pagnell from which it had operated for so many years.

When the DB9 appeared, the future looked bright indeed: the new 2+2 was not only stunningly good looking, but it also had all the power it needed to compete at the top end of the supercar league, a suspension set-up that gave it breathtaking agility, and a simply gorgeous hand-crafted cockpit. Indeed, at the time of its launch in 2004, the Aston Martin DB9 was one of the most advanced and technically sophisticated cars of all.

Its bonded aluminium frame is light, strong and highly efficient structurally: despite the fact that the bodyshell is some 25 per cent lighter than that of the DB7, its frame has twice the torsional rigidity. The engine, transmission and suspension are mounted on the frame, then the body panels are bonded to the frame, increasing the stiffness of the whole structure but also eliminating squeaks and rattles. The front wings, bonnet and roof are made of aluminium, while the rear wings and boot lid are constructed from lightweight composites. The DB9's front suspension is mounted on a separate aluminium subframe, while the rear suspension and transaxle is mounted on its own subframe. Forged aluminium wishbones and aluminium-bodied shock absorbers are used front and rear. Braking is by disc front and rear, incorporating a host of electronic aids, including Electronic Brakeforce Distribution, BrakeAssist and ABS.

At the heart of the DB9 is a V12 developed from the Vanquish unit, a 48-valve quad-cam 5,953 cc engine that produces 450 bhp at 6,000 rpm and 570 Nm of torque at 5,000 rpm, some 80 per cent of which is available as low as 1,500 rpm, which makes the car immensely tractable at low speeds and wonderfully responsive at higher speeds. The DB9 achieves 0–60 mph in just 4.7 seconds and has a top speed of 186 mph / 299 km/h. The engine is mounted as far back as possible and is connected to the rear transaxle by a carbon-fibre propshaft inside an aluminium torque tube, an arrangement that ensures the optimal 50:50 weight distributions. The gearbox is available as either a six-speed manual or six-speed automatic, the latter being one of the world's first shift-by-wire arrangements, which allows the driver to select park, reverse, drive or neutral by pressing a dashboard button. The driver can also shift gears manually using paddles on the steering column.

But perhaps more important than its mechanical specification is the appearance of the DB9. Its design is a thoroughly modern reinterpretation of classic Aston Martin sports car style: curved, elegant, clean and smooth, while at the same time hinting at the power potential and the lithe agility of the car.

Very soon after the launch of the DB9 came the introduction of the DB9 Volante, which features a fully retractable hood that is then stored within the body of the car to avoid spoiling its elegant lines. Operated with the push of a button, it takes just 17 seconds to open or close. Mechanically, the Volante is very similar to the DB9 coupé, though it does feature extra roll-over sensors that detect an imminent rollover and deploy two hoops from the rear seat headrests, which operate in tandem with the front windscreen to withstand weight more than twice that of the car.

**ASTON MARTIN DB9 2004**

**ENGINE:** 5,953 cc V12

**MAXIMUM POWER:** 450 bhp at 6,000 rpm

**MAXIMUM TORQUE:** 570 Nm at 5,000 rpm

**MAXIMUM SPEED:** 186 mph / 299 km/h

**0–60 MPH ACCELERATION:** 4.7 secs

**TRANSMISSION:** 6-speed manual or 6-speed automatic

**LENGTH:** 184¾ in / 4,691 mm

**WIDTH:** 73¾ in / 1,875 mm

**HEIGHT:** 51½ in / 1,305 mm

**WHEELBASE:** 107¾ in / 2,740 mm

**MANUFACTURE DATE:** 2004–present

**BRAKES:** disc (f and r)

**SUSPENSION:** double wishbone (f and r)

**WHEELS:** alloy, 19 in

**TIRES:** 235/40 ZR-19 (f), 275/35 ZR-19 (r)

# Bentley Brooklands

This is not just any old car. It's not even just any old Bentley. It's the very latest Bentley Brooklands coupé, a two-door version of the venerable Arnage/Azure range, and, until the Arnage is finally replaced, the latest flagship model of the Bentley family. But to see it as either an Arnage coupé or an Azure with a hard top is missing the point. The Brooklands is faster, sportier and more aggressively styled than either of its brethren and has a character all of its own, such that it's virtually an all-new model.

This ultimate Bentley is a stylish, four-seat, grand touring coupé, with classic British proportions and muscular performance. It's a true hardtop, with no center window post to spoil its flowing, elegant lines. Sporting design cues are matched by the phenomenal performance engineering of Bentley's legendary Crewe-built V8 engine. Under the long sweeping bonnet of the Bentley Brooklands lies the most powerful V8 the company has ever produced – a 530 bhp, twin-turbocharged 6.75-liter unit that also produces a prodigious 1,050 Nm of torque.

Amazingly, Bentley's V8 was first launched in the Bentley S2 saloon way back in 1959, with a capacity of 1.37 gallons /

6.23 liters. It was very advanced for its time, with an all-aluminium construction, a five-bearing crankshaft and a well-supported camshaft, producing nearly 200 bhp and 400 Nm of torque. The result was a light and supple powertrain that produced maximum torque at low engine speeds – the hallmark of every Bentley ever produced.

In 1969, the capacity was increased to 6.75 liters (and this has remained constant), but by far the most significant change came in 1982, with the introduction of a turbocharger to create the near-300 bhp Mulsanne Turbo, a car that transformed the image of Bentley. Twin turbos arrived in the Arnage in 2002, developing up to 450 bhp.

For the 2007 model Arnage, the V8 engine saw a step-change in performance and refinement, which became the starting point for the new Bentley Brooklands. A reprofiled camshaft and new, low-inertia turbochargers, which operate with greater efficiency at lower engine speeds, have resulted in reduced turbo lag, enhancing that prodigious wave of torque at any revs. For the Bentley Brooklands, further component optimization and engine calibration ensure record power and torque levels from this hand-assembled engine, which is

**BENTLEY BROOKLANDS 2007**

**ENGINE:** 6,751 cc V8

**MAXIMUM POWER:** 530 bhp at 4,000 rpm

**MAXIMUM TORQUE:** 1,050 Nm at 3,200 rpm

**MAXIMUM SPEED:** 184 mph / 296 km/h

**0–62 MPH ACCELERATION:** 5.3 secs

**TRANSMISSION:** 6-speed automatic

**LENGTH:** 213 in / 5,411 mm

**WIDTH:** 81¾ in / 2,078 mm

**HEIGHT:** 58 in / 1,473 mm

**WHEELBASE:** 122¾ in / 3,116 mm

**MANUFACTURE DATE:** 2007

**BRAKES:** disc (f and r)

**SUSPENSION:** double wishbone (f and r)

**WHEELS:** alloy, 20 in

**TIRES:** 255/40 ZR-20 (f and r)

matched to a six-speed automatic transmission.

Each Brooklands coupé is lovingly hand-assembled, employing traditional coach-building techniques and the craftsmanship skills in wood veneer and leather hide for which Bentley has long been renowned. As an example of attention to details, the flowing line where the roof meets the rear wings is hand-welded, and Bentley insist that's the only way of making the join imperceptible. The Brooklands costs a cool £236,500, and as if that alone wasn't enough to ensure exclusivity, lifetime production will be strictly limited to just 550 cars.

Bentley's plan in developing the Brooklands was to offer 'exhilarating, effortless, accessible performance for those truly passionate about their driving'. It has certainly achieved that aim, even though the bare figures don't suggest the ultimate in performance. The 0–62mph acceleration time, for example, is 5.0 seconds – respectable, but no longer in the supercar league. Similarly, its 184 mph / 296 km/h top speed is fast, but by no means the fastest available.

But in no other car can you sit in such sumptuous comfort and feel such an explosion of raw power as under acceleration the bonnet lifts and the Brooklands sits down on its haunches. Considering that it weighs around 2.56 tons / 2.6 tonnes, it's also astonishing how swiftly the huge car can be hustled around corners. Reassuringly, it stops as well as it goes, too, thanks to massive carbon brakes in each of the 20-inch wheels.

The Bentley Brooklands is a fantastic *tour de force* – a fact that has clearly been recognized by potential customers. Of the 550 cars that the company vowed would be made, 500 had been sold before the first one had rolled off the production line.

# Bentley R-Type Continental

One of the 1953 Bentley R-Type Continental's chief claims
to fame was that, at the time of its launch, it was comfortably
the most expensive car in the world. But far more importantly,
it was also one of the world's most elegant, beautiful and
desirable cars. After World War II, Bentley badly needed a
flagship model that would re-establish the marque in its own
right. Bentley had been taken over by Rolls-Royce in 1931,
and since then, Bentley models had been based on Rolls-
Royce designs. They might have been a little sportier than the
stately Rolls models, but Bentleys were never allowed to shine,
because that might have undermined the Rolls-Royce claim to
be the top car brand in the world.

In 1952, the Bentley R-Type was launched to replace the
earlier Mark VI. Powered by a 4,566 cc straight-six engine, the
R-Type saloon was spacious, luxurious and showed a fair turn
of speed – the 0–60 mph time of 13.25 seconds seems sedate

Continental's performance was transformed. At that time, Bentley chose not to reveal the power output of its engines, but instead allowed the performance to tell the story. In this case, the top speed was increased to 115 mph / 185 km/h – at the time, an impressively high figure.

And the fortunate owners of a Continental enjoyed its performance in style. The cabin was awash with leather, wood and deep carpets, while, as might be expected from a Bentley, the quality of every component was top notch.

With its high cost, the Bentley R-Type Continental was never going to sell in huge numbers. In the mid-1950s, a small standard car such as a Morris Minor cost just under £600, less than a twelfth of the price of a Continental. In any case, the coachbuilding firm Mulliners could not have coped with large volumes. Of the 2,320 R-Type Bentleys produced, only around 200 were Continentals.

The R-Type Continental marked a renaissance for the Bentley marque. For the first time since the company had been taken over by Roll-Royce, a Bentley was more than a somewhat watered-down version of the group's main product. Once again, Bentley had become a genuine alternative to a Rolls-Royce.

by today's standards, but the car's top speed of 102 mph / 164 km/h was entirely respectable.

If the saloon cost a great deal of money in those days – £4,481 – that was nothing compared to the cost of a special coachbuilt two-door version produced by H.J. Mulliner. The R-Type Continental cost a massive £7,608. It was the first time that Bentley had used the name 'Continental', though it was to be by no means the last: this was the first of a long, honourable line of high-speed Grand Tourers that continues to this day.

The R-Type Continental had the same engine as the saloon, and indeed as the Rolls-Royce Silver Dawn, upon which the R-Type was based. But for the Continental, the compression ratio was raised, larger carburettors were installed, the inlet and exhaust manifolds were modified, and a close-ratio manual gearbox was specified in place of the saloon's auto box to ensure better acceleration. For good measure, a higher final drive ratio was adopted to allow for relaxed high-speed cruising.

As for the bodywork that Mulliner created, this was something truly special. While the front of the car was relatively conventional, the sloping rear was unique at the time. This was the world's first fastback design, in which the body sweeps straight down from the roofline to the bumper, with the rear window and the boot lid in a single unbroken plane.

But the sensuous, sweeping bodywork was more than just fabulously stylish. It was also considerably lighter than the saloon's, and significantly more aerodynamic. As a result, the

# BMW Z8

The BMW 507 Roadster of 1956 is reckoned by many to be one of the most beautiful cars ever conceived. BMW's designers decided to see if they could recreate a modern interpretation of that earlier car, and duly unveiled a Z09 concept car at the 1997 Tokyo Motor Show. It was so well received that it re-appeared at the 1998 Detroit Show, where once again the reaction was universally favourable, so BMW took the decision to put the car into production.

The production car, the BMW Z8 that appeared in 2000, had its engine at the front under a long, low bonnet, a cockpit set towards the rear of the car, tapered overhangs, and a low beltline – all reminiscent of the 507 – and its rounded, curvaceous style was very different to the more angular designs that were popular at the turn of the millenium. The original designer of the classic 507, Count Albrecht Goertz, was certainly impressed: 'If I were to design the 507 today, it would look like the Z8', he said.

The Z8 had a retro air, but the technology underneath the sensuous body was absolutely state of the art. Its 4,941 cc V8 engine produced a storming 394 bhp and drove the rear wheels through a six-speed transmission, while its suspension system – MacPherson struts at the front and a multi-link set up at the back

**BMW Z8 2000**

**ENGINE:** 4,941 cc V8

**MAXIMUM POWER:** 394 bhp at 6,600 rpm

**MAXIMUM TORQUE:** 492 Nm at 3,800 rpm

**MAXIMUM SPEED:** 155 mph / 249 km/h

**0–60 MPH ACCELERATION:** 4.3 secs

**TRANSMISSION:** 6-speed manual

**LENGTH:** 172¼ in / 4,374 mm

**WIDTH:** 72 in / 1,831 mm

**HEIGHT:** 52 in / 1,318 mm

**WHEELBASE:** 98½ in / 2,504 mm

**MANUFACTURE DATE:** 2000–03

**BRAKES:** disc (f and r)

**SUSPENSION:** MacPherson strut (f), multi-link (r)

**WHEELS:** alloy, 18 in

**TIRES:** 245/45 ZR-18 (f), 275/40 ZR-18 (r)

bumpers at another. The engine and transmission came from a third BMW plant. All the parts were then brought together to Munich, where the cars were virtually hand-built by craftsmen. In all, the Z8 took ten times longer to assemble than a normal BMW saloon.

In 2003, the year the Z8 went out of production, an even faster Alpina version was launched, with a five-speed automatic transmission in place of the standard six-speed manual. This was mated to a tuned 4.8-liter V8 that produced less power (375 bhp) but more torque (519 Nm instead of 492 Nm), for more relaxed cruising.

BMW had no trouble selling the Z8, despite its hefty £80,000 price tag, perhaps because the car gained worldwide publicity just before its official launch when it appeared, driven by Pierce Brosnan, in the 1999 James Bond movie *The World Is Not Enough.*

– was lifted off the M5 saloon, generally reckoned to be one of the best-handling cars in the world. Better still, the engine was set well back in the chassis to provide perfect 50:50 weight distribution.

The Z8's body was constructed in lightweight aluminium and it was mounted to an aluminium spaceframe that was both light and incredibly stiff, which gave the car superb performance: it accelerated from 0 to 60 mph in 4.3 seconds, from 0 to 100 mph in 10.5 seconds, and had an electronically limited top speed of 155 mph / 250 km/h. The Z8 was as quick as any Porsche or Ferrari, but in many ways far more civilized. For example, it had an infinitely variable electronically controlled valve timing system, and this ensured that at low speeds the car was as tractable and easy to drive as any BMW saloon.

The Z8 was a true convertible, with a powered soft top as standard, though every car was also offered with a body-coloured hardtop too. The cabin offered its occupants luxury and comfort levels of a high order. Electric windows, cruise control, a navigation system and climate control were all standard equipment. So although it promised supercar performance, the Z8 could also be used as a day-to-day car. It was a heady combination of speed and beauty, sophisticated modern technology and classic elegance.

Building the Z8 was a study in complicated logistics: the bodies were built and painted in one factory, the front and rear

# Bugatti EB 16/4 Veyron

Many extravagant claims are made at motor shows, but none were more radical than those made by Ferdinand Piech at the Frankfurt Show in 1999. Standing in front of a concept called the Bugatti 18/4 Veyron, the boss of the Volkswagen Group (which by now owned Bugatti) said the car would go into production by 2000. He also claimed it would have over 1,000 bhp, which would make it the most powerful production car ever. And, just for good measure, he assured listeners that it would also be the fastest and most expensive, too.

Amazingly, the car that was eventually produced in 2005 was very similar to that original concept, though in the intervening years, the W18 engine with three banks of six cylinders had been amended to a W16 with four banks of four cylinders. To boost the power to the magic 1,000 bhp mark, four turbochargers were specified.

It was an incredible feat of engineering, though it came to market five years later than Piech had promised because of difficulties over cooling, aerodynamics and tires. Good aerodynamics meant smooth airflow, but in order to get cooling air to the engine, vents or ducts were required, and these increased drag and lowered the top speed. The solution – to give an example of the hurdles that had to be overcome – was to give the Veyron ten different radiators: three for the engine, two for the air conditioning, the others for the intercooler, engine oil, transmission oil, differential oil and hydraulic oil. The problem with the tires was that none existed that were capable of carrying the weight of the Veyron at speeds of up to 250 mph / 402 km/h. The solution was found with the help of Michelin, who created a special Pilot Sport tire especially for the Veyron.

Eventually, much hard work paid off, and a pre-production prototype ook to a test track and recorded 253 mph / 407 km/h. This speed was possible not only because of the awesome power of the engine but also because at higher speeds, above 137 mph / 220 km/h, the car comes alive – an adjustable spoiler at the back is raised, a diffuser at the rear provides the necessary downforce to maintain stability, and the hydraulic dampers lower the car to reduce ground clearance. But to achieve the very highest speeds, the driver has to use a special key to put the car into High Speed Mode. It is this that allows the ground clearance to be reduced still further, from the standard 5 in / 125 mm to just 2½ in / 65 mm, for the spoiler to retract, and for the air diffusers to close to reduce aerodynamic drag.

So, the Veyron had fulfilled Piech's claim that it would be the fastest car in the world – for good measure it was recorded at an eye-watering 2.4 seconds for 0–60 mph acceleration – and it produced 1,001 bhp, breaking the 1,000 bhp mark that had been promised. All that was left was for the price to be announced. Sure enough, the final promise was fulfilled: the new car cost 1,000,000.

driven in either manual or auto mode. It is created from aluminium
panels fitted to a carbon fibre monocoque with an aluminium
front subframe and a stainless-steel rear subframe.

The Bugatti Veyron is truly a unique machine. There is
nothing else like it in the world and it's difficult to conceive that
there will ever be anything like it again.

**BUGATTI EB 16/4 VEYRON 2006**

**ENGINE:** 7,993 cc W16

**MAXIMUM POWER:** 1,001 bhp at 6,000 rpm

**MAXIMUM TORQUE:** 1,250 Nm at 3,300 rpm

**MAXIMUM SPEED:** 253 mph / 407 km/h

**0–60 MPH ACCELERATION:** 2.4 secs

**TRANSMISSION:** 7-speed semi automatic

**LENGTH:** 175¾ in / 4,463 mm

**WIDTH:** 78¾ in / 1,999 mm

**HEIGHT:** 47¾ in / 1,212 mm

**WHEELBASE:** 106¾ / 2,710 mm

**MANUFACTURE DATE:** 2006–present

**BRAKES:** disc (f and r)

**SUSPENSION:** control arm (f and r)

**WHEELS:** alloy, 20 in (f), 21 in (r)

**TIRES:** 265/680 ZR500A (f), 365/710 ZR540A (r)

# Bugatti EB110 SS

When Bugatti, one of the motor industry's most famous and revered names, was acquired by Italian businessman Romano Artioli in 1987, he announced ambitious plans to produce the most technically sophisticated supercar the world had ever seen. Artioli employed Marcello Gandini, who had designed the Lamborghini Countach, and Mauro Forghieri, one of the most famous racing car engineers, to head up the development team. Between them, they came up with a stunning mid-engined design powered by a 60-valve 3,449 cc V12 with four turbochargers to boost the power output to a peak of 560 bhp. That gave the new car, the Bugatti EB110, acceleration from 0 to 62mph in 4.5 seconds and a top speed of 213 mph / 343 km/h, which was absolutely outstanding in its day, and truly worthy of the Bugatti name. (Incidentally, the car was named after the company's founder, Ettore Bugatti – his initials plus the number of year's since his birth.)

The new car had a carbon-fibre monocoque chassis manufactured by the French aeronautics company Aerospatiale, which had learnt about the material in developing its rockets. This in itself set the EB110 apart from any car that had gone before – it was the first to use this construction technique. The body was composed of aluminium panels bonded to the monocoque and, unusually, it incorporated a glass panel over the engine so owners could view the bespoke powerplant. Forward-lifting scissor doors ensured a small piece of theatre every time the car was parked,

## BUGATTI EB110 SS 1992

**ENGINE:** 3,498 cc V12

**MAXIMUM POWER:** 603 bhp at 8,000 rpm

**MAXIMUM TORQUE:** 637 Nm at 4,200 rpm

**MAXIMUM SPEED:** 217 mph / 349 km/h

**0–60 MPH ACCELERATION:** 3.2 secs

**TRANSMISSION:** 6-speed manual

**LENGTH:** 157¾ in / 4,400 mm

**WIDTH:** 76½ in / 1,940 mm

**HEIGHT:** 44¼ in / 1,125 mm

**WHEELBASE:** 100½ in / 2,550 mm

**MANUFACTURE DATE:** 1992–95

**BRAKES:** disc (f and r)

**SUSPENSION:** double wishbone (f and r)

**WHEELS:** alloy, 18 in

**TIRES:** 245/40 ZR-18 (f), 325/30 ZR-18 (r)

though on the road, the view most people would have had was of the back of the car, with its speed-sensitive rear wing, which rose at higher velocities. To ensure all that power could be evenly transmitted to the road, the EB110 was fitted with a permanent four-wheel drive system that directed 27 per cent of the power to the front and the remaining 73 per cent to the rear. Massive stopping power was provided by Brembo brakes, while the huge tires were specially made by Michelin. For good measure, French oil company Elf provided a unique organic lubricant, which had originally been developed for the Benetton F1 team.

The EB110 was launched in 1991, but just a year later, it was improved still further in the EB110 SS (Supersport) model, which was was introduced at a price of £281,000. This car was lighter and produced even more power (up to 603 bhp). The result was a slightly higher top speed of 217 mph / 349 km/h, but markedly quicker acceleration through the six-speed gearbox: 0–62 mph now took a mere 3.2 seconds. The Supersport retained the EB110's original four-wheel drive system, but the aluminium bonnet, engine cover and venturi undertray were replaced with even lighter carbon-fibre panels, the wheels were changed from aluminium alloy to magnesium, and the moveable rear wing became a fixed unit. The extra power had been squeezed out of the engine by installing bigger injectors and a revized electronic control unit, and by removing two of the energy-sapping catalytic converters in the exhaust. On the open road, the EB110 SS was even more extreme that the EB110. Indeed, it was so outstanding that F1 champion Michael

Schumacher bought one for himself and kept it for many years, even after he moved to become a Ferrari driver.

Sadly, Artioli's dream wouldn't last long. He over-extended himself by developing a four-door EB112 model, and at the same time, bought the British company Lotus. Bankruptcy followed in 1995, which brought to an end the production of the mighty EB110 after only 139 had been built. Volkswagen Group bought the rights to the Bugatti marquee in the late 1990s, but the original EB110 remains one of the rarest and finest supercars ever made.

# Bugatti Type 35

When he was just 19, Ettore Bugatti designed his first car, which won a gold medal at the 1901 Milan trade fair. During the early years of the 20th century, he build a handful of models, but it was not until after World War 1 that he started to make a real name for himself.

The breakthrough came in 1921, when five Bugattis entered the Voiturette Grand Prix at Brescia and took the first four places. In the following years, private entrants bought his cars as Bugatti became known as the top manufacturer of racing cars in Europe. Unfortunately, the period of success didn't last long: Fiat and others introduced supercharging and the Bugattis became uncompetitive.

This led Ettore Bugatti to create the car that made him a legend and his Bugatti marque as a world leader. To replace the earlier Type 30 and Type 32 cars, he introduced the Type 35, for which he further developed the 2.0-liter eight-cylinder in-line engine that had been used in earlier cars by adopting five main bearings instead of three. This allowed the engine to be revved harder, up to 6,000 rpm, and for the power output to increase to 95 bhp. Normally, this might not have been enough power to be truly competitive on the racetrack, but Bugatti had created a car that was light, nimble and handled beautifully. It

was also extremely reliable, which in the early days of racing was an extraordinary achievement.

A four-speed manual gearbox was used on the Type 35. The suspension was basic leaf springs front and rear, but there were other innovations, such as cable-operated drum brakes and a hollow front axle to reduce unsprung weight and improve the handling. The Type 35 also featured innovative cast-alloy wheels that had the drum brakes integrated within them, so that as the wheel was removed, so were the brakes. The car had an elegant aluminium body with a distinctive horseshoe-shaped radiator at the front – the first occurence of what has since become a Bugatti trademark.

The Type 35's first appearance was at the 1924 Lyons Grand Prix, where tire problems led to the car being retired. At the next Grand Prix, in San Sebastian, wider tires were fitted and the car took second place. After that there was no stopping the Type 35, which won over 2,000 races in the next five years.

As time went on, Bugatti had to continue developing the Type 35 to ensure it remained competitive, but he also introduced other models of the Type 35. The 35A, launched in 1925, was the first of these. It was never really intended for racing and had a simplified engine to decrease maintenance requirements.

Then, in 1926, came the 35C, which was fitted with a Rootes supercharger that boosted the power output to 128 bhp and ensured Bugattis remained at the front of the GR grids. The 35T, a special model intended to compete in the Targa Florio, was launched same year. Its capacity was increased to 2.3 liters, which made it ineligible for Grands Prix, where capacity was still limited to 2.0 liters. However, when GP regulations changed, Bugatti introduced the most powerful Type 35 of all, the 35B. It had the same 2.3-liter engine as the 35T but had a supercharger bolted to it to raise peak output to 138 bhp.

In all, around 340 Bugatti Type 35 cars were built between 1924 and 1929. Quite apart from creating Bugatti's reputation, the Type 35 can fairly claim to be the most successful racing car of all time, not only because of the sheer number of victories it won – although 2,000 is undoubtedly impressive – but also because they came in so many different areas of motorsport, from Grands Prix to endurance races and even hillclimbs and sprints.

**BUGATTI TYPE 35 1924**

**ENGINE:** 1,991 cc inline 8-cylinder

**MAXIMUM POWER:** 95 bhp at 6,000 rpm

**MAXIMUM TORQUE:** not quoted

**MAXIMUM SPEED:** 118 mph / 190 km/h

**0–60 MPH ACCELERATION:** not disclosed

**TRANSMISSION:** 4-speed manual

**LENGTH:** 145¾ in / 3,700 mm

**WIDTH:** 52 in / 1,320 mm

**HEIGHT:** 38¾ in / 985 mm

**WHEELBASE:** 94½ in / 2,400 mm

**MANUFACTURE DATE:** 1924–29

**BRAKES:** drum (f and r)

**SUSPENSION:** rigid axle (f), live axle (r)

**WHEELS:** alloy

**TIRES:** 27x4.40 (f and r)

# Cadillac Eldorado Convertible

Eldorado is the mythical City of Gold that enticed thousands of European sailors and explorers to cross the Atlantic in search of treasures in South America. It's also the Cadillac model that, more than any other, represents the hopes and aspirations of the late 1950s. The very first Cadillac Eldorado was a concept car shown at GM's Motorama Show in the ballroom of a swanky New York hotel, an annual event at which all GM's brands put their latest models and their ideas for the future on display. (First staged in 1949, Motorama was the USA's first major motor show.)

It was an enormous convertible vehicle, 220¾ in / 5,610 mm long and 78¾ in / 2,000 mm wide, and available in only four special colours – red, white, yellow and blue, with either a white or black folding convertible roof. It was powered by GM's 5,424 cc V8 that produced a relatively modest 210 bhp.

Though billed as a concept car, the 1953 Eldorado was for sale – to those with pockets deep enough to afford its high price tag. At $7,750, it was easily the most expensive Cadillac on the market at the time. Nevertheless, more than 500 were sold and the Eldorado became a mainstream model, still at the top end of the price range, but slightly more affordable and with a less

opulent specification than the first Motorama cars.

As the 1950s progressed, the Cadillac Eldorado was refined and improved. But what made it especially iconic was its use of extravagant rear fins. They were first used on the 1955 Eldorado Brougham Town Car and over the next few years they became bigger, higher and more extreme.

And so, by the time the 1959 Cadillac Eldorado was launched, with its larger and far more powerful engine, the Caddy flagship became a symbol for the new jet-age era that worshipped both speed and modernity.

Under the massive bonnet was a 6,396 cc V8 producing 345 bhp and providing a top speed of 120 mph / 193 km/h despite its enormous bulk and 5,000 lb / 2,268 kg weight. The engine was mated to a three-speed Hydra-Matic automatic transmission that drove the rear wheels via a 2.94:1 rear axle gear ratio.

This was a car built for comfort and cruising rather than out-and-out performance, and although it was available as both a coupé and a convertible, it is the convertible that represents that classic era of rock and roll, drive-in diners and drive-in movies.

With its jutting rear fins, acres of chrome, quad headlights

and rather bulbous bodywork, the 1959 Cadillac Eldorado cannot be described as beautiful, elegant or sophisticated. It wasn't even that distinctive mechanically by 1959, because its triple carburettor engine was by then available as an option on every other Cadillac in the range, whereas previously, the rest of the Cadillac range had had to make do with a lower-powered single-carburettor engine.

Yet it is the 1959 Eldorado that has gained near-iconic status as the years have passed. Just 1,320 convertibles and 975 coupés were built during that famous model year, and sold at a factory price of $7,401 – considerably less than the original 1953 model. The specification included air suspension and electric windows with air conditioning as an added-cost option.

Today, at auction, the best examples of a Cadillac Eldorado are reaching around $230,000, a clear sign that the iconic finned monster remains one of the most potent symbols of an era of excitement, extravagance and excess. It may not have been pretty, it may even have been rather tasteless, but it was certainly flamboyant, and it was exactly what the public wanted then and what still gets car enthusiasts' hearts beating faster today.

**CADILLAC ELDORADO CONVERTIBLE 1959**

**ENGINE:** 6,396 cc V8

**MAXIMUM POWER:** 345 bhp at 4,800 rpm

**MAXIMUM TORQUE:** 590 Nm at 3,400 rpm

**MAXIMUM SPEED:** 120 mph / 193 km/h

**0–60 MPH ACCELERATION:** 10.5 secs

**TRANSMISSION:** 3-speed automatic

**LENGTH:** 225 in / 5,610 mm

**WIDTH:** 80¼ in / 2,040 mm

**HEIGHT:** 54½ in / 1,382 mm

**WHEELBASE:** 130 in / 3,302 mm

**MANUFACTURE DATE:** 1959–60

**BRAKES:** drum (f and r)

**SUSPENSION:** air ride (f and r)

**WHEELS:** alloy, 15 in

**TIRES:** 8.20x15 (f and r)

# Chevrolet Camaro Z28

In 1967, Chevrolet was looking for a muscle car that could challenge the all-conquering Ford Mustang in the Trans-Am race series. To be eligible, the car would have to be based on a production vehicle with at least 1,000 street-legal examples sold, and its engine would have to be restricted to no more than 305 cu in in capacity. Chevvy already had 5,359 cc and 4,638 cc V8s, and by putting a 283 crankshaft into the 5,359 cc block it created a 4,949 cc unit, well within the Trans-Am regulations. But to make up for the power lost in reducing the capacity, Chevrolet's engineers then specified a Holley four-barrel carburettor, specially tuned inlet manifold, a reprofiled camshaft and other modifications to give the new engine an official output of 290 bhp at 5,800 rpm and 393 Nm of torque at 4,200 rpm. In fact, the power output was considerably more and could have been close to 400 bhp, depending on which inlet and exhaust manifolds were used.

The Camaro, a new model that shared the GM F-Body platform with the Pontiac Firebird, was chosen as the production model, but bizarrely, Chevrolet never advertized what became known as the Z28 version. Those in the know had to go to a dealership and order a base Camaro and then specify the Z28 package from a long list of options. This then transformed a fairly ordinary vehicle into one of the great muscle cars of the 1960s. It gained not only the 4,949 cc engine but also wider tires on lightweight Corvette alloy wheels, disc brakes, a quicker ratio steering rack, upgraded radiator and what was described as the F-41 suspension package – basically firmer coil springs and upgraded shock absorbers. There was no choice over the transmission, as only a four-speed Muncie manual was available.

The total cost of the Z28 package was $2,966 – just $500 more than the base six-cylinder Camaro. For this, buyers didn't even get any Z28 badges (they were first introduced in 1968), merely wide racing stripes on the bonnet and bootlid. A rear bootlid spoiler was available as an option for those wanting to make more of a visual statement. A further popular option was the

RS package, which included hidden headlamps and revised taillamps. Although the Camaro was offered as both a coupé and a convertible, the Z28 package was only ever made available on the coupé. Despite the very existence of the Z28 options package being hidden way down in the small print, 602 of the 220,000 Camaros sold in 1967 were prime examples of America's latest muscle car. It seems that Chevrolet got round the Trans-Am 1,000 homologation number by homologating the 350 cu in Camaro under FIA

Group I rules and then qualifying the base vehicle with Z28 option under Group II rules.

The following year, some changes were made to the specification. These later Z28 cars are recognizable by their raised cowl induction hoods. Gradually more people got to hear of the availability of the Z28, and 7,199 were sold in 1968 and 20,302 in 1968. Amazingly, GM applied the same warranty to the Z28 as it did to the rest of the Camaro range – two years and 24,000 miles for the car as a whole and five years and 50,000 miles for the powertrain.

On the Trans-Am scene, the Camaro was a near-instant success. GM didn't have an official factory team but instead lent its support to Roger Penske's semi-official team. Driving for Penske, Mark Donohue took the title in both 1968 and 1969 and his successes on the track substantially drove up sales of the Camaro in showrooms right across the USA.

**CHEVROLET CAMARO Z28 1967**

**ENGINE:** 4,958 cc V8

**MAXIMUM POWER:** 290 bhp at 5,800 rpm

**MAXIMUM TORQUE:** 393 Nm at 4,200 rpm

**MAXIMUM SPEED:** 140 mph / 241 km/h

**0–60 MPH ACCELERATION:** 6.9 secs

**TRANSMISSION:** 4-speed manual

**LENGTH:** 185 in / 4,700 mm

**WIDTH:** 72½ in / 1,840 mm

**HEIGHT:** 51¼ in / 1,300 mm

**WHEELBASE:** 108 in / 2,746 mm

**MANUFACTURE DATE:** 1967–69

**BRAKES:** discs (f), drums (r)

**SUSPENSION:** independent A-arm (f), semi-elliptic leaf spring (r)

**WHEELS:** steel, 14 in

**TIRES:** 7.35x14 (f and r)

# Chevrolet Corvette Sting Ray

The first Chevrolet Corvette was launched in 1953 and over the years its combination of style and power ensured that it was not only a very popular element in the General Motors range, but also a very profitable one for the company.

Ten years after its launch, however, it was clear that the Corvette needed attention. By 1962, although it certainly wasn't lacking in terms of power, it struggled to compete with a new generation of European sports cars, which had far more sophisticated chassis and suspension arrangements, and which therefore rode and handled much better than the Corvette.

GM's response was already in preparation: during 1961, GM's styling chief, Bill Mitchell, had created a concept car called the Mako Shark – his own idea of the direction in which Corvette should be heading. It was aggressive in appearance but with smooth, sleek and aerodynamic lines – just like a shark, in fact. It was also a closed-top coupé design, with a split rear window with deeply curved glass panels. Until then, all Corvettes had been convertibles, so the Mako Shark offered the potential for broadening the appeal of the model.

The Mako Shark was accepted as the basis for a new generation of Corvettes, which, to maintain the deep-sea theme, was called the Corvette Sting Ray. Importantly, the Sting Ray wasn't just a smart new body over the old mechanicals. A whole new chassis was designed, with a shorter wheelbase, front suspension of unequal-length upper and lower arms with coil springs, and fully independent rear suspension consisting of control arms, shock absorbers and a transverse leaf spring fitted between the rear differential and each rear wheel.

Buyers could choose between four versions of the 327 cu in, 5,359 cc V8 that had been introduced the year before. The base model produced 250 bhp, while with different carburettors fitted, this output could be boosted to 300 bhp or 340 bhp. The final option was a 360 bhp fuel-injected version, though this was expensive ($480 extra) and needed frequent servicing to keep it in tune. It produced its peak power at 6,000 rpm and also offered a healthy 477 Nm of torque at 4,000 rpm, more than enough to offer 0–60 mph acceleration in 5.9 seconds, 0–100 mph in 14.5 seconds and a top speed of 142 mph / 229 km/h.

Whichever engine option was chosen, it was mated to either a three-speed manual, a four-speed Borg-Warner manual or a three-speed Powerglide auto box.

The Corvette Sting Ray was an instant success: more than 21,000 were sold in 1963 alone, at prices starting at $4,037 for the convertible and $4,257 for the coupé. In many ways this was one of the most technically advanced cars on the American market at the time: it was the first to use fibreglass plastic body panels, its V8 engine provided great levels of performance, and even if its independent suspension wasn't as sophisticated as that fitted to the Jaguar E-Type, it still represented a major step forward.

The Sting Ray stayed in production until 1967 and was developed and improved each year. For example, the split rear glass remained for only one year before being changed for a single glass unit; in 1965, disc brakes were adopted and the 396 cu in 'Big Block' V8 was offered, and this engine was later bored out to 427 cu in in 1966. This 6,974cc version is one of the most collectable today.

Rarest of all the first-generation Sting Rays is the L-88, a version of the 427 aimed at the racing fraternity. Bored out to 6,997 cc, it produced 550 bhp at 6,200 rpm and a stunning

637 Nm or torque at 5,200 rpm. Only 20 of these 170 mph / 274 km/h beasts were sold.

The L-88 may be the most extreme Sting Ray, but any Sting Ray is a highly desirable car. Some will argue that the 1967 models were the best, while others will insist that the 1963 version with the split rear window is the real classic, but every model is a great American sports car.

**CHEVROLET CORVETTE STING RAY 1963**

**ENGINE:** 5,359 cc V8

**MAXIMUM POWER:** 360 bhp at 6,000 rpm

**MAXIMUM TORQUE:** 477 Nm at 4,000 rpm

**MAXIMUM SPEED:** 142 mph / 229 km/h

**0–60 MPH ACCELERATION:** 5.9 secs

**TRANSMISSION:** 4-speed manual

**LENGTH:** 175¼ in / 4,453 mm

**WIDTH:** 69½ in / 1,768 mm

**HEIGHT:** 50 in / 1,265 mm

**WHEELBASE:** 98 in / 2,489 mm

**MANUFACTURE DATE:** 1963–67

**BRAKES:** drum (f and r)

**SUSPENSION:** independent wishbone (f), independent trailing arm (r)

**WHEELS:** alloy, 15 in

**TIRES:** 6.70x15 (f and r)

# De Lorean DMC-12

The DeLorean DMC-12, designed by Giorgio Giugiaro, was supposedly the recipient of massive engineering development resources and was intended to be modern, radical, technically advanced and premium priced. What it turned out to be was a good-looking sports coupé that was ill-developed, underpowered, poorly built and late coming to market. Given that about the only goal set for it that held good was its high price – and indeed that doubled – it's no wonder that *Time* magazine voted it one of the 50 Worst Cars Of All Time.

The DeLorean project had started off with such high hopes. John Z DeLorean was a sharp-dressing automotive executive with a shining career at GM behind him – he had developed both the Pontiac GTO and the Firebird in his time. He had persuaded the British Government to provide grants for a new factory in Northern Ireland and had commissioned from Giugiaro a derivative of his Tapiro concept car design of 1970. What made the gullwinged two-seater so extraordinary was not just its sharp lines, reminiscent of the Lotus Esprit, but that its body panels were all constructed from unpainted stainless steel. The idea was that it wouldn't need painting and minor scratches and blemishes wouldn't show.

The DMC-12 (DMC was DeLorean Motor Company and the 12 referred to the planned list price of $12,000 in the USA, expected to be its biggest market) was powered by an all-alloy 2,849 cc V6 then in use in Peugeot, Renault and Volvo models.

Either five-speed manual or three-speed automatic transmission was available. DeLorean planned a car with about 200 bhp, but the engine he settled upon was good for only about 170 bhp. Worse, emissions regulations in the USA meant that its output had to be reduced to 130 bhp, and this resulted in woeful performance: 0–60 mph took more than 10 seconds and the top speed was only about 110 mph / 177 km/h. The lack of performance was all the more disappointing because the car had a sophisticated suspension system derived from the Lotus Esprit, with double wishbones at the front and a multi-link arrangement at the rear.

But if the performance was unimpressive, the price of the DMC-12 was a real shock. Despite that target price of $12,000, it came to market, three years late, with a price tag of $25,000, or $25,650 for the automatic version. Even so, the early hype was such that many buyers paid premiums of some $10,000 extra just to get their hands on one of the first cars in 1981. Little did they know that by the end of 1982, DeLorean would be bankrupt, the factory would be closed and thousands of unsold cars would be flooding the market at prices well below list.

The British Government had advanced loans of around £85,000,000 to get production started near Belfast, where unemployment was high. But, fearing there had been some financial mismanagement, it put the plant into administration in October 1982. Just one week earlier, federal drug agents had arrested DeLorean in a Los Angeles motel, where he was allegedly negotiating a drugs deal. Though he was eventually acquitted on the grounds of entrapment, the DeLorean car business was at an end.

John DeLorean's legal problems were not over, however. A Michigan Grand Jury started investigating the whereabouts of $17,650,000 that had disappeared from the company and that was assumed to be in Swiss bank accounts. DeLorean was acquitted for lack of proof, but he didn't pay his $150,000 lawyer's fees and never returned to Michigan state.

Only 8,583 cars had been built by the time the plant was closed, which happened too soon for either the car or the company to benefit from the worldwide publicity the DMC-12 derived from being showcased in the *Back To The Future* movies.

**DE LOREAN DMC-12 1981**

**ENGINE:** 2,849 cc V6

**MAXIMUM POWER:** 130 bhp at 5,500 rpm

**MAXIMUM TORQUE:** 208 Nm at 2,750 rpm

**MAXIMUM SPEED:** 110 mph / 177 km/h

**0–60 MPH ACCELERATION:** 10.5 secs

**TRANSMISSION:** 5-speed manual or 3-speed automatic

**LENGTH:** 168 in / 4,267 mm

**WIDTH:** 78¼ in / 1,990 mm

**HEIGHT:** 45 in / 1,140 mm

**WHEELBASE:** 94¾ in / 2,408 mm

**MANUFACTURE DATE:** 1981–82

**BRAKES:** disc (f and r)

**SUSPENSION:** independent coil spring (f), independent trailing arm (r)

**WHEELS:** alloy, 14 in (f), 15 in (r)

**TIRES:** 195/60 HR-14 (f), 235/60 HR-15 (r)

# Ferrari 246 GT Dino

When first launched at the Turin Motor Show in 1968, the 206GT Dino on Ferrari's stand had neither a Ferrari badge nor the famous Prancing Horse logo. It also lacked the 12-cylinder engine for which Ferrari was famous, and instead had a 2.0-liter V6 mounted behind the driver. But it was still very much a Ferrari, and indeed it bears the name of Enzo Ferrari's only legitimate son, who had tragically died from kidney disease at the age of just 24. It was also the model that permitted the company to greatly increase its production by offering a new, smaller and lighter car that would widen the marque's appeal without offending the Ferrari purists, who would never consider any model without a V12 under its bonnet.

In fact, the Dino was one of the company's most significant models of all, as not only did it boost production volumes but it also brought Ferrari closer to the giant Fiat conglomerate, which was eventually to take a majority shareholding in the company. Ferrari wanted to race in Formula 2, but new regulations meant that it had to built at least 500 examples of the 1.6-liter V6 engine in order to comply, so a deal was struck with Fiat under which Ferrari would design a V6 engine and Fiat would manufacture it in large enough volumes to homologate the unit for racing, provide engines for a new small Ferrari model and allow Fiat itself to create its own sports car, the front-engined Fiat Dino.

Although the racecars had the 1.6-liter engine, early production cars used a 2.0-liter engine, and these were fitted to the first run of Dino Ferraris, the 206GT. Only around 150 of these were made before the engine was bored out to 2.4 liters, and the classic 246GT starting rolling off the production line in 1969. It differed from the earlier 206 in that, as well as boasting a larger-capacity engine, it now had a steel body instead of an alloy one, its wheelbase was increased slightly and it had a more luxurious cabin.

The four-cam 2,418 cc V6 with triple Weber carburettors was transversely mounted behind the driver and mated to a five-speed manual transmission. Suspension was by double wishbones, coil springs and telescopic dampers. With 195 bhp at 7,600 rpm, the performance of the Dino was never going to match that of the mighty V12 Ferraris, despite its relatively low 2,800 lb / 1,270 kg weight, but it still managed a very respectable top speed of 146 mph / 235 km/h and acceleration from 0 to 60 mph in 7.0 seconds. More to the point, its well-designed chassis produced wonderful handling and beautifully fluid dynamic finesse, which meant that it could be driven faster than many cars with far more power.

Whatever it may have lacked in terms of outright performance, the Dino more than made up for in its appearance. It was one of the most graceful, delicate and elegant cars that Ferrari ever offered, with near-perfect proportions and a clever 'flying-buttress' design around the rear pillars that solved the

1974 - 246GTS DINO

**FERRARI 246 GT DINO 1968**

**ENGINE:** 2,418 cc V6

**MAXIMUM POWER:** 195 bhp at 7,600 rpm

**MAXIMUM TORQUE:** 225.07 Nm at 5,500 rpm

**MAXIMUM SPEED:** 146 mph / 235 km/h

**0–60 MPH ACCELERATION:** 7.0 secs

**TRANSMISSION:** 5-speed manual

**LENGTH:** 171 in / 4,343 mm

**WIDTH:** 67 in / 1,702 mm

**HEIGHT:** 45¼ in / 1,150 mm

**WHEELBASE:** 92¼ in / 2,340 mm

**MANUFACTURE DATE:** 1968–74

**BRAKES:** disc (f and r)

**SUSPENSION:** unequal wishbone (f and r)

**WHEELS:** alloy, 14 in

**TIRES:** 205/70 VR-14 (f and r)

problem of fitting an engine midships. Pininfarina's design looks stunning from every angle, and this timeless beauty is what makes the 246GT Dino one of Ferrari's most iconic models of all.

Most of the Dinos sold were GTs, though a 246GTS Spyder version was introduced in 1972, which, instead of being a true convertible, had a lift-off targa panel. Of the total production of just under 4,000, some 1,275 were Spyders. Interestingly, the V6 Dino engine continued to be made long after the Dino went out of production in 1974, to be replaced by the 308 GT4 – most importantly in the Lancia Stratos, which dominated World Rallying in the 1970s.

# Ferrari 250 GTO

The iconic Ferrari GTO started life as a development of the 250 GT intended for competition in the World Sportscar Championship. The FIA had declared that the Grand Touring cars that were taking part in competition should be genuinely production cars – in Italian, GTO stands for Gran Turismo Omologato. The 250 GT's aerodynamics prevented it exceeding around 150 mph / 241 km/h, despite the healthy 280 bhp its 3.0-liter V12 was producing. So Ferrari hatched a plan to create a new aerodynamic body and claim it was only a variant of the 250 GT, which would mean the company wouldn't have to build the full 100 GTOs that homologation would normally require.

The styling was entrusted to Giotto Bizzarrini, who would later create his own supercar. He devised a low-nose, high-tail wedge-shape that radically improved airflow over the body without creating excessive lift at high speeds. At the front, the grille was reduced in size and the headlights were faired in, while the rear was shortened and incorporated an integral spoiler. Under the beautiful flowing bodywork was a classic Ferrari chassis, consisting of a hand-welded alloy-tubing frame with double-wishbone and coil-spring front suspension and a live rear axle with semi-elliptical springs, shock absorbers and double Watts linkage. Most Ferrari racing cars had fully independent rear suspension by this time, but Ferrari was forced to stick with this rather agricultural arrangment because of the pretence that the GTO was simply a development of the earlier GT. Disc brakes and Borrani wire wheels completed the package.

At the heart of the GTO was a magnificent aluminium V12 fed by a bank of six twin-barrel Weber carburettors producing 300 bhp at 7,500 rpm and 294 Nm of torque at 5,500 rpm. It was a dry sump design, which meant it could be mounted lower in the car to the benefit of both center of gravity and aerodynamics. Power was fed to the rear wheels via a new five-speed manual transmission. Its performance was sensational: 0–60 mph in 6.1 seconds, 0–100 mph in 13.1 seconds, and, thanks to Bizzarrini's work on the aerodynamics, the top speed was pushed up to 173 mph / 278 km/h.

Because this was primarily a racing car, little attention was paid to either driver comfort or ergonomics in what was, by any standards, an extremely sparse cabin. The driver had to put up with oddly positioned pedals, an over-large steering wheel and an awkward long-throw gearshift. The passenger, meanwhile, had to share space with a frame brace, the battery and the engine-oil tank. Instrumentation was rudimentary – not even a speedometer was fitted, as only a rev counter was considered necessary for racing – and many of the switches were proprietary units lifted off the humble Fiat 500.

But the Ferrari GTO was built for speed, not for comfort. And it certainly made its mark on the racetrack, running away with the 1962 World Sportscar Manufacturers' Championship that year

and again in 1963 and 1964. It also won the GT class at Le Mans in 1962 and came a stunning second overall.

Not only was the 250 GTO highly successful, but it is also generally considered to be one of the most elegant and beautiful cars that Ferrari – or any other manufacturer – has ever produced. It is also part of racing history in that it was the very last successful front-engined racing car that Ferrari ever produced. In total, just 39 examples of the 250 GTO were produced, between 1962 and 1964, at a price of around £6,000. Today's supercars may be quicker, but the 250 GTO remains one of a kind, and because of its rarity, it has become one of the most desirable and valuable cars in the world, with one example changing hands at auction in 2008 for $28,500,000.

**FERRARI 250 GTO 1964**

**ENGINE:** 2,953 cc V12

**MAXIMUM POWER:** 300 bhp at 7,500 rpm

**MAXIMUM TORQUE:** 294 Nm at 5,500 rpm

**MAXIMUM SPEED:** 173 mph / 278 km/h

**0–60 MPH ACCELERATION:** 6.1 secs

**TRANSMISSION:** 5-speed manual

**LENGTH:** 169¼ in / 4,300 mm

**WIDTH:** 69¼ in / 1,760 mm

**HEIGHT:** 45 in / 1,140 mm

**WHEELBASE:** 94½ in / 2,398 mm

**MANUFACTURE DATE:** 1962–64

**BRAKES:** disc (f and r)

**SUSPENSION:** independent double wishbone (f), live axle (r)

**WHEELS:** alloy, 15 in

**TIRES:** 600lx15 (f and r)

# Ferrari 365 GTB/4 Daytona

During the 1960s, Ferrari gained a rival in the supercar stakes. Ferrucio Lamborghini, a wealthy manufacturer of tractors, set up shop at Sant'Agata Bolognese, just a few miles from Ferrari's Modena headquarters, and stunned the automotive world when he revealed his mid-engined Miura in 1966.

Ferrari's response was another traditional front-engined, rear-wheel drive car, but it was one that was destined to become one of the world's all-time classics – the 365GTB/4. The 365 refers to the capacity of each of its 12 cylinders, GTB stands for Grand Turismo Berlinetta, the body is a GT Coupé and the /4 indicates that it had four camshafts in its engine.

Known as the Daytona (because the previous year Ferrari had finished 1-2-3 at Daytona Beach in Florida, America's most prestigious sports car race), it was the most expensive production car Ferrari had ever produced, the most powerful road car of its time, and also the fastest when it was launched in 1968.

Its 4,390 cc V12 engine produced 352 bhp at 7,500 rpm together with 431 Nm of torque at 5,000 rpm. That was enough to provide a top speed of around 175 mph / 282 km/h and acceleration from 0 to 60 mph in just 5.4 seconds and 0–100 mph in 12 seconds. If this wasn't enough, Ferrari offered a handful of its favoured customers a tuning upgrade to some 380 bhp.

But what set the Daytona apart from the rest was not only its powerful speed, but also the way in which it handled. Although steering was heavy at low speeds, it lightened up as speed increased, grip was outstanding for the time, despite the limitations of 1960s tires, and its handling was truly outstanding, thanks in part to the 50/50 weight distribution achieved by mounting the five-speed transaxle at the rear. Disc brakes all round and independent suspension, consisting of unequal-length wishbones and spring/damper units, completed the dynamic package.

On top of all this, the Daytona was, by any standards, one of the most beautiful cars on the road, and it was practical, too. The Daytona was a genuine Grand Tourer, with a relatively spacious and comfortable cabin, with leather bucket seats, optional electric windows and even air conditioning, and a reasonably sized boot.

| FERRARI 365 GTB/4 DAYTONA 1970 | | WIDTH: 69¼ in / 1,760 mm |
|---|---|---|
| ENGINE: 4,390 cc V12 | | HEIGHT: 49 in / 1,245 mm |
| MAXIMUM POWER: 352 bhp at 7,500 rpm | | WHEELBASE: 94½ in / 2,400 mm |
| MAXIMUM TORQUE: 431 Nm at 5,000 rpm | | MANUFACTURE DATE: 1968–74 |
| MAXIMUM SPEED: 175 mph / 282 km/h | | BRAKES: disc (f and r) |
| 0–60 MPH ACCELERATION: 5.4 secs | | SUSPENSION: double wishbone (f and r) |
| TRANSMISSION: 5-speed manual | | WHEELS: alloy, 15 in |
| LENGTH: 174¼ in / 4,425 mm | | TIRES: 215/70 VR-15 (f and r) |

Despite its weight, the Daytona was also reasonably successful on the track. Although Ferrari never officially raced the car, private entrants were encouraged, and, upgraded to 450 bhp, the Daytona managed a creditable fifth place at Le Mans in 1972 and second at Daytona in 1979.

Styling, as so often at Ferrari, was by Pininfarina, though the cars were actually built by Scaglietti. The chassis was constructed from tubular steel, on which a steel body was fixed, though the doors, bonnet and bootlid were constructed from aluminium alloy in order to save weight. The earliest Daytonas had four headlights set behind clear plastic lenses, but these were later changed to retractable pop-up headlights because of US regulations.

The Daytona stayed in production for six years, until 1974, by which time around 1,285 Coupés and 127 softtop Spyders

had been built. The convertible Spyder, launched in 1969, initially generated little interest, but in later years, it became so desirable that a number of Coupés were converted to convertibles by ardent collectors.

After the Daytona went out of production, Ferrari built further front-engined V12 cars, but this was the last front-engined true performance car that Ferrari produced for many years. It was replaced as the flagship of Ferrari's range by the mid-engined Berlinetta Boxer, and a succession of mid-engined Ferrari supercars followed. Yet in the 1990s, the very real packaging benefits of the conventional front-engine, rear-wheel drive layout brought Ferrari's engineers back to the drawing board to produce modern classic such as the 456GT, 550, 575 and 612 Scaglietti.

The Daytona remains as one of its generation's most elegant, luxurious and quick Grand Tourers, which is why values of the few examples that come on the market today are stratospheric.

# Ferrari California

Launched in 2008, the Ferrari California was inspired by the legendary 1957 Ferrari 250 California, a model with which it shares much of its essential DNA. Both cars are elegant convertibles designed first and foremost for high-performance track work, and both represent the very pinnacle of speed, exclusivity, craftsmanship and desirability.

Like every recent Ferrari model, the California was styled by Pininfarina. It offers a host of typical Ferrari design cues – it certainly couldn't be mistaken for any other make – yet at the same time, the body has been honed for optimum aerodynamics. It has low drag for higher top speeds and lower fuel consumption, while still producing enough downforce to ensure absolute stability.

The California's all-aluminium V8 engine is positioned at the front – a first for Ferrari, which has only ever placed a V12 up front before. The 4,300 cc powerplant produces 460 bhp at 7,500 rpm and 485 Nm of torque at 5,000 rpm, though 75 per cent of that torque is available as low as 2,250 rpm, which makes this one of the most tractable, as well as one of the most fuel-efficient, Ferraris of modern times. Stunning performance is available thanks to direct fuel injection and variable valve timing – 0–62 mph takes under four seconds and the top speed is 193 mph / 311 km/h.

Power from the engine is directed to the rear transaxle via a new double-clutch seven-speed gearbox that preselects the next gear to allow virtually instant gear changes. It also allows the driver to choose either manual or fully automatic mode.

The California driver can also opt for other settings, not

**FERRARI CALIFORNIA 2008**

**ENGINE:** 4,300 cc V8

**MAXIMUM POWER:** 460 bhp at 7,500 rpm

**MAXIMUM TORQUE:** 485 Nm at 5,000 rpm

**MAXIMUM SPEED:** 193 mph / 311 km/h

**0–60 MPH ACCELERATION:** 3.9 secs

**TRANSMISSION:** 7-speed semi-automatic

**LENGTH:** 179¾ in / 4,563 mm

**WIDTH:** 75 in / 1,902 mm

**HEIGHT:** 51½ in / 1,308 mm

**WHEELBASE:** 105 in / 2,670 mm

**MANUFACTURE DATE:** 2008–present

Brakes: disc (f and r)

**SUSPENSION:** independent double wishbone (f), independent multi-link (r)

**WHEELS:** alloy, 19 in

**TIRES:** 245/40 ZR-19 (f), 285/40 ZR-19 (r)

impractical, but this one is different. It's certainly available in red, and it's certainly achingly desirable. But it's also usable on an everyday basis, its less demanding to drive fast than most supercars and it's reasonably spacious and practical. It's also easy to get in and out of – something that can't be said for every sports car capable of nearly 200 mph / 322 km/h.

The new California won't be quite as exclusive as the original 250 California, launched some 50 years earlier, of which only 125 were ever made. Production volumes have been set at 2,500 units a year and at launch in 2008, the entire first two years' worth of cars had been pre-ordered. No wonder it's attracted so much interest: the California is a true supercar with fabulous aesthetics that can still be taken to the supermarket to pick up the shopping.

least the 'Manettino', positioned on the steering wheel (just like on a Formula 1 car), which controls the gearbox, stability and traction-control systems and the suspension set-up. Either Comfort or Sport modes can be selected for road use, or, when on a track, the driver can switch off all the electronic aids except ABS braking.

The California's traction-control system, called F1-Trac, is so sophisticated that as well as ensuring maximum grip and stability, it is claimed to produce 20 per cent better acceleration out of corners than can be offered by a traditional system.

But this is not the car's only safety system: it also has an automatic roll bar that rises in milliseconds if the car overturns, as well as front and side airbags. You wouldn't want to crash a California, but if you do, it will mitigate the effects.

Both chassis and bodywork are aluminium to keep weight to a minimum. Also constructed from aluminium is the retractable hardtop that transforms the California from a coupé to a convertible at the touch of a button in just 14 seconds. There is a choice of either rear seats or a bench arrangement, and cleverly, boot space remains generous for a car of this class, whether the top is up or down and with: Ferrari claims it's possible to carry golf clubs or skis.

Any new Ferrari is expected to be sexy, sassy, red and

# Fisker Karma

The environmental movement is growing and it's not going to go away. Whether or not climate change is taking place as a result of man's activities, it clearly makes sense to reduce as far as possible the levels of carbon dioxide and other greenhouse gases that are being produced. And it's also the case that the world's supply of oil is dwindling, which is why governments and motor manufacturers are devoting increasing attention to these issues.

Some manufacturers, including BMW and Mercedes-Benz, are researching the use of fuel cells, and BMW has already launched a hydrogen-powered 7-Series limousine. Others, notably Honda and Toyota, have taken the hybrid route, combining electric motors with conventional engines to reduce fuel consumption. Yet others are striving to make compact, fully electric cars more user friendly with improved performance and range.

Former BMW and Aston Martin designer Henrik Fisker – he was responsible for the BMW Z8 and the Aston Martin B9 and V8 Vantage – is one of those working on hybrid-electric cars. However, his interest is not in a small, lightweight runabout, and in the Fisker Karma, he is offering a car that is sleek, elegant and

supremely comfortable. As he has said: 'There's no rule written anywhere that says a green car has to be ugly or small or uncomfortable'.

The Fisker Karma was first unveiled at the 2009 Detroit Auto Show, where more than 1,000 orders for the 100 mpg / 42.5 km/l plug-in hybrid were taken. It is powered by two 201 bhp electric motors that are in turn powered from a lithium-ion battery pack that is charged by connecting it directly to the household electricity supply. If driven in purely 'Stealth Mode', it has a range of 50 miles / 80 km, during which it produces no emissions whatsoever. According to Fisker, that will be enough for the majority of drivers, for whom the daily commute or a trip to drop children at school and do the shopping rarely exceeds this distance.

However, if greater range or greater performance is needed, then the driver can switch to 'Sport Mode', in which a 260 bhp turbocharger 2.0-liter Ford Ecotec direct injection petrol engine comes into play. It does not drive the wheels directly, but instead runs a generator that powers the two electric motors on the rear differential. Operating in this way, the Karma produces some 400 bhp and gives 0–60 mph acceleration in under six seconds and

| FISKER KARMA 2009 | |
|---|---|
| **ENGINE:** 2 x electric motors plus 1,998 cc in-line 4-cylinder | |
| **MAXIMUM POWER:** 2 x 150KW (400 bhp) | |
| **MAXIMUM TORQUE:** 1300 Nm | |
| **MAXIMUM SPEED:** 125 mph / 201 km/h | |
| **0–60 MPH ACCELERATION:** 5.8 secs | |
| **TRANSMISSION:** not required | |
| **LENGTH:** 196¼ in / 4,987 mm | |
| **WIDTH:** 78 in / 1,984 mm | |
| **HEIGHT:** 52¼ in / 1,330 mm | |
| **WHEELBASE:** 124½ in / 3,160 mm | |
| **MANUFACTURE DATE:** 2009 | |
| **BRAKES:** disc (f and r) | |
| **SUSPENSION:** A-arm (f and r) | |
| **WHEELS:** alloy, 22 in | |
| **TIRES:** 245/35 R22 (f and r) | |

a top speed of around 125 mph / 201 km/h. Total range using the engine and the electric motors is around 300 miles / 483 km. What is perhaps even more extraordinary is that a fully charged Karma can achieve an average fuel consumption of around 100 mpg / 42.5 km/l.

And, thanks to its low center of gravity and sports suspension system, its handling and ride is claimed to offer a world-class driving experience.

Importantly, it does all this without sacrificing either style or comfort. The Karma is the height of a Porsche 911, the length of a Mercedes CLS and the width of a BMW 7-Series. Its low, wide body is aerodynamic in shape to keep drag to a minimum, and it has the world's largest continuously formed glass solar-panel roof. This incorporates photovoltaic cells, which generate enough electrical charge to keep the car cool and avoid having to use an energy-sapping air-conditioning unit.

Different trim levels are offered in the cabin, with conventional leather seating if required. However, there's also an Eco-Chic package, which uses no animal products, replacing leather with bamboo viscose, and uses wood trim from fallen trees and interior trim made from fossilized leaves.

Production of the Fisker Karma, which is priced at $87,900, has been contracted to Finnish company Valmet Automotive, which has also made cars for Saab and Porsche.

# Ford GT40
# Mk I Production

In the early 1960s, Ford decided it should get into GT racing, and in its quest to win the Le Mans 24-Hour race, it entered negotiations to buy Ferrari. At first, Ferrari's owner, Enzo Ferrari, seemed keen, and let the Ford people into his factory to take a complete inventory prior to the sale. But then he changed his mind and showed Ford the door. Henry Ford II, by then chairman of the company that bore his name, was not happy, and vowed to 'kick Ferrari's ass' by beating him at Le Mans.

And so, with the help of race specialists Lola, Ford began development of its own mid-engined Le Mans car, powered by a Ford 4.2-liter V8. It produced 350 bhp and 368 Nm of torque and tests showed it was good for a top speed of 207 mph / 333 km/h, more than enough to make it competitive with the Ferraris of that time. The car was just 40 in / 1,016 mm high, which is how it got its name, GT40.

Ford entered three cars at Le Mans in 1964, but all failed to finish, leaving Ferrari to take the honours. After further development, and with the engine capacity increased to 4.7 liters, the car went into limited production in 1965. Fifty had to be built to qualify for Production Sports Car homologation, and these Mark I GT40s were offered for sale at just £5,900 each! The GT40 was again taken to Le Mans and again failed to win.

As well as better reliability, Ford realized it needed more power, so a 7.0-liter V8 was shoehorned into the car, producing maximum power of 485 bhp and peak torque of 636 Nm. In 1966, it finished first, second and third at the Daytona 24 Hours and the cars then crossed the Atlantic for the Le Mans 24 Hours; here too, the GT40 took first, second and third places. It also became the first car ever to be measured at a speed of over 200 mph / 322 km/h on Le Mans' famous Mulsanne Straight. In 1967, 1968 and 1969, the GT40 again won at Le Mans, making it four in a row – Ford had well and truly 'kicked Ferrari's ass'!

| FORD GT40 MARK I PRODUCTION 1966 | | WIDTH: 70 in / 1,778 mm |
|---|---|---|
| **ENGINE:** 4,736 cc V8 | | **HEIGHT:** 40 in / 1,016 mm |
| **MAXIMUM POWER:** 335 bhp at 6,500 rpm | | **WHEELBASE:** 95 in / 2,413 mm |
| **MAXIMUM TORQUE:** 446 Nm at 3,200 rpm | | **MANUFACTURE DATE:** 1966–1972 |
| **MAXIMUM SPEED:** 164 mph / 264 km/h | | **BRAKES:** disc (f and r) |
| **0–60 MPH ACCELERATION:** 5.2 secs | | **SUSPENSION:** unequal wishbone (f), dual trailing arm (r) |
| **TRANSMISSION:** 5-speed manual | | **WHEELS:** alloy, 15 in |
| **LENGTH:** 158½ in / 4,028 mm | | **TIRES:** 7.00x15 |

The GT40 had a fibreglass body that was fitted on a sheet-steel semi-monocoque chassis. Its suspension arrangement incorporated wishbones with coil springs and an anti-roll bar at the front, and a transverse top link with a lower wishbone, coil springs and anti-roll bar at the rear. Disc brakes were fitted all round and the Ford V8 drove the rear wheels via a five-speed manual ZF transmission.

In total, 107 GT40 cars were produced at Ford Advanced Vehicles in Slough in England between 1966 and 1972, and of these, 31 were road cars. Rarest of all is the Mk III car, intended to be the ultimate road car, only seven of which were built, between 1967 and 1969. The engine was detuned to produce

306 bhp at 6,000 rpm and 440 Nm of torque at 4,200 rpm, though this was still plenty to provide 0–60 mph acceleration in 5.2 seconds, 0–100 mph in 12.2 seconds and a top speed of 160 mph / 257 km/h. Since it was intended for road use, the car was fitted with silencers that actually worked, a great deal more interior trim, and even a modicum of luggage space, achieved by extending the body at the rear to make space for a small locker. The Mk III cars look a little different to the racecars, mainly because the headlamps had to be changed to meet traffic regulations. Unlike the earlier cars, this had a central gearshift, which meant left-hand drive was possible. Sadly, the GT40 became uncompetitive at the top end of motorsport and Ford canned the whole project.

Original GT40s are now among the most collectable cars in the world, worth many hundreds of thousands of pounds. But for those of more limited means, there are more replicas of the GT40 on the roads than originals. Copying the classic has become something of an industry in itself.

# Ford Mustang

The 1960s was the era of youth, free choice and individualism. It was also the time, especially in the USA, of postwar wealth creation after the austerity years of the 1950s, which gave consumers far greater buying power. This had an effect on the auto industry: families were no longer restricted to one car and younger drivers were starting to clamour to own a car of their own. Ford in general, and its genius marketer Lee Iacocca in particular, saw this trend developing earlier than anyone else. Iacocca argued that if Ford could produce a car that looked good and looked as though it had plenty of performance, it would sell, even if, in truth, it was manufactured from low-cost, standard components.

The stylists at the Ford's headquarters in Dearborn, Michigan, came up with a classic sports car look – two doors, choice of convertible or coupé body styles, a long bonnet and short boot – together with a reasonably practical four-seat cabin. Under that exciting-looking exterior were parts taken from Ford's standard cars, including a rigid rear axle, though the car did have independent front suspension. The engine was lifted from Ford's smallest car, the Falcon. It was a 2.8-liter six-cylinder unit producing just 101 bhp, which meant top speed was under 100 mph / 161 km/h.

The Ford Mustang was launched in April 1964 and was an instant success, partly because it looked great, partly because it was cheap – just $2,320 – and partly because it was perhaps the first car in the world to be offered with a huge range of options and accessories that allowed buyers to customize their own cars. One of those options was a 4.2-liter V8 engine mated to either a three-speed auto or four-speed manual gearbox, which produced 164 bhp and gave the Mustang reasonable performance.

On day one, 22,000 orders were taken, and more than 400,000 cars were sold in the first year, despite Ford having predicted maximum sales of 100,000 a year. With such a huge success on its hands, Ford's biggest problem was finding ways of boosting production to meet demand. It also became clear that real performance was a desire of many buyers, so two more V8 engine options were offered, including the legendary 4.7-liter V8, which churned out 200 bhp at the time of its launch and 270 bhp in its most powerful variant. Ford also introduced a third body variant, the Fastback, as a 1965 model. But the most visible signs of the Mustang gaining more power and more real sporting ability were the trademark racing stripes on the sills, dual exhaust pipes and GT badges.

As the 1960s progressed, so the Mustang became larger and heavier and needed ever-more powerful engines to maintain its performance potential. By 1968, a 6,997 cc V8 producing 390 bhp was offered, and the same year, a 7,014 cc Cobra Jet variant was made available for racing enthusiasts. In 1969, yet more engine options were offered, along with a range of special editions, such as the Grand Luxury with its vinyl roof, the Mach I, the Boss 302 and 429 and the Shelby GT350 and GT500.

In the early 1970s, the Mustang grew more portly than ever

| FORD MUSTANG 1964 | | WIDTH: 68¼ in / 1,732 mm |
| --- | --- | --- |
| ENGINE: 4,727 cc V8 | | HEIGHT: 51¼ in / 1,300 mm |
| MAXIMUM POWER: 270 bhp at 6,000 rpm | | WHEELBASE: 108 in / 2,743 mm |
| MAXIMUM TORQUE: 423 Nm at 3,400 rpm | | MANUFACTURE DATE: 1964–73 |
| MAXIMUM SPEED: 128 mph / 206 km/h | | BRAKES: drum (f and r) |
| 0–60 MPH ACCELERATION: 7.3 secs | | SUSPENSION: independent coil spring (f), live axle (r) |
| TRANSMISSION: 4-speed manual | | WHEELS: alloy, 14 in |
| LENGTH: 181½ in / 4,613 mm | | TIRES: 7.00x14 |

– it now weighed 600 lb / 272 kg more than the original. Worse, the fuel crisis resulted in a rapid growth of demand for more fuel-efficient vehicles, and the 'dinosaur' muscle cars fell out of favour. The last of the first-generation Mustangs went out of production in 1973, but not before Ford's first 'pony car' had prompted other manufacturers to respond, with models such as the Chrysler Barracuda and Chevrolet Camaro. The Mustang is still in production today, though it's a very different car to the original. The truly great Mustangs were the light and compact early cars, which still have a true magic about them.

# Ford Thunderbird

Is it possible that Ford could have sold more than three million examples of a car named the Whizzer? It seems unlikely, and yet that was one of the front runners as Ford marketing executives pondered a name for their new two-seater before they eventually plumped for Thunderbird. There were two catalysts in Ford's decision to design this supercar. Firstly, thousands of American servicemen had spent time in Europe during World War II, where they had seen the small, nimble and elegant sports cars that were available there from manufacturers such as MG, Jaguar and Mercedes-Benz. Secondly, Ford's arch-rival GM had just launched the Corvette.

Ford needed to respond, and it did so with a concept at the Detroit Auto Show in January 1954 that was put into production later that same year. The original Thunderbird was not a straight copy of the Corvette, and in fact Ford was at pains to differentiate their model. It was not a sports car as such, but what they described as a 'personal luxury car', an elegantly styled, well-appointed and powerful convertible with a speedometer that read speeds up to a dizzying 150 mph / 241 km/h. It was both a

very clever design – it raided the parts bins of many other Ford models so production and development costs were kept to a minimum – and a very simple one, with sheet-metal body panels and a large V8 driving the rear wheels through either a manual or automatic transmission.

The Thunderbird sold solidly, though it quickly became clear that the lack of rear seats was adversely affecting sales. The second-generation Thunderbird – usually called the 'Squarebird' because of its strongly angular design – rectified this problem. This later car also developed the simple chassis and body-on-frame construction of the original to a more modern monocoque design, and for the first time, both hardtop and convertible options were available. Interestingly, the hardtop was much more popular: of a total of around 38,000 Thunderbirds sold per year, only some 2,000 were soft tops.

In 1961, the Thunderbird underwent a total restyle, becoming longer, wider and lower. This sleeker, more aerodynamic design resembled a bullet, and thus these third-generation Thunderbirds, which were produced until 1964,

were commonly known as 'Bullet Birds' or 'Projectile Birds'. Reflecting the general interest of the time in flying and jet planes, impressive fins and taillights were adopted at the back. The sleek modern design was extended to the interior too, where the ends of the wraparound fascia curved into the door panels. Another new feature on the 1961 Thunderbird was a steering wheel that could be swung away to make getting in and out of the car a little easier.

If the design changed, however, the basic structure did not. The Bullet Bird retained the monocoque structure of the Squarebird, though the suspension was revised to give a more comfortable and compliant ride. Power came from a 300 bhp 6,391 cc V8, which provided some true sporting flavour, especially in the rare Sports Roadster, whose power was increased to 340 bhp with the adoption of a Holley two-barrel carburettor. Even so, the Thunderbird, which tipped the scales at close to two tonnes, could never be described as outstandingly quick. It took a leisurely 10.5 seconds to reach 60 mph from a

**FORD THUNDERBIRD 1963**

**ENGINE:** 5,768 cc 352 cu.in

**MAXIMUM POWER:** 300 bhp at 4,400 rpm

**MAXIMUM TORQUE:** 535 Nm at 2,800rpm

**MAXIMUM SPEED:** 120 mph / 193 km/h

**0–60 MPH ACCELERATION:** 10.5 secs

**TRANSMISSION:** 3-speed automatic

**LENGTH:** 205.3 in / 5,164 cm

**WIDTH:** 77 in / 1,956 cm

**HEIGHT:** 52.5 in / 1,333 cm

**WHEELBASE:** 119 in. / 3,022 cm

**MANUFACTURE DATE:** 1954–64

**BRAKES:** drum (f and r)

**SUSPENSION:** independent coil spring (f), live axle (r)

**WHEELS:** alloy, 14 in

**TIRES:** 8.00x14

standstill, and its owners could only ever dream of attaining the
150 mph / 241 km/h the speedometer promised.

When the Bullet Birds went out of production in 1964, they
were followed by the sharper, more angular 'Jet Birds'. Next came
the 'Big Birds' of 1972–76, the 'Torino Birds' of 1977–79 and the
thoroughly mediocre 'Fairmont Birds' of 1980–82. Not until the
1983–86 'Aero Birds' did Ford recapture a hint of the true
sporting nature of the 1963 Thunderbird. However, although
the Aero Birds remain highly sought after today, the true classic,
iconic Thunderbird remains the 1961–63 Bullet Bird.

# Infiniti FX50

Infiniti is to Nissan as Lexus is to Toyota and Acura is to Honda. All three Japanese manufacturers realized many years ago that if they were to achieve their ambition of moving upmarket into the premium sector, it would have to be with a separate brand, sold from separate, smarter showrooms. The Infiniti brand was introduced into the US market in 1989, and the following year, it launched the Q45 saloon, a powerful, elegant car with active suspension and a truly luxurious cabin. Later, it launched the QX4, a premium luxury SUV, and in 2003, the G35, a sports coupé based on the Nissan Skyline, which became an instant hit thanks to its outstanding performance and fine handling.

Then in 2003, came the FX, one of the first examples of the 'cross-over' vehicle, in which the lower part of the vehicle is a chunky SUV while the upper part is sleeker and smarter – a body more likely to be found on a sports car. The car thus provides both the high performance of a GV and the functionality of an SUV. At launch, two versions were offered: the FX35, fitted with a 280 bhp 3.5-liter V6, and the FX45, which has a 320 bhp V8 under its bonnet. In keeping with the Infiniti image, both models were very highly specified. After a facelift in 2006, a totally redesigned model was introduced at the Geneva Motor Show in 2008 to coincide with the Infiniti brand's launch in Europe. Although their proportions are very similar to those of the earlier FX, the new FX35 and FX50 have what some commentators

have described as 'challenging' styling. Others have dismissed the cars as just plain ugly.

However, there's no doubting the dynamic abilities of the FX50, in particular. Its 5,026 cc V8 produces 390 bhp at 6,500 rpm and 500 Nm of torque at 4,400 rpm. That's enough to provide 0–62 mph acceleration in 5.8 seconds and a top speed of 155 mph / 249 km/h. Power is transmitted mainly to the rear wheels via a seven-speed automatic transmission operated by paddles on the steering wheel, though when extra traction is required, the electronically controlled all-wheel-drive system comes into play. The smaller engined FX35, incidentally, can be specified either as a two-wheel-drive or an all-wheel-drive vehicle. Suspension is by double wishbones and electronically controlled dampers at the front, and multi-link with the same electronically adjustable dampers at the rear. Four piston discs at the front and two piston discs at the rear ensure adequate stopping power.

The basic dynamic set-up of the FX50 is backed up by a whole army of electronic aids, including Lane Departure Prevention, which uses the brakes to ensure the vehicle does not drift out of its lane; Intelligent Cruise Control with Distance Control Assist, which uses a forward radar to ensure a constant distance is kept from the car in front; and Intelligent Brake Assist, which can bring the FX50 to a complete stop and then resume the selected speed. It raises the theoretical possibility of the car being driven for miles on a highway without the driver ever having to touch the brake, accelerator or even the steering wheel. The awesome specification continues in the cabin, which is equipped with a hard-drive navigation system with more than 9GB of digital music storage, tire-pressure monitoring, diamond quilted leather front seats that can be heated and cooled, and even an ionizing air-purification system.

The FX50 is, in many ways, a quite remarkable vehicle, offering performance and luxury in equal measures. And there's no doubt that the best place to view the FX50 is from inside the cabin, as only from there is the unfortunate exterior styling invisible.

| INFINITI FX50 2008 | |
| --- | --- |
| **ENGINE:** | 5,026 cc V8 |
| **MAXIMUM POWER:** | 390 bhp at 6,500 rpm |
| **MAXIMUM TORQUE:** | 500 Nm at 4,400 rpm |
| **MAXIMUM SPEED:** | 155 mph / 249 km/h |
| **0–62 MPH ACCELERATION:** | 5.8 secs |
| **TRANSMISSION:** | 7-speed automatic |
| **LENGTH:** | 189 in / 4,803 mm |
| **WIDTH:** | 75¾ in / 1,925 mm |
| **HEIGHT:** | 65 in / 1,651 mm |
| **WHEELBASE:** | 112¼ in / 2,850 mm |
| **MANUFACTURE DATE:** | 2008–present |
| **BRAKES:** | disc (f and r) |
| **SUSPENSION:** | independent strut (f), independent multi-link (r) |
| **WHEELS:** | alloy, 20 in |
| **TIRES:** | 265/50 R-20 (f and r) |

# Jaguar D-Type

The Jaguar D-Type was conceived with just one aim in mind: to win at Le Mans. The earlier C-Type had won in 1951 and 1953 and the D-Type's job was to go out and do it again.

The D-Type was a radically different car from its predecessor. Although it used the same six-cylinder XK engine, the D-Type had a monocoque chassis welded to a subframe. This was a radical departure, as it was the first time that aircraft engineering techniques had been applied to a racing car. The same techniques were also employed in the design of the bodywork. The highly aerodynamic shape was created by Malcolm Sayer, who had a background in aircraft engineering and who also designed the earlier C-Type and later E-Type.

To increase stability on the long Mulsanne straight at Le Mans, where the highest speeds were routinely reached, Sayer specified a large vertical fin behind the driver, and it is this feature that made the D-Type instantly recognizable.

The engine was developed from Jaguar's 3,442 cc straight-six design, but was fitted with a dry-sump lubrication system that both lowered the height of the engine (allowing for a more aerodynamic profile) and also reduced the risk of oil surge under severe cornering. The engine produced 250 bhp at 6,000 rpm and 325 Nm of torque at 4,000 rpm, which gave the car acceleration from 0 to 60 mph in around seven seconds and a top speed of 170 mph / 274 km/h. The close-ratio four-speed manual gearbox and Salisbury rear axle were lifted directly from the production XK, though the ratios were changed for ultimate performance rather than long-legged cruising.

First time out, at the 1954 Le Mans 24-Hour race, the D-Type came a creditable second, just one lap behind a victorious Ferrari. The following year, a longer nose was fitted to improve aerodynamics still further and permit a faster top speed. The D-Type of Mike Hawthorn and Ivor Bueb took the chequered flag, though the victory was overshadowed by one of motor racing's worst accidents, when the Mercedes-Benz SLR of Pierre Levegh crashed into the crowd, killing 80 people. The D-Type won Le

Mans again in 1956, thanks to the efforts of the privately entered Ecurie Ecosse team. Jaguar withdrew from racing at the end of 1956 and it was once again left to Ecurie Ecosse to take first and second place in 1957.

In all, 68 Jaguar D-Types were built, but after the company's withdrawal from motor racing, 25 were left over. These were converted to road-going cars, known as the Jaguar XKSS. Bumpers and faired-in headlights were added to make the car road legal, the rear fin was removed, and a passenger-side door was installed. The cockpit remained fully exposed to the elements, alhough a rather rudimentary canvas hood was added to the specification, along with leather seats and a full range of instrumentation.

The mechanical specification of the XKSS was virtually identical to that of the racing D-Type and the car offered scintillating performance – 0–60 mph acceleration in 5.2 seconds and a top speed of 144 mph / 232 km/h with a standard 3.54:1 ratio axle. Customers could, however, opt for a higher ratio axle that gave a top speed of nearly 160 mph / 257 km/h.

Sadly, however, only 16 XKSS cars were completed before a massive factory fire at Jaguar's Browns Lane plant in Coventry, England, halted all production for six weeks. After that, it seemed much more important to increase production of the 3.4 Jaguar saloon, and the XKSS was consigned to history.

The XKSS went on sale at the 1957 New York Auto Show and one of the earliest customers was film star Steve McQueen. Of the 16 XKSS cars built, 12 were sold in the USA, two in Canada and one each in the UK and Hong Kong.

**JAGUAR D-TYPE 1954**

**ENGINE:** 3,442 cc inline 6-cylinder

**MAXIMUM POWER:** 250 bhp at 6,000 rpm

**MAXIMUM TORQUE:** 325 Nm at 4,000 rpm

**MAXIMUM SPEED:** 170 mph / 274 km/h

**0–60 MPH ACCELERATION:** 7.0 secs

**TRANSMISSION:** 4-speed manual

**LENGTH:** 154 in / 3,912 mm

**WIDTH:** 65½ in / 1,664 mm

**HEIGHT:** 54 in / 1,372 mm

**WHEELBASE:** 90½ in / 2,300 mm

**MANUFACTURE DATE:** 1954–56

**BRAKES:** disc (f and r)

**SUSPENSION:** double wishbone (f), solid axle (r)

**WHEELS:** steel, 16 in

**TIRES:** 6.5x16

# Jaguar E-Type

When the Jaguar E-Type was first revealed at the Geneva Motor Show in 1961, it wasn't its sleek and elegant proportions that caused the most wonder, nor was it the claimed 150 mph / 241 km/h top speed; it was the fact that its list price was just £1,500. That was still a lot of money at a time when small runabouts could be had for a few hundred pounds, but it was far less than a Ferrari or Mercedes sports car cost back then.

The E-Type's construction was relatively simple, with a cockpit comprised of welded-steel pressings with independent coil-spring rear suspension carried on a sub-frame beneath. At the front, square-section steel tubing supported the engine, and torsion-bar front suspension and a smaller tubular-steel subframe supported the radiator and the forward-hinged bonnet.

Under that massively long bonnet was Jaguar's 3,781 cc straight-six engine producing 265 bhp at 5,500 rpm and 352 Nm of torque at 4,000 rpm. Drive was directed to the rear wheels via a four-speed manual gearbox.

**JAGUAR E-TYPE 1970**

**ENGINE:** 4,235 in-line six cylinder

**MAXIMUM POWER:** 265 bhp at 5,400 rpm

**MAXIMUM TORQUE:** 380 Nm at 4,000 rpm

**MAXIMUM SPEED:** 150 mph / 241 km/h (claimed)

**0-60 MPH ACCELERATION:** 7.1 secs

**TRANSMISSION:** 4-speed manual

**LENGTH:** 175¼ in / 4,450 mm

**WIDTH:** 65¼ in / 1,650 mm

**HEIGHT:** 48 in / 1,220 mm

**WHEELBASE:** 96 in / 2,440 mm

**MANUFACTURE DATE:** 1961–75

**BRAKES:** disc (f and r)

**SUSPENSION:** independent wishbone (f), independent lower wishbone (r)

**WHEELS:** alloy, 15 in

**TIRES:** ER70 VR-15

and rounded shape that aided airflow over the body. It also had the same low build and long bonnet that emphasized a racing heritage. No surprise then, that the E-Type, too, soon found itself out on the track, in the form of a lightweight racer, developed in 1963 to compete with the likes of the Ferrari 250GT and Aston Martin DB4GT. But it was on the road that the E-Type made the biggest impression: its combination of massive performance potential and head-turning good looks made it the sports car that every enthusiastic driver ached to own.

Over the years, the E-Type was continually improved. In 1964, just three years after the launch of the Series I cars – recognizable by their glass-covered headlights and smaller air intake at the front – it gained a larger 4.2-liter engine and a decent gearbox. This car version of the E-Type became known as the Series 1½. The 1966 Series II cars included a larger cabin option, with two small rear seats in the form of the 2+2. Finally, the Series III cars had a 5,343 cc V12 engine shoehorned under the bonnet in 1971.

By the time the E-Type finally went out of production in 1975, 70,000 had been sold. Not surprisingly, given that even archrival Enzo Ferrari, when he first saw the E-Type, described it as 'the most beautiful car ever made'.

At the time, Jaguar claimed that the top speed of the fixed head coupé (FHC) was 150 mph / 241 km/h, that of the slightly less aerodynamic roadster was 149 mph / 240 km/h, and both versions of the E-type could reach 60 mph in seven seconds. It seems that Jaguar was guilty of gilding the lily somewhat: when specialist motoring magazines got their hands on cars for testing, the magic 150 mph / 241 km/h was never attainable. But that didn't mean the E-Type was not incredibly quick for its time and nor did it stop those early testers from raving about this wonderful new and graceful Jaguar.

In particular, its ride and handling set new standards that would not be surpassed for years. The E-Type was not perfect – its inboard disc brakes suffered from overheating and its clunky Moss gearbox was hardly state of the art – yet it very quickly established itself as the quintessential sports car and a vibrant symbol of the Swinging Sixties.

It was called E-Type to link the car to Jaguar's Le Mans winning C-Type and D-Type racers. All three cars had bodies designed by Malcolm Sayer, whose background was in the aircraft industry. His smooth and efficient designs gave these Jaguars an aerodynamic advantage over their rivals that to a large degree accounted for their success on the racetrack.

Like its predecessors, the E-type was given a smooth

# Jaguar XFR

For decades, Jaguar has been building upmarket saloons and sports cars. Its reputation as a sportscar manufacturer really started in 1948, when the XK120 appeared. It was dazzlingly beautiful and offered performance that was as good as that of any of its competitors. It started a heritage that ran through various other XK derivatives, the C-, D- and E-Type Jaguars, and, more recently, to the XKR high-performance two-seater roadster and coupé. But Jaguar has a heritage of building fast, comfortable saloons too, so much so that the company's motto for a while was 'Grace, Pace and Space' – the three key ingredients that made a Jaguar car unique.

When it was launched in 2008, the Jaguar XF was radically different in design terms from its predecessor, the S-Type, but there was no doubt that it encapsulated each of those virtues. Its bold modern design was certainly graceful; 0–62 mph in 5.7 seconds and a top speed of 155 mph / 249 km/h most definitely gave it pace; and although it was designed to look like a coupé, the XF's four-door body provided plenty of space for four passengers and their luggage.

The flagship derivative of the XF range takes the Jaguar experience to all-new levels, retaining the grace and the space but shifting the emphasis towards the sort of pace normally associated with supercars.

At the very core of the Jaguar XFR is a new 5.0-liter direct-injection supercharged V8 that produces 510 bhp at 6,000 rpm and 625 Nm of torque at 2,500 rpm. Driving the rear wheels via a six-speed automatic transmission, the XFR accelerates from 0 to 62 mph in 4.9 seconds and on to an electronically limited top speed of 155 mph / 249 km/h. Perhaps more relevantly on today's congested roads, the car accelerates from 50 to 70 mph in just 1.9 seconds, which gives it XFR Ferrari or Lamborghini standards of overtaking.

It's an engine that not only provides outstanding performance but also manages to be more fuel efficient and produces fewer emissions than the 4.2-liter V8 found in other XF models, conforming both to the European EU5 and the American ULEV2 emissions regulations. It achieves this partly thanks to a high-efficiency twin-vortex supercharger and partly to a world first – central spray-guided direct injection, delivering fuel at a pressure of 150 bar directly into the cylinders to maximize air-fuel mixing, improve combustion control and thereby increase both efficiency and torque.

On paper, the performance looks outstanding; on the road, it's even better. That's because instead of wasting all that horsepower on spinning the wheels, the XFR is fitted with Active Differential Control and Adaptive Dynamics – new technologies that involve the electronically controlled differential and the suspension system working in tandem to optimize traction in both acceleration and cornering. The differential automatically varies the torque directed to each of the rear wheels depending on the surface condition and the amount of power applied, and so it differs fundamentally from a conventional traction-control system, which relies on the brakes to counteract wheelspin after it has occurred. The Adaptive Dynamics suspension is also a major development, automatically adjusting the damper settings to suit the road conditions and the way in which the car is being driven. So instead of a choice between 'Comfort' and 'Sport' modes, as in many other systems, it offers a fully progressive variable damping strategy to provide comfort and pin-sharp handling in all conditions.

Visually, the XFR is distinguishable by its unique bonnet louvres and grille, its four exhausts, boot spoiler and its special 20-inch alloy wheels. In fact, it has all that's needed – performance, luxury, style and desirability – to justify its position as the definitive Jaguar sports saloon.

**JAGUAR XFR 2009**

**ENGINE:** 5,000 cc V8

**MAXIMUM POWER:** 510 bhp at 6,000 rpm

**MAXIMUM TORQUE:** 625 Nm at 2,500 rpm

**MAXIMUM SPEED:** 155 mph / 249 km/h

**0–62 MPH ACCELERATION:** 4.9 secs

**TRANSMISSION:** 6-speed automatic

**LENGTH:** 195¼ in / 4,961 mm

**WIDTH:** 74 in / 1,877 mm

**HEIGHT:** 57½ in / 1,460 mm

**WHEELBASE:** 114½ in / 2,909 mm

**MANUFACTURE DATE:** 2009–present

**BRAKES:** disc (f and r)

**SUSPENSION:** double wishbone (f and r)

**WHEELS:** alloy, 20 in

**TIRES:** 245/35 R20 (f and r)

# Lamborghini Miura P400

There's no doubt which was the most important model to grace the 1966 Geneva Motor Show: the Lamborghini Miura was a sleek mid-engined design with ultra-modern bodywork, designed by Bertone, that covered a technically extremely advanced chassis, engine and transmission.

Ferrucio Lamborghini manufactured agricultural machinery and had bought a number of Ferraris as his personal cars. But he was dissatisfied with the quality of the cars, and even more dissatisfied with the way he felt he was treated at the Ferrari factory. His response was to finance, build and market his own supercar in Ferrari's backyard. Appropriately, Lamborghini, who was also a lover of fine livestock, chose a raging bull as the logo for the supercar company he founded, and named his first car, the Miura, after one of the finest breeds of fighting bull.

Lamborghini recruited some of the best people in the business to create the Miura, including Giotto Bizzarini to build the engine, Gianpaolo Dallara to hone the chassis and Bertone to design the bodywork. Marcello Gandini, who was then employed at Bertone, is usually credited with the styling, but Giorgetto Giugiaro, who had earlier worked at Bertone, claimed

that 70 per cent of the design work was his. The team created a cutting-edge new car that took the motor industry by storm.

Not only was it one of the most rakishly beautiful supercars of its time, but it had the performance to match. In addition, it was one of the very first successful mid-engined designs, thanks to Bizzarini's ingenious work. He managed to fit the V12 transversely within the Miura's monocoque and take the drive to the rear wheels via a five-speed transaxle fitted within the crankcase – the same solution that Alec Issigonis had come up with for the original Mini.

One interesting aspect of the Miura's design was that the fuel tank was positioned at the front of the car, which meant that as fuel was burnt, the front became lighter, which resulted in difficult handling at very high speeds.

The original plan was to build a limited run of just 50 cars, but the Miura was so successful that 762 cars were delivered in all. The earliest Miura models were known as P400 and boasted 350 bhp; the P400S, which appeared in 1968, offered a little more power, together with more creature comforts in the cabin, including electric windows.

Finally, in 1971, the P400SV was launched, the best – and

the most sought-after – Miura. The SV had revised cam timing and different carburettors that boosted power to 385 bhp at 7,000 rpm, more than enough to provide a top speed of 170 mph / 274 km/h and acceleration from 0 to 60 mph in 6.2 seconds. It had wider tires, revised suspension geometry and its chassis was built from heavier gauge steel, which helped improve the handling. The SV (which stands for Spinto Veloce or pushed fast) also had a limited slip differential fitted to further improve both handling and outright grip.

The Miura became an icon of the 1960s. There was one in the opening sequences of the *The Italian Job* (1969). A Miura roadster prototype was revealed at the 1968 Brussels Motor Show but it never went into production as Lamborghini decided, probably wisely, to avoid the distraction of producing another model and concentrate instead on delivering cars to customers.

However, the next model was already in the wings: at the 1971 Geneva Motor Show, Lamborghini not only launched the Miura SV, but also presented another prototype, the LP500 Countach.

**LAMBORGHINI MIURA P400 1971**

**ENGINE:** 3,929 cc V12

**MAXIMUM POWER:** 350 bhp at 7,000 rpm

**MAXIMUM TORQUE:** 400 Nm at 5,750 rpm

**MAXIMUM SPEED:** 170 mph / 274 km/h

**0–60 MPH ACCELERATION:** 6.2 secs

**TRANSMISSION:** 5-speed manual

**LENGTH:** 172¾ in / 4,390 mm

**WIDTH:** 70 in / 1,780 mm

**HEIGHT:** 43¼ in / 1,100 mm

**WHEELBASE:** 98½ in / 2,504 mm

**MANUFACTURE DATE:** 1966–72

**BRAKES:** disc (f and r)

**SUSPENSION:** independent double wishbone (f and r)

**WHEELS:** alloy, 15 in

**TIRES:** 205/70 VR-15 (f and r)

# Maserati
# GranTurismo S

Maserati was bought by Fiat in 1993 after years of decline at the once-great Italian carmaker. Investment in a new model to re-establish Maserati's reputation was the first priority for the new owners, and with Fiat's help, the Maserati 3200GT duly appeared in 1999. It was an elegant coupé, styled by Giugiaro's ItalDesign and powered by a 3.2-liter turbocharged V8. It looked good, it performed well and it put Maserati back on the road to full recovery. During 1999, control of Maserati was passed to Ferrari (which was also owned by Fiat), with the idea that Maserati would become Ferrari's luxury-car division, while Ferrari itself continued to concentrate on supercars. With Ferrari's input, the Maserati Coupé and the convertible Maserati Spyder superseded the 3200GT in 2004.

Three years later, these models, in turn, were superseded by the Maserati GranTurismo. Maserati chose the same designer, Pininfarina, that it had used for its Quattroporte, and the GranTurismo shares its platform, suspension and engine with this earlier model. The GranTurismo's stylist, Jason Castriota, created a classic Maserati, with an eggshell grille that harks back to earlier models set into an aggressive but flowing 'coke-bottle' body shape that does more than hint at the car's performance potential. It's one of the most beautiful cars on the road today, effortlessly attracting attention wherever it goes.

Its 4,244 cc V8 produced 400 bhp at 7,100 rpm and 460 Nm of torque at 4,750 rpm and provided effortless performance: 0–62 mph in 5.2 seconds and a top speed of 177 mph / 285 km/h. That was more than enough to provide serious competition for the likes of the Aston Martin V8 Vantage or even the Porsche 911. Because Maserati viewed the GranTurismo as a grand tourer – hence its name – it was available only with automatic transmission, though it could be manually controlled via steering-wheel paddleshifters.

Then in 2008, Maserati introduced the GranTurismo S, fitted with a bigger and more powerful engine, uprated 'Skyhook' suspension, Brembo brakes and a sequential robotized manual transmission capable of changing gear in 100 milliseconds. Power from the V8, now bored out to 4,691 cc, was increased to 440 bhp at 7,000 rpm and maximum torque to 490 Nm at 4,750 rpm, which resulted in the 0–62 mph time coming down to 4.9 seconds and the top speed going up to 183 mph / 295 km/h. It shares the same engine, incidentally, with the Alfa Romeo 8C Competizione, though it has been tuned slightly differently here to suit the Maserati's greater weight and grand tourer character.

On the road, the GranTurismo S is one of the best-handling Maseratis of recent times. With the transmission incorporated in the rear transaxle, weight is 47:53 front to rear for good traction and reasonable balance, and thanks to the innovative Skyhook system's Sport mode, the dampers in the adaptive suspension system are sharpened up, the throttle response is quickened and the upshift points in the six-speed auto gearbox are raised when the car is being driven vigorously. Inside, the cabin is luxuriously tailored with fine Poltrona Frau leather upholstery and refined wood trims. It's a sophisticated, elegant and mature sort of environment with touches of Italian flair.

Soon after, a fully automatic GranTurismo S was launched, and in many ways, this became the perfect grand tourer. In place of the rear transaxle, the gearbox is fitted to the rear of the engine, and this improves the balance of the car to a near-perfect 49:51 front to rear. It can still be brutally fast when speed is required, but when driven more sedately, it provides the most comfortable and elegant means possible to transport four people and their luggage.

**MASERATI GRANTURISMO S 2008**

**ENGINE:** 4,691 cc V8

**MAXIMUM POWER:** 440 bhp at 7,000 rpm

**MAXIMUM TORQUE:** 490 Nm at 4,750 rpm

**MAXIMUM SPEED:** 183 mph / 295 km/h

**0–62 MPH ACCELERATION:** 4.9 secs

**TRANSMISSION:** 6-speed automatic

**LENGTH:** 192¼ in / 4,881 mm

**WIDTH:** 75½ in / 1,915 mm

**HEIGHT:** 53¼ in / 1,353 mm

**WHEELBASE:** 116 in / 2,942 mm

**MANUFACTURE DATE:** 2008–present

**BRAKES:** disc (f an r)

**SUSPENSION:** double wishbone (f and r)

**WHEELS:** alloy, 20 in

**TIRES:** 245/35 R-20 (f), 285/35 R-20 (r)

# Mercedes-Benz 300 SL

When the aluminium-bodied Mercedes-Benz 300 SL was first revealed at the International Motor Sports Show in New York in February 1954, it was immediately clear that this was something truly special. Not only did it have eye-catching gullwing doors, but it was also claimed to be the fastest production car in the world, with a top speed of 165 mph / 266 km/h.

The 300 SL was originally conceived as a racing car, and it certainly proved its worth in 1952, winning at Le Mans, the Nürburgring and the Carrera Panamericana in Mexico. There were no plans to put it into production until Maxi Hoffman, the US importer of Mercedes cars, begged for a sports car to offer his wealthy customers. The 300 SL and the smaller 190 SL were duly signed off for limited production, though Mercedes-Benz never expected to sell very many, pricing the 300 SL at 29,000 Marks at a time when a standard Mercedes 170 saloon cost 7,900 Marks.

It wasn't just the gullwing doors that set the 300 SL apart. Its highly aerodynamic bodywork is beautifully proportioned and supremely elegant – and it's to the credit of its designers that it still looks fresh even today, more than half a century later. The aluminium body panels are fitted to a tubular frame, and it's that frame that dictated the choice of gullwing doors – because the frame extends so far up the side of the car, it would have been impossible to fit conventional doors.

The engine of the 300 SL was a six-cylinder 2,995 cc unit that was tilted to one side to fit it under the bonnet. This reduced space in the passenger's footwell, but helped keep the center of gravity as low as possible, as well as right in the center of the car. One of the 300 SL's innovations was the adoption of fuel injection, which raised the power output to 215 bhp, enough to provide a top speed of 146 mph / 235 km/h and 0–60 mph acceleration in 8.8 seconds with the standard set of gear ratios.

Other ratios were offered, which either improved the acceleration or boosted the top speed to a maximum of 165 mph / 266 km/h.

With its 215 bhp on tap and a total weight of 2,855 lb / 1,295 kg, the 300 SL was extremely rapid for its time, though customers wanting yet more performance could opt for a model constructed entirely from light-alloy aluminium, which reduced the total weight by 176 lb / 80 kg. Only 29 SL customers opted for this model, which is why these all-aluminium cars are so highly sought-after today.

Inside the 300 SL's cockpit, fabric seat material was standard, though most customers upgraded to a leather option. Getting in and out over the high sills was not easy, though facilitated thanks to a folding steering wheel. What all 300 SL models benefitted from was secure handling, impressive roadholding, accurate and precise steering, and performance that put most of its contemporaries in the shade. Its dynamic abilities alone were enough to ensure the 300 SL's place in history. But the addition of those gullwing doors established its destiny as one of the all-time classics. It was even voted 'Sports Car of the Century' in a poll held at the end of the 20th century.

Incredibly, only 1,400 of these 300 SL Coupés were built between 1954 and 1957. Of these, 1,100 were sold in the USA, which indicated that Hoffman knew his market well. He also quickly recognized, however, that demand was growing for a slightly larger, more comfortable and convertible sports car. He conveyed this message to Mercedes-Benz management, which first listened, then responded, with the more practical, open-topped 300 SL Roadster that first appeared in 1957.

**MERCEDES-BENZ 300 SL 1954**

**ENGINE:** 2,995 cc inline 6-cylinder

**MAXIMUM POWER:** 215 bhp at 5,800 rpm

**MAXIMUM TORQUE:** 275 Nm at 4,600 rpm

**MAXIMUM SPEED:** 146 mph / 235 km/h

**0–60 MPH ACCELERATION:** 8.8 secs

**TRANSMISSION:** 4-speed manual

**LENGTH:** 178 in / 4,520 mm

**WIDTH:** 70 in / 1,778 mm

**HEIGHT:** 51¼ in / 1,302 mm

**WHEELBASE:** 94½ in / 2,400 mm

**MANUFACTURE DATE:** 1954–57

**BRAKES:** drum (f and r)

**SUSPENSION:** independent coil spring (f and r)

**WHEELS:** steel, 15 in

**TIRES:** 6.70x15

# Plymouth Superbird

To race in the NASCAR series in 1970, it wasn't enough for a manufacturer to build a certain number of standard road cars for homologation purposes – they also had to sell road cars that looked the same, aerodynamic add-ons and all. And that is how the Plymouth Superbird came to be one of the most outlandish, extravagent muscle cars of them all.

It had a long, bullet-shaped nose cone fitted at the front, a lengthened bonnet, a modified flush-fitting rear window and a massive rear aerofoil. In truth, the rear wing had virtually no aerodynamic effect at under 90 mph / 145 km/h and the reason it was set so high was mundane – it allowed the rear boot to be opened. Though the angle was fixed on road cars, in NASCAR racing, its angle was carefully adjusted to suit the characteristics of each different track.

All the 1,935 Plymouth Superbirds that were sold to the public also sported a vinyl roof, necessary to conceal the welding marks incurred during installation of that modified rear window. And if that wasn't enough to grab attention, the Superbird also came as standard with huge 'Plymouth' decals on the rear wings.

The standard Superbird engine was GM's 7,210 cc, fitted with a four-barrel carburettor and mated to a three-speed TorqueFlite automatic gearbox. It produced 375 bhp at 4,600 rpm and a healthy 650 Nm of torque at 3,200 rpm. An uprated 390 bhp version of the same engine with three dual-barrel carbs could be opted for and a four-speed manual transmission was also an option. Finally, owners looking for the optimum in performance

could opt for the 6,981 cc Hemi engine, with its dual four-barrel carbs that churned out 425 bhp at 5,000 rpm and a tire-smoking 664 Nm of torque at 4,000 rpm. The Hemi may have been the ultimate Superbird, but performance was outstanding whatever engine was fitted. Even the base Superbird was good for 0–60 mph acceleration in under six seconds, while the Hemi-engined versions shaved that time to 4.8 seconds. Top speed was between 130 and 160 mph / 209 and 257 km/h depending on the model.

The Plymouth Superbird was closely related to the Dodge Charger Daytona and it shared its torsion bar and heavy-duty hydraulic shock absorbers, front suspension and rear leaf semi-elliptical springs and heavy-duty shocks. It wasn't a sophisticated set-up, but then this was not a sophisticated car. Its sole aim was to extract maximum performance from its massive V8 engine. Vented disc brakes were fitted at the front, while self-adjusting rear drums were specified at the back. Inside, black or white vinyl bench seats were standard, though front bucket seats could be ordered. The carpets, instrument panel, rear shelf panel, steering wheel and headlining were black in all versions.

The Superbird remained in production for only one year, because NASCAR officials changed the regulations and decreed that any car running these aerodynamic modifications would be restricted to 4,998 cc engines, which would have made them uncompetitive. Though it seems strange today, Plymouth dealers struggled to find homes for all the Superbirds

| | |
|---|---|
| **PLYMOUTH SUPERBIRD 1970** | **WIDTH:** 76½ in / 1,941 mm |
| **ENGINE:** 6,981cc V8 | **HEIGHT:** 61½ in / 1,560 mm |
| **MAXIMUM POWER:** 425 bhp at 5,000 rpm | **WHEELBASE:** 115¾ in / 2,941 mm |
| **MAXIMUM TORQUE:** 664 Nm at 4,000 rpm | **MANUFACTURE DATE:** 1970 |
| **MAXIMUM SPEED:** 160 mph / 257 km/h | **BRAKES:** disc (f), drum (r) |
| **0–60 MPH ACCELERATION:** 4.8 secs | **SUSPENSION:** torsion bars (f), live axle (r) |
| **TRANSMISSION:** 3-speed auto or 4-speed manual | **WHEELS:** steel, 15 in |
| **LENGTH:** 220 in / 5,588 mm | **TIRES:** F60x15 (f and r) |

that had been produced, and some were even converted back to standard Road Runner specification just to get rid of them. Maybe it was because this supercar's appearance was just a little too extreme. Maybe it was because its extra 19 in / 483 mm in length meant it wouldn't fit in a standard garage. Or maybe it was because the standard colours – Lemon Twist Yellow, Limelight Green and Vitamin C Orange, for example – had rather too much visual impact.

Since then, however, it has become one of the most desirable and valuable muscle cars of all, with auction values for good examples reaching as high as $200,000 – not bad for a model that was difficult to sell for $4,298 in 1970!

# Rolls Royce Phantom Drophead Coupé

To celebrate its 100th anniversary in 2004, Rolls-Royce created the 100EX concept, a stunning drophead coupé that, in typical Rolls-Royce style, effortlessly combines elegance and engineering. It was displayed at various motor shows around the world and was so well received that work on a production version started almost immediately.

By the time of the 2006 Detroit Motor Show, the 100EX had been transformed into the Rolls-Royce Phantom Drophead Coupé, a two-door four-seater convertible that combines an ultra-modern aluminium spaceframe chassis with traditional craftsmanship – wood, leather, chrome and brushed steel are all part of the mix.

Thanks in no small measure to its hand-welded spaceframe chassis, the Drophead is not just one of the most rigid convertibles in the world but also one of the safest. The body uses both aluminium and brushed steel in the construction of the bonnet, grille and A-frame around the windscreen. (To solve the problem of corrosion, which is usually inevitable when these two metals are brought together, the Rolls-Royce engineers studied 20-year old stainless-steel-bodied DeLorean cars to assess long-term durability.)

The car features double-wishbone suspension at the front incorporating a hydraulic mount to reduce vibration. The multi-link rear suspension employs anti-lift and anti-dive technology to maximize comfort levels and ensure a smooth ride. To improve handling, the engine, gearbox and propshaft are sited as low as possible within the chassis to ensure a low center of gravity, and the lack of a roof helps in this respect, too.

The Drophead Coupé is powered by Rolls-Royce's 6,749 cc naturally aspirated V12, which produces 453 bhp at 5,350 rpm and 720 Nm of torque at 3,500 rpm. The company describes the output of the direct injection and variable valve timing engine, which is mated to a six-speed automatic shift-by-wire gearbox, as 'ample'. In this instance, 'ample' means 0–60 mph acceleration in 5.7 seconds and an electronically limited top speed of 149 mph / 240 km/h. Stopping power is provided by massive ventilated disc brakes as part of a sophisticated braking system that incorporates a four-channel anti-lock system, and Emergency Brake Assist in case of an emergency. This braking system operates in conjunction with an advanced dynamic stability control system that gives outstanding car control on the ragged edge.

So the Drophead Coupé is clearly no slouch on the open road, but most customers are not going to choose this car because of its performance, but because of its elegance, its

## ROLLS-ROYCE PHANTOM DROPHEAD COUPÉ 2007

**ENGINE:** 6,749 cc V12

**MAXIMUM POWER:** 453 bhp at 5,350 rpm

**MAXIMUM TORQUE:** 720 Nm at 3,500 rpm

**MAXIMUM SPEED:** 149 mph / 240 km/h

**0–60 MPH ACCELERATION:** 5.7 secs

**TRANSMISSION:** 6-speed automatic

**LENGTH:** 220¾ in / 5,609 mm

**WIDTH:** 78¼ in / 1,987 mm

**HEIGHT:** 62¼ in / 1,581 mm

**WHEELBASE:** 130¾ in / 3,320 mm

**MANUFACTURE DATE:** 2007–present

**BRAKES:** disc (f and r)

**SUSPENSION:** double wishbone (f) multi-link (r)

**WHEELS:** alloy, 21 in

**TIRES:** 265/790 R540 (f and r)

luxurious cabin and its sheer beauty. The successfully achieved aim of the designers was to provide a practical all-weather convertible passenger compartment with the style and luxury expected of a Rolls-Royce. Inspiration came from the purposeful elegance of the 1930s America's Cup J-class yachts and, like a yacht, the Phantom Drophead Coupé was designed to be used in all weathers. In case of a sudden downpour, the seats have a smooth surface so moisture can be wiped off, and ultra-practical sisal mats are fitted. To ensure the car's suitability to all environments, hot-weather tests were held in Death Valley, USA, and the Namib Desert, while cold-weather testing was undertaken in the harsh winter conditions of Scandinavia.

Of course, it's doubtful whether owners will drive in the rain with the five-layer hood down, but the nautical theme is continued at the rear, where teak decking is used instead of conventional metals for the area under which the convertible roof is stored. Incidentally, according to Rolls-Royce, even with the roof down, there's still enough luggage space for three golf bags.

Those fortunate enough to be able to afford the Phantom Drophead Coupé are given a choice of nine unique exterior colours, six hood colours, 10 interior leather colours and six different wood veneers. Given that only a few hundred examples are made each year, this means that the chances are high that each one truly is unique.

# Rolls-Royce Phantom

The German BMW Group took full control of the famous British Rolls-Royce Motor Cars Limited in July 1998 after a tussle with Volkswagen Group, which thought it had bought both Bentley and Rolls-Royce from the Vickers Group. It transpired that the rights to the Rolls-Royce remained with a different company, aero-engine maker Rolls-Royce Aerospace, so VW was left with Bentley and all the joint company's production facilities, while BMW owned the rights to use the Rolls-Royce name and little else.

BMW therefore got to work designing a new car from the ground up and building a brand new factory at Goodwood in southern England. By 2002, the first pre-production prototypes were completed, and the all-new Phantom was launched at the Detroit Motor Show in early 2003.

The design harked back to famous Rolls-Royce cars of the past, in particular the Phantom I and II models of the 1930s, the Silver Cloud of the 1950s and the Silver Shadow of the 1960s. All these earlier cars shared an extended wheelbase, a short front overhang, a prominent C-pillar, an enormous bonnet and an almost crouching stance, which gave the car the appearance of acceleration even when parked. These fundamental Rolls-Royce design elements were all incorporated into the new Phantom,

which of course also boasted the famous front grille and The Spirit of Ecstasy mascot.

Inside, the cabin is trimmed with the very finest leathers, cashmere trim and intricate cabinetwork. The rear doors open backwards in a feature that is not only another reminder of classic Rolls-Royce models of the past, but also allows easier access to the rear passenger compartment with its curved rear seat.

If the design and appearance of the Phantom looks to the past for inspiration, however, the car is as modern as it could be in technical terms. It has a lightweight aluminium spaceframe body, a bespoke V12 engine producing massive power and torque, self-levelling air springs and electronic dampers, which combine with the multi-link rear suspension, long wheelbase and high-profile tires to give both a wonderfully smooth ride and surprisingly good handling for such a large car.

One of the most astonishing features of the Phantom is

that it is genuinely a driver's car. Its 6,749 cc direct-injection V12 produces 453 bhp at 5,350 rpm and 720 Nm of torque at 3,500 rpm. Despite its massive 5,478 lb / 2,485 kg total weight, it accelerates from 0 to 60 mph in 5.8 seconds and from 0 to 100 mph in 15.2 seconds and has an electronically limited top speed of 149 mph / 240 km/h. Yet despite its performance potential, the latest in combustion technology – which includes variable valve lift, variable valve timing and direct injection – gives the Phantom exceptional fuel economy for a super-luxury car of this size and weight. On the EU extra urban cycle it returns 25.7 mpg / 10.9 km/l and a combined figure of 17.8 mpg / 7.6 km/l.

When the new Rolls-Royce Phantom was launched, a number of unique detail touches ensured that no-one was left in any doubt that this is a truly special motor car. For example, the Spirit of Ecstasy mascot is electrically retractable, so it can be lowered out of sight whenever the car is parked; the interlinked

double-R logo at the center of each freely revolving wheel hub remains upright at all times; and an umbrella is stored in each rear door.

Developed from scratch, the Roll-Royce Phantom is a triumph of design and engineering. It oozes quality, luxury and distinction, while employing the best of modern technology. It's a truly worthy latest addition to one of the world's most famous brands.

| ROLLS-ROYCE PHANTOM 2008 | |
|---|---|
| **ENGINE:** 6,749 cc V12 | |
| **MAXIMUM POWER:** 453 bhp at 5,350 rpm | |
| **MAXIMUM TORQUE:** 720 Nm at 3,500 rpm | |
| **MAXIMUM SPEED:** 149 mph / 240 km/h | |
| **0–62 MPH ACCELERATION:** 5.8 secs | |
| **TRANSMISSION:** 6-speed automatic | |
| **LENGTH:** 229¾ in / 5,834 mm | |
| **WIDTH:** 78¼ in / 1,990 mm | |
| **HEIGHT:** 64¼ in / 1,630 mm | |
| **WHEELBASE:** 140½ in / 3,570 mm | |
| **MANUFACTURE DATE:** 2003–present | |
| **BRAKES:** disc (f and r) | |
| **SUSPENSION:** double wishbone (f), multi-link (r) | |
| **WHEELS:** alloy, 21 in | |
| **TIRES:** 255/50 R-21 (f), 285/45 R-21 (r) | |

# Spyker C8 Laviolette

'Nulla tenaci invia est via' is the Dutch Spyker company's motto, which, translated from the Latin, reads 'For the tenacious, no road is impassable'. The company started as long ago as 1880, building the Golden Carriage in 1889 that is still used by the Dutch Royal Family, as well as a range of road and race cars – and also aeroplanes and aero engines during World War I – until it went bankrupt in 1926.

Then, in 1999, Victor Muller, a wealthy Dutch businessman, acquired the rights to the brand name. Within a very short period of time, the company has made a big impact, launching a series of high-performance supercars and creating the Spyker Squadron factory racing team to compete in endurance events such as the 24 Hours of Le Mans and the 12 Hours of Sebring. It even bought the Midland (formerly Jordan) Formula 1 team in 2006, racing under the Spyker name until selling it on to Force India in 2008.

Spyker's first car was unveiled at the Amsterdam Motor Show in 2001, and it was clear from the very outset that this was a different kind of supercar. As Victor Muller acknowledged, no one needs this sort of car, any more than anyone needs a Louis Vuitton handbag, but people still want to buy them.

The Spyker C8 Laviolette represents the extremes of both luxury and performance. Huge scissors doors that open upwards and a plush quilted-leather interior combine with gimmicks such as an engine starter button concealed by a red safety toggle (as found in jet fighters) to produce a car that's unashamedly like no other and that's done well in the Middle East as well as with Hollywood rappers and actors.

Whether you love or hate the car's 'in-your-face' style, there's no denying that its engineering is exemplary. It has an aluminium space frame, to which aluminium panels are mounted, and fully adjustable F1-style suspension with Koni in-board shock absorbers and massive ventilated disc brakes. The mid-mounted 4.2-liter V8 engine is fitted with stainless-steel four-into-one high-performance exhausts on either side. It drives the rear wheels through a sequential or manual six-speed gearbox via an optional limited slip differential. ABS is standard, as is switchable ASR traction control. Performance is sparkling: the car accelerates from 0 to 62 mph in 4.5 seconds and can reach a top speed of 187 mph / 301 km/h.

Many companies are set up to produce supercars – usually the dream of one man. But Spyker is different in that in a very short period of time it has created a range of supercars. Just eight years on from that initial launch in 2001, Spyker is offering, in addition to the 'normal' C8 Laviolette, a short wheelbase C8 Laviolette SWB, a convertible C8 Spyder, an extraordinary D8 Peking-to-Paris SUV and, most extraordinary of all, a C12 Zagato, of which only 24 will be built at a cost of £334,000 each.

The latter's Audi-powered V8 is boosted to 5,998 cc and its power output to 500 bhp with 610 Nm of torque – more than enough to provide 0–62 mph acceleration in 3.8 seconds and a top speed of 195 mph / 314 km/h.

One thing is certain about the Spyker Laviolette – it is aimed at the very wealthiest car enthusiasts in the world. Having placed their £210,000 order, they can watch their very own car being built via a personal web cam installed at the workstation in the factory at Zeewolde in Holland. And while watching the aluminium panels being lovingly positioned, they can consider which options to add: perhaps a Chronoswiss Spyker watch with their own chassis number engraved for £24,000, a set of bespoke luggage for £12,350, or even a Louis Vuitton tool kit at £2,500.

**SPYKER C8 LAVIOLETTE 2001**

**ENGINE:** 4,172 cc V8

**MAXIMUM POWER:** 400 bhp at 7,000 rpm

**MAXIMUM TORQUE:** 480 Nm at 7,500 rpm

**MAXIMUM SPEED:** 187 mph / 301 km/h

**0–60 MPH ACCELERATION:** 4.5 secs

**TRANSMISSION:** 6-speed sequential or manual

**LENGTH:** 159½ in / 4,050 mm

**WIDTH:** 74 in / 1,880 mm

**HEIGHT:** 49 in / 1,245 mm

**WHEELBASE:** 100½ in / 2,550 mm

**MANUFACTURE DATE:** 2001–present

**BRAKES:** disc (f and r)

**SUSPENSION:** double wishbone (f and r)

**WHEELS:** alloy, 18 in

**TIRES:** 225/40 ZR-18 (f), 255/35 ZR-18 (r)

FAST CARS

# AC Cobra 427

In 1961, AC Cars was an old-established British car company that had been manufacturing cars since 1904 and had been building the Ace sports car at its Thames Ditton factory in Surrey since 1953. The Ace, an elegant two-seater, was fitted with a Bristol 2.0-liter straight-six engine, a pre-World War II BMW engine whose performance was no longer really up to par. However, the chassis of the Ace was an excellent design. Consisting of a rigid ladder-frame construction with fully independent suspension all round, it was capable of handling far more power than the aged Bristol/BMW engine could offer.

American racing driver Carroll Shelby had raced in Europe and had noticed the Ace's potential – given a great deal more horsepower. He reckoned that a large V8 engine would transform the car, and asked AC if it could create a car modified to take just such an engine. He approached General Motors to see if they would provide the V8, then powering the Corvette, but was rebuffed, as the company at that time had a policy against racing. Ford, however, greeted Shelby with open arms, and offered him its recently developed 3.6-liter small-block V8.

Back at Thames Ditton, AC's engineers fitted the new V8 with little difficulty and, to cope with the added torque, mated it to a stronger Salisbury rear differential. With its disc brakes mounted inboard, this was the same unit used on the Jaguar E-Type. The first prototypes were ready in 1962 and so impressed Shelby and Ford that Shelby pressed AC to put thee cars into immediate production and Ford offered the even more powerful 4.2-liter V8 it had recently developed for the Fairline saloon.

Production duly started in 1962, AC building the cars and then shipping them to the US, where Shelby completed the fitting out in Los Angeles. Seventy-five of these Mark I AC Cobras were built before Ford uprated the Fairline engine to 4,736 cc, and these were then fitted from 1963 to the Cobra Mk II, of which around 500 examples were built. It was this engine that powered the Cobra to countless racing victories in the US and around the world.

A couple of years later, Shelby reckoned he needed even more power if he was to remain competitive. Thankfully, in 1965, Ford introduced a massive new seven-liter V8 for its Galaxy saloon, and this soon found its way under the bonnet of the AC Cobra. This Mark III Cobra – then called the 427 (the capacity of the 6,997 cc engine in cubic inches) – produced 425 bhp at 6,000 rpm and 490 bhp at 6,500 rpm in racing versions. All that extra power required some major modifications to the chassis, 4-speed manual transmission, and even the wheels and tires. All had to be strengthened and upgraded. What had started as an elegant and relatively understated sports car now had something of the appearance of a hotrod. The 427 was a nakedly aggressive beast whose appearance screamed raw power, and nothing demonstrated that potential more than the massive wheels and the widely splayed wheel arches that accommodated them.

And it wasn't all for show. The Mk III Cobra had a top speed of 180 mph and 0–60 mph acceleration in 4.5 seconds and 0–100 mph in 10.3 seconds. More radically, a special closed-top coupé, produced to compete at Le Mans, was clocked at 196 mph on the M1 motorway in England. Around 300 Mk III Cobras were despatched from England to Shelby in the US, including 31 cars intended for racing that were detuned and modified for the road. These S/C cars are among the rarest Cobras of all.

The final AC Cobras were made in 1967. Although since then, various similar models have been produced by AC and AutoKraft in the UK, and even by Shelby himself in the US, the real thing was made only in the 1960s, when the AC Cobra became a living embodiment of the American saying 'there's no substitute for cubic inches'.

## AC SHELBY COBRA 427 1965

**ENGINE:** 6,997 cc V8

**MAXIMUM POWER:** 410 bhp at 5,600 rpm

**MAXIMUM TORQUE:** 626 Nm at 2,800 rpm

**MAXIMUM SPEED:** 165 mph / 266 km/h

**0–60 MPH ACCELERATION:** 4.5 secs

**TRANSMISSION:** 4-speed manual

**LENGTH:** 156 in / 3,962 mm

**WIDTH:** 68 in / 1,727 mm

**HEIGHT:** 49 in / 1,245 mm

**WHEELBASE:** 90 in / 2,286 mm

**MANUFACTURE DATE:** 1965–67

**BRAKES:** disc (f and r)

**SUSPENSION:** unequal wishbone (f and r)

**WHEELS:** alloy, 15 in

**TIRES:** 185x15 (f), 195x15 (r)

# Aston Martin DB5

**ASTON MARTIN DB5 1963**

**ENGINE:** 3,995 cc inline 6-cylinder

**MAXIMUM POWER:** 282 bhp at 5,500 rpm

**MAXIMUM TORQUE:** 380 Nm at 4,500 rpm

**MAXIMUM SPEED:** 135 mph / 217 km/h

**0–60 MPH ACCELERATION:** 8.6 secs

**TRANSMISSION:** 5-speed manual

**LENGTH:** 180 in / 4,572 mm

**WIDTH:** 66 in / 1,676 mm

**HEIGHT:** 52 in / 1,321 mm

**WHEELBASE:** 98 in / 2,489 mm

**MANUFACTURE DATE:** 1963–65

**BRAKES:** disc (f and r)

**SUSPENSION:** wishbone (f), live axle (r)

**WHEELS:** alloy, 15 in

**TIRES:** 6.70x15

The Aston Martin DB5 looked very similar to its predecessor, the DB4, and it remained in production for only two years, during which time just 1,033 cars were built. Yet in 2006, one example went under the hammer for more than $2,000,000. Such is the power of Hollywood, because what made the DB5 famous above all else was its product placement in a series of James Bond films, most memorably *Goldfinger*, in which Bond's specially adapted car had revolving number plates, machine guns, a rear bullet-proof screen and even an ejector seat as part of its specification.

That $2,000,000 was for one of the four cars that had been specially adapted for the *Goldfinger* film, but even standard DB5s now attract astronomical values – not bad for a car that could be driven out of the showroom in 1963 for £4,175, or £4,490 for the convertible. Getting the DB5 into *Goldfinger* was brilliant timing for Aston Martin, even though its owner David Brown (the car took his initials) was apparently rather doubtful about loaning cars to the filmmakers. Aston had pulled out of motor racing, and the DB5 represented a heaven-sent opportunity to establish Aston Martin as a prestige road car marque.

In real life, the DB5 was closely based on the DB4, sharing its pressed-steel platform and wheelbase and its six-cylinder DOHC engine, though the capacity was increased from 3,670 cc to 3,995 cc. Maximum power was upped to 282 bhp at 5,500 rpm and peak torque now reached 380 Nm at 4,500 rpm. Other improvements over the DB4 included the adoption of an alternator, better Girling disc brakes in place of Dunlops, Sundym glass, electric windows and an oil pressure gauge as standard equipment. Performance was good for its time, though not outstanding: 0–60 mph acceleration in 8.6 seconds and a top speed of 135 mph / 217 km/h.

At the car's launch in 1963, buyers could choose between a four-speed manual gearbox (with electric overdrive as an added-cost option) and a three-speed Borg Warner automatic. A further option was a new all-synchromesh five-speed ZF manual. This became a standard fitment the following year and the old four-speed unit was dropped. In 1964, too, the Vantage model was introduced, with significantly more power, thanks to the fitment of triple twin-choke Weber carburettors, boosting maximum power output to 325 bhp at 5,500 rpm and maximum torque to 390 Nm at 3,850 rpm.

Both saloon and convertible bodies were available, with a detachable steel hardtop available for the convertible as an on-cost option. Although the bodies were made in England at Aston Martin's factory in Newport Pagnell in Buckinghamshire, they were constructed under licence from Touring of Italy, whose Superleggera – or Super Light – method involved fitting aluminium body panels over a lightweight tubular structure.

The result is one of the most effortlessly elegant coupés ever built. Not surprisingly, the DB5 is regularly voted the most iconic and the most beautiful British car ever made.

In typical Aston Martin fashion, the cockpit features plenty of wood, pile carpets and leather – as all traditional British sports cars should. It's the sort of décor found in London gentlemen's clubs and it gives the car a homely yet luxurious feel. Suspension was by double wishbones at the front and a live rear axle, rack and pinion steering and disc brakes all round completed the specification.

For all its charm, the DB5 was beginning to show its age by 1964. Air conditioning was available only as a rather clunky add-on costing £320 and driving the car was a real effort, as both steering and the clutch pedal required considerable strength to operate. The car had also put on a great deal of weight, which meant it was out-performed by the Jaguar E-Type, which cost half as much to buy. These and other issues would be addressed in the later DB6 (1965–70), but not before 898 coupés, 123 convertibles and 12 very rare Shooting Breaks had been built.

# Aston Martin V8 Vantage

The Aston Martin V8 Vantage was first shown as a concept car at the Geneva Motor Show in 2003 and was so well received that it was little surprise when a full production version was unveiled at the same show two years later. Like all Astons bearing the Vantage name, this is a serious performance car. At its heart is a newly developed, all-aluminium-alloy V8 tuned for both high power – 380 bhp – and low emissions. Each of the 4.3-liter engines is meticulously hand-assembled at Aston Martin's engine plant in Cologne, Germany.

Before the V8 Vantage was released for sale, 78 prototypes were relentlessly tested over a total of more than a million miles. High-speed testing was conducted at the Nardo test track in Italy and extensive testing was also carried out at Nurburgring's Nordschleife in Germany. Performance is superb, with 0–60 mph acceleration in 4.7 seconds and a maximum speed of 175 mph / 282 km/h. Its price was exceptional, too: at £79,000 in 2006, it cost considerably less than the DB9 and the flagship Aston Martin Vanquish. At the car's launch, the company said that it expected to sell around 3,000 a year, but response to the car was so good that within two years, more than 10,000 had been sold.

The engine of the V8 Vantage is front mid-mounted and connected to the rear transaxle and its six-speed manual transmission by a cast-aluminium torque tube and carbon-fibre prop shaft. This results in 49:51 weight distribution. The reduction of weight is almost an obsession in the design of the V8 Vantage. Its chassis is constructed from lightweight aluminium extrusions, precision castings and pressings, and the underframe is bonded with aerospace adhesives and mechanically fixed with self-piercing rivets. This unique VH (Vertical Horizontal) architecture provides a strong backbone, while the use of materials such as lightweight alloys, magnesium and advanced composites for the body further contributes to the car's low weight and high rigidity.

Unlike other Aston Martins, the V8 Vantage has a large luggage area behind the driver and passenger seats, accessed by a hatchback for practicality. But as with all Astons, owners have

| ASTON MARTIN V8 VANTAGE 2005 | | WIDTH: 73½ in / 1,866 mm |
| --- | --- | --- |
| ENGINE: 4,280 cc V8 | | HEIGHT: 49½ in / 1,255 mm |
| MAXIMUM POWER: 380 bhp at 7,000 rpm | | WHEELBASE: 102¼ in / 2,600 mm |
| MAXIMUM TORQUE: 410 Nm at 5,000 rpm | | MANUFACTURE DATE: 2005–present |
| MAXIMUM SPEED: 175 mph / 282 km/h | | BRAKES: disc (f and r) |
| 0–60 MPH ACCELERATION: 4.7 secs | | SUSPENSION: double wishbone (f and R) |
| TRANSMISSION: 6-speed manual | | WHEELS: alloy, 18 in |
| LENGTH: 184¼ in / 4,683 mm | | TIRES: 235/45 ZR-18 (f), 275/40 ZR-18 (r) |

immense choice in the customization of the interior, with literally thousands of colour and trim options.

Soon after the V8 Vantage Coupé was launched, a convertible Roadster was introduced. A new cross-member was added to the chassis to compensate for the rigidity lost with the removal of the roof, but even the additional 200 lb / 91 kg of weight did little to affect the performance – it had the same 175 mph / 282 km/h top speed as the Coupé and only marginally slower acceleration (0–60 mph in 4.9 seconds). But Aston Martin looked after those owners wanting even more performance, offering various packages that increased the engine output, uprated the suspension and improved the aerodynamics. Then in 2007, a special N400 edition was announced to celebrate

Aston's racing successes. It produced 400 bhp, had graphite wheels and upgraded suspension and was available in just three colours – black, silver and orange.

The whole range was updated in 2008, with the engine bored out to 4,700 cc to increase the power output to 420 bhp and peak torque to 470 Nm. In addition, a 'Sportshift' semi-automatic gearbox was offered as an alternative to the manual unit, the suspension was stiffened, and new 20-spoke alloy wheels were specified. The result was a higher top speed of 180 mph / 290 km/h and marginally improved acceleration, but more importantly, it benefited from a healthy increase in mid-range torque, making it even easier to drive quickly on winding roads.

But there's more to the Aston Martin V8 Vantage than mere performance. The reason why Aston had a three-year waiting list for this car is simply that it looks and sounds absolutely fantastic. Rivals such as the Porsche 911 and Audi R8 might beat the Vantage in terms of outright speed, but neither can touch the Aston for sheer elegance and beauty.

# Audi Quattro

'Win on Sunday and sell on Monday' is a phrase often used to justify a highly expensive motorsport programme. The belief is that a car or brand that is successful on the track will create a halo effect that will benefit all the models in the same company's showrooms, thereby increasing sales. Another justification given for motor sport is that the technological lessons learnt in designing track cars benefit and speed up the development of the models that ordinary people can buy.

There's some truth in both arguments, and both are especially true of the Audi quattro (always spelt with a lower case 'q'), which was developed to take advantage of new regulations in world rallying that would allow four-wheel drive for the first time in 1980.

The development brief was handed to Ferdinand Piech (the great-nephew of Ferdinand Porsche), who moved to Audi after designing the legendary Porsche 917 racing car. Piech's genius was shown in his creation of a world-beating car at relatively low cost using components that already existed within the Audi range.

The starting point was the Audi 80 Coupé, which provided some of the bodywork, interior, and the front suspension, while the Audi 200 5T saloon shared its 2,144 cc five-cylinder turbo-charged engine, which produced 200 bhp at 5,500 rpm. Piech brought these parts together and created an elegant coupé that attracted much interest at the 1980 Geneva Motor Show.

That interest was directed underneath the car. The four-wheel-drive system was again lifted from the existing Volkswagen company parts bin, in this case from an off-road vehicle, called the Iltis, that VW had built for the German army. The system was a permanent four-wheel-drive arrangement, under which, depending on the conditions, either the front and rear differentials, or the rear differential alone, could be locked.

The new car was a revelation in the 1980 World Rally Championship, winning races in its first season, and attracted even more attention when Michele Mouton became the world's

| AUDI QUATTRO 1980 | | WIDTH: 67¾ in / 1,722 mm |
| --- | --- | --- |
| ENGINE: 2,144 cc in-line 5-cylinder | | HEIGHT: 53 in / 1,346 mm |
| MAXIMUM POWER: 200 bhp at 5,500 rpm | | WHEELBASE: 99¼ in / 2,522 mm |
| MAXIMUM TORQUE: 285 Nm at 3,500 rpm | | MANUFACTURE DATE: 1980–91 |
| MAXIMUM SPEED: 137 mph / 220 km/h | | BRAKES: disc (f and r) |
| 0–62 MPH ACCELERATION: 7.1 secs | | SUSPENSION: independent MacPherson strut (f and r) |
| TRANSMISSION: 5-speed manual | | WHEELS: alloy, 15 in |
| LENGTH: 173½ in / 4,404 mm | | TIRES: 205/60 VR-15 (f and r) |

first female ever to win a World Rally Championship. With a little development it did even better: Audi won the World Rally Constructors' Championship in 1982 and 1984, while the quattro took Hannu Mikkola and Stig Blomqvist to the World Rally Champions' title in 1983 and 1984 respectively.

On the road, the quattro made an equally impressive statement. On paper, its performance wasn't in the supercar league – it accelerated from 0 to 60 mph in 7.1 seconds and had a top speed of 137 mph / 220 km/h – but it had so much traction, particularly in poor weather conditions, that it could be hustled along swiftly and safely even by less experienced drivers.

The quattro remained in production until 1991, by which time 11,452 examples had been built. Over those 11 years, the body remained largely unchanged, though the engine was boosted to 2,200 cc in 1987, increasing power to 2,220 bhp and top speed to 143 mph / 230 km/h. At the same time, the manual center differential was changed to an automatic Torsen unit. On the rally circuit, the quattro clocked up 21 World Championship wins and then proceded to dominate other events, including the Pike's

Peak International Hill Climb in 1986 and 1987.

The ultimate incarnation was the Sport quattro, developed on a shorter wheelbase for Group B rallying in 1984. Just a handful of these carbon–Kevlar-bodied rockets were offered as road cars, producing 306 bhp and offering 0–60 mph in five seconds and a top speed of 150 mph / 241 km/h.

So successful was the original quattro that every four-wheel drive Audi since has been dubbed 'quattro' (the word, of course, means 'four' in Italian). As to Ferdinand Piech, the quattro's development chief, he went on to become the chief executive of the whole Volkswagen Group, which he expanded by buying Lamborghini, Bentley and Bugatti.

# Audi R8

The centerpiece of Audi's stand at the 2003 Frankfurt Motor Show was the Le Mans concept, a two-seater sports car that paid homage to Audi's recent successes in the world-famous 24-hour race. Three years later, the concept became a reality when the Audi R8 was finally unveiled at the 2006 Paris Motor

Show. But there was no doubting the heritage of this new supercar and, pointedly, it was officially revealed by Le Mans winners Tom Kristensen and Jacky Ickx.

Audi's audacious plan for the R8 was that, from day one, it should compete on an equal footing with the likes of the Porsche 911 and Aston Martin V8 Vantage. It was a tall order, but Audi is a company that thrives on competition. It put all the knowledge learnt from endurance racing, and particularly Le Mans, into the R8. The new car had a lightweight aluminium spaceframe chassis, a dry-sump aluminium V8 engine, with direct fuel injection and permanent four-wheel drive. Transmission is either a six-speed manual or a shift-by-wire R-Tronic semi-automatic controlled by paddles mounted on the steering wheel, which, in true motorsport tradition, has a flattened bottom.

Power comes from what is essentially the same engine as fitted to the Audi RS4, though adapted for dry-sump lubrication to allow the unit to be placed lower in the spaceframe to keep the center of gravity as low as possible. The 32-valve V8 produces 414 bhp at 7,800 rpm and 430 Nm of torque

**AUDI R8 2006**

**ENGINE:** 4,163 cc V8

**MAXIMUM POWER:** 414 bhp at 7,800 rpm

**MAXIMUM TORQUE:** 430 Nm at 3,500 rpm

**MAXIMUM SPEED:** 187 mph / 301 km/h

**0–60 MPH ACCELERATION:** 4.6 secs

**TRANSMISSION:** 6-speed manual or semi-automatic

**LENGTH:** 174½ in / 4,431 mm

**WIDTH:** 75 in / 1,904 mm

**HEIGHT:** 49¼ in / 1,249 mm

**WHEELBASE:** 104¼ in / 2,650 mm

**MANUFACTURE DATE:** 2006–present

**BRAKES:** disc (f and r)

**SUSPENSION:** double wishbone (f and r)

**WHEELS:** alloy, 19 in

**TIRES:** 235/35 ZR-19 (f), 295/30 ZR-19 (r)

to get their hands on an early example. But despite this enormous commercial success, Audi refused to rest on its laurels and continued to develop the car still further. First came a V10-engined version with even greater power and performance. The engine – a development of the Lamborghini Gallardo V10 – has a capacity of 5,204 cc and produces 525 bhp at 8,000 rpm and 530 Nm of torque. Its 0–62 mph acceleration drops to only 3.9 seconds and the top speed is a whisker under 200 mph / 322 km/h.

If that weren't enough, at the 2008 Detroit Show, Audi showed an R8 TDI Le Mans concept, which had a 6.0-liter V12 diesel engine producing 493 bhp and a staggering 1,000 Nm of torque. The car looked even more aggressive than the standard R8, because the extra cooling requirements of the engine required a NACA duct on the roof. Sadly, however, the company believed that the cost of re-engineering the car to accommodate the longer V12 engine would be too high for them ever to make a return on their investment, and so what might have been the world's ultimate diesel-powered supercar never made it to market.

at 3,500 rpm. That translates into 0–62 mph acceleration in 4.6 seconds and a top speed of 187 mph / 301 km/h, which, as Audi planned all along, makes it a genuine alternative to either the Porsche 911 or Aston V8 Vantage.

With a list price of £76,725 at the time of its launch in summer 2007, the Audi R8 cost a little more than the 911 at £71,980 and a little less than the Aston at £82,800. But it has some advantages over both its rivals. For a start, it shares much of its chassis and floorpan with that of the Lamborghini Gallardo, so there's no doubting its serious provenance. The Audi also scores in having permanent four-wheel drive for optimum traction and grip. And it's fitted with optional Magnetic Ride dampers, which can be changed from comfort to sport in an instant to improve handling still further at higher speeds. It's a system that's also used in the Chevrolet Corvette and the Ferrari 599.

The Audi's bodywork is distinctively low, wide and long. Its style has been dictated by the demands of aerodynamics, so it has large and distinctive air apertures under the front light, on the rear flanks and under the rear lights, too. Large diffuser openings and a small pop-up rear spoiler provide extra rear downforce at high speeds.

As soon as the Audi R8 went on sale, demand was such that buyers were willing to pay substantial premiums over the list price

# Bentley Continental Supersports

Bentley's current factory in Crewe has seen many changes since it started life building Merlin aero-engines for the Spitfire during World War II. After the war, crafting of luxury cars recommenced, but because of the high degree of craftsmanship involved in the woodwork, the leather interior, and even in the manufacture of its bespoke V8 engine, production numbers remained low for decades. As the new millennium came in, barely 1,000 Bentleys were being made per year: by 2008, just over 10,000 were assembled on the site.

The model that instigated this success story was the Continental GT, launched in 2003, which was smaller, lighter and significantly cheaper than other Bentleys. It also relied rather heavily on the Volkswagen Group parts bin, and, specifically, on the floorpan and engine of the VW Phaeton. But in terms of its style, its exclusivity and its effortless power delivery, it was a true Bentley. It is no exaggeration to say that the Continental GT transformed Bentley's fortunes. Unlike the traditional Bentley V8, the engine of the Continental GT was a 6.0-litre twin-turbocharged W12 design, producing 560 bhp at 6,100 rpm and 650 Nm of torque at only 1,500 rpm. It gave a top speed of 317 km/h / 197 mph and 0–62 mph acceleration in 4.7 seconds. Also new for Bentley was the Continental's permanent four-wheel drive system and electronically controlled six-speed automatic transmission. The GT's unique styling was the work of Bentley's Belgian design chief Dirk van Braeckel.

The Continental GT was an immediate sales success right around the world. But instead of resting on its laurels after the launch of the new car, Bentley immediately embarked upon a development programme, launching the four-door Flying Spur in 2005, the convertible GTC in 2006, and a more powerful GT Speed in 2007. For the latter, power was upped to 603 bhp, top speed to 325 km/h / 202 mph (incidentally, this was the first production Bentley capable of exceeding 322 km/h / 200 mph) and 0–62 acceleration in 4.3 seconds. But there was yet more to come. In early 2009, Bentley announced the Continental Supersports, the fastest and most powerful production Bentley

## BENTLEY CONTINENTAL GT SUPERSPORTS 2009

**ENGINE:** 5,998 cc W12

**MAXIMUM POWER:** 621 bhp at 6,000 rpm

**MAXIMUM TORQUE:** 800 Nm at 1,700 rpm

**MAXIMUM SPEED:** 204 mph / 328 km/h

**0–62 MPH ACCELERATION:** 3.9 secs

**TRANSMISSION:** 6-speed automatic

**LENGTH:** 189¼ in / 4,804 mm

**WIDTH:** 86½ in / 2,194 mm

**HEIGHT:** 54¼ in / 1,380 mm

**WHEELBASE:** 108 in / 2,745 mm

**MANUFACTURE DATE:** 2009–present

**BRAKES:** disc (f and r)

**SUSPENSION:** double wishbone (f), multi-link (r)

**WHEELS:** alloy, 20 in

**TIRES:** 275/35 X-20 (f and r)

ever. It's also the first Bentley capable of running on either petrol or biofuel. The Supersports started as a project exploring the possibilities of weight reduction on the GT, but it soon blossomed into an official new car programme, with dramatic results. With output from the W12 raised yet again, this time to 621 bhp, and a new 'Quickshift' transmission that halves shift times, the Supersports sets new performance benchmarks, with acceleration from 0–62mph in 3.9 seconds and a top speed of 328 km/h / 204 mph.

To justify its 'Supersports' name, the latest Continental GT incarnation has a significantly uprated chassis and suspension, including retuned steering, and firmer shock absorbers and anti-roll bars. The rear track has been widened (so the rear wings are more flared), and the package is completed with new lightweight 20-inch alloy wheels and a unique electronic stability programme. Carbon ceramic brakes are a standard fitment – just one of the areas in which the engineering team managed to shave 110 kg / 242 lb off the car's weight. The body has a more extreme appearance, with new vertical air intakes at the side, and twin bonnet vents. The exterior grills, light bezels and window surrounds have been given a unique smoked-steel finish. And the changes continue in the cockpit, where carbon fibre and Alcantara trim are used to convey sporting intent and also to save weight. It is styling that underlines the Continental GT Supersports' supercar character – and that signal that this is the fastest, most extreme Bentley ever.

The 'Supersports' name is inspired by the original two-seater, three-litre Bentley Supersports model introduced in 1925, itself an evolution of the three-litre Speed. The lightweight, 85 bhp Supersports was the first production Bentley to reach 161 km/h / 100 mph and was also renowned for the application of Le Mans-winning race technology.

# BMW M1

BMW's epic mid-engined M1 supercar was conceived in the mid-1970s as a homologation special: to race in Group 4 and Group 5, at least 400 production cars had to be built within a two-year period, and this was the design that BMW created. It was destined to become the very first of BMW's famous 'M' performance cars, and the first ever mid-engined BMW.

Yet, perversely, the performance potential of the car was never truly tested on the racetracks because BMW switched its attention to Formula 1 before the M1 was ever given a real chance to get into its stride. During 1979–80, a Procar series was instituted, which saw F1 drivers competing in identical M1 cars at each Grand Prix meeting of the season, but apart from that, the factory showed very little interest in the car. As a result, of the 455 M1s that were built between 1978 and 1981, only 56 were racecars; the rest were road cars.

The M1 was a truly radical leap of faith for BMW, which traditionally built front-engined, rear-wheel-drive cars, though it had produced a mid-engined concept in 1972 called the BMW Turbo. In fact, though the M1 is badged a BMW, the Bavarian company contributed only the engine initially – a modified 3,453 cc, six-cylinder inline unit producing 277 bhp at 6,500 rpm and 329 Nm of torque at 5,000 rpm. The design was by Giugiaro at Ital Design and the chassis engineering and manufacture was

initially contracted out to Lamborghini, but the Italian company's financial problems meant that BMW had to switch final assembly to German coachbuilder Baur. The engine was mounted behind the driver and drove the rear wheels via a five-speed transaxle incorporating a limited slip differential. The all-independent suspension incorporated coil springs and wishbones front and rear, while massive disc brakes were fitted all round.

Performance was outstanding, with 0–62 mph acceleration in 5.6 seconds and a maximum speed of 162 mph / 261 km/h – figures that matched the performance of rivals such as the Ferrari Boxer or Lamborghini Countach. More importantly, the chassis that Lamborghini originally designed did a great job: the M1 enjoyed high levels of grip, neutral handling and great stopping power. In short, it had superb racetrack ability, and this pedigree was evident in the road cars too.

In fact, the customer cars were well equipped, with plush supportive seats, full carpeting, electric windows and even air conditioning. The engine was unstressed at 277 bhp output (the same unit produced 470 bhp in the Group 4 racers and was later modified, turbocharged and bored out to produce 850 bhp in Group 5 trim), and the M1 was tractable, easy to drive, reliable and reasonably practical. When the engine was revved freely, a cacophony of sound made its way into the cockpit from the

engine positioned just behind the driver, but when driven gently, the M1 was both civilized and even refined. In addition, in true BMW tradition, it was beautifully built – not something that could be said of many Italian supercars of that era. Not until Honda launched its NSX would there be another supercar that was so user-friendly.

Some observers at the time suggested that the M1 was not Giugiaro's finest example of design, and the car is certainly not as extreme as contemporaries such as the Lamborghini Countach, but the fact is that BMW imposed certain restraints, not least that the car had to have its trademark duel-kidney grille and had to use stock taillights. Nevertheless, its clean, elegant design has stood the test of time.

**BMW M1 1978**

**ENGINE:** 3,453 cc inline 6-cylinder

**MAXIMUM POWER:** 277 bhp at 6,500 rpm

**MAXIMUM TORQUE:** 329 Nm at 5,000 rpm

**MAXIMUM SPEED:** 162 mph / 261 km/h

**0–60 MPH ACCELERATION:** 5.6 secs

**TRANSMISSION:** 5-speed manual

**LENGTH:** 171¾ in / 4,360 mm

**WIDTH:** 71¾ in / 1,824 mm

**HEIGHT:** 45 in / 1,140 mm

**WHEELBASE:** 100¾ in / 2,560 mm

**MANUFACTURE DATE:** 1978–81

**BRAKES:** disc (f and r)

**SUSPENSION:** wishbone (f and r)

**WHEELS:** steel, 16 in

**TIRES:** 205/55 VR-16 (f), 205/50 VR-16 (r)

# BMW M3 CSL

At BMW, the letters 'CSL' are given only to very special models. The first CSL (it stands for Coupé, Sports and Lightweight) appeared in 1938 in the guise of the aluminium-bodied 328 Mille Miglia Coupé. In the 1970s, a further CSL appeared, derived from the 3,000 cc Coupé. Most recently, in 2001, a CSL made its appearance in the form of the BMW M3 concept car, which was followed two years later by a limited run of production cars.

The task faced by BMW engineers was how to improve on the BMW M3 model, which was already one of the fastest and best-handling compact saloons on the market. The starting point was to reduce the car's weight, and so wherever possible, sheet steel was replaced by carbon-fibre-reinforced plastic, as used in Formula 1 cars of that time. It's found in the roof, front bumper and air diffuser. The boot is made of sheet moulding compound (SMC) and incorporates an integral spoiler.

The engine is the straight six used in the M3, but modified with a new carbon-fibre air intake, larger inlet manifolds, revised camshaft profiles and modified exhaust valves to improve the flow of exhaust gases through a lighter thinwall exhaust system. The bald figures are 360 bhp at 7,900 rpm and 370 Nm of torque at 4,900 rpm. This engine is mated to a unique sequential M gearbox with Drivelogic, which again derives from F1 technology and which allows gearshifting in just 0.08 seconds. It can be driven in automatic mode or in manual mode using paddles on the steering wheel. The transmission also contains a sort of 'launch control', which guarantees maximum acceleration as the Drivelogic system shifts the six gears at exactly the optimum point shortly before the engine reaches the rev limit. Other modifications include revised suspension, uprated vented and cross-drilled brakes, a quicker steering rack and new 19-inch lightweight alloy wheels to further reduce unsprung weight.

On paper, the end result of all this development work appears to be not very much: 243 lb / 110 kg of weight have been removed, which is significant, if not life-changing; power is up from 343 bhp on the standard M3 to 360 bhp, and the 0–62 mph acceleration time is slightly

quicker, at 4.9 seconds. The top speed, as in most BMW's, is electronically limited to 155 mph / 249 km/h and so remains the same as that of the M3. But one hint of the M3 CSL's capabilities is shown by the fact that on production of a racing licence, BMW would remove that maximum speed limiter.

Settle into the racing seat that keeps the driver in place, despite 1.5G of lateral acceleration, and it becomes clear that the M3 CSL is indeed a very special car, and one of the very fastest that BMW has ever offered to the public. The first job is to use the many buttons to select the speed of the gearchange, the sharpness of the throttle response and perhaps to turn off the stability control system. There's another button to programme the car for a racetrack because, quite frankly, the outer limits of the CSL's potential could never be found on public roads, not least because the suspension is set so rock hard that it tends to bounce over bumps rather than soak them up.

But on a track, the CSL can truly come alive, and despite that relatively small increase in power and relatively small decrease in weight, it is radically, unbelievably quicker than the standard M3. BMW claim that when it ran the CSL around the north circuit of the Nurburgring, its lap time was a full 30 seconds less than that of the standard M3. And it's able to do this, quite simply because the M3 CSL accelerates and can be cornered faster and comes to a standstill more quickly when the driver applies the brakes. This is the basic difference between the

standard M3 and the M3 CSL: the former is a civilized and versatile road car and the latter is a wholly uncompromising road-legal racing car. One other difference is that, at £58,455, the M3 CSL, cost £18,720 more than the standard M3 when it went on sale in 2003.

# Chevrolet Corvette ZR-1

The Corvette is a living legend in American automotive history. Marketed as an affordable sports car for young adults, the first plastic-bodied Corvette was launched in 1953, and there's been a Corvette in production ever since. ZR1 is also a famous name in Corvette history, the first high-powered ZR1 joining the Corvette line-up in 1990. The latest Corvette, the Z06, went on sale in the summer of 2004 and the ZR1 was released as a 2009 model. For sportscar enthusiasts, it was well worth the wait, because it is a quite extraordinary beast.

For a start, its 6,162 cc supercharged V8 produces 638 bhp at 6,500 rpm and 819 Nm of torque at 3,800 rpm. That alone makes it the most powerful Corvette model ever produced. For good measure, it's also the most expensive, with a $105,000 list price at launch. But the cost is perhaps justified by the fact that the Corvette ZR1's performance and specification is the sort of thing that might be expected of an exotic supercar costing two or three times as much as this Corvette.

The supercharged V8 is hand-assembled at GM's Performance Build Center in Wixom, Michigan, using heavy-duty yet lightweight reciprocating components for optimum performance. It is then mated to a new, stronger six-speed manual transmission and a twin-disc clutch. ZR1-specific gearing in the transmission provides a steep first-gear ratio that boosts initial acceleration, and top speed is achieved in sixth gear – a change from the fifth-gear top-speed run-outs in the manual-transmission 'standard' Corvette.

The ZR1 is built on the same aluminum chassis as the Corvette Z06 and features similar independent front and rear suspensions, using wishbones with aluminum upper and lower control arms, transverse composite leaf springs, electronically adjustable Monotube shock absorbers and anti-roll bars. The ZR1 differs in the way the suspension is tuned and optimized for its massively wide front and rear tires. Magnetic Selective Ride Control is standard and tuned specifically for the ZR1. This provides a comfortable and compliant ride at normal speeds while at the same time enabling the dampers to be firmed up instantaneously when required, so that in vigorous cornering, the ZR1 can exceed a lateral 1g.

With such massive performance potential, stopping power is vital, which is why the ZR1 boasts vented and cross-drilled carbon-ceramic discs that are 15½ in / 394 mm in diameter at the front and 15 in / 380 mm in diameter at the rear – the largest on any production vehicle.

The ZR1 is instantly recognizable, thanks to its raised carbon-fibre bonnet. This incorporates a clear, polycarbonate window so that onlookers can see the top of the engine, which has the legend 'LS9 SUPERCHARGED' embossed on its sides and the Corvette crossed flags logo on the front. Carbon fibre is

widely used to reduce weight, on the roof, front splitter, front bumpers and full-width, body-coloured rear spoiler. The theme continues in the cockpit with its lightweight seats.

The result is a car with a power-to-weight ratio of 420 bhp per tonne. That's better than that of the Porsche 911 GT2, the Ferrari 599 GTB Fiorano and the Lamborghini LP640 Murcielago. This is reflected in astonishing raw performance figures: a 0–60 mph acceleration time of 3.4 seconds – even quicker than the Ferrari Enzo's – and a 0–100 mph time of 7.8 seconds. Its maximum speed of more than 205 mph /330 km/h can be reached from a standstill in a little over 30 seconds. In June 2008, Corvette development engineer Jim Nero set a lap time of 7 minutes 26.4 seconds on the famous 12.9-mile Nürburgring race track in Germany, driving a standard production ZR1. At the time, this was the fastest lap ever recorded for a production car. Indeed, only a handful of cars are faster. One such is the Bugatti Veyron, but then it also costs more than $1,000,000 more to buy.

At launch, GM executives said they planned to build around 3,000 Corvette ZR1s a year. That means the ZR1 will remain a relatively rare sight – and the most likely view of it will be a glimpse of its rear end fast disappearing towards the horizon.

**CHEVROLET CORVETTE ZR-1 2009**

**ENGINE:** 6,162 cc V8

**MAXIMUM POWER:** 638 bhp at 6,500 rpm

**MAXIMUM TORQUE:** 819 Nm at 3,800 rpm

**MAXIMUM SPEED:** 205 mph / 330 km/h

**0–60 MPH ACCELERATION:** 3.4 secs

**TRANSMISSION:** 6-speed manual

**LENGTH:** 176¼ in / 4,476 mm

**WIDTH:** 76 in / 1,928 mm

**HEIGHT:** 49 in / 1,244 mm

**WHEELBASE:** 105¾ in / 2,685 mm

**MANUFACTURE DATE:** 2009–present

**BRAKES:** disc (f and r)

**SUSPENSION:** wishbone (f and r)

**WHEELS:** alloy, 19 in (f), 20 in (r)

**TIRES:** 285/30 ZR-19 (f), 335/25 ZR-20 (r)

# Dodge Challenger SRT8

'King of the asphalt', booms the advertising material. 'Flawlessly sculpted design packing serious Hemi muscle with track-ready suspension and legendary styling.' Dodge could be describing its 1970s Challenger muscle car, but in fact it's praising an all-new 2008 Challenger, built some 35 years after the original. The new Challenger looks, sounds and performs like a muscle car. What Dodge has so successfully created is a design that remains faithful to the Challenger heritage while incorporating a host of modern technologies. What is also encouraging is that the production Challenger remains pretty faithful to the concept car originally shown at the 2006 Detroit Auto Show. It's bold and aggressive in appearance and clearly harks back to the 1970s Challenger without becoming a dull retro design.

The latest Dodge Challenger SRT8 was engineered with a focus on the five pillars of every SRT vehicle: bold exterior design that resonates with the brand image, a race-inspired interior, precise ride and handling, an outstanding powertrain and benchmark braking. Under the long bonnet is a 6.1-liter Hemi V8 producing 425 bhp at 6,200 rpm and 569 Nm of torque at 4,800 rpm which translates into tire-smoking 0–60 mph acceleration in 5.0 seconds and a top speed of some 170 mph / 274 km/h – all for a shade under $38,000.

Unlike smaller-engined versions of the Challenger, the SRT8 is recognizable by its much deeper front spoiler, a rear spoiler and large brake-cooling ducts. Inside the cabin, the driver settles into a deep leather bucket seat and is faced with an array of dials and computer read-outs set into carbon-fibre trim materials. The on-board computer, incidentally, records not only fuel consumption and current speed but also 0–60 mph acceleration, standing

## DODGE CHALLENGER SRT8 2008

**ENGINE:** 6,059 cc V8

**MAXIMUM POWER:** 425 bhp at 6,200 rpm

**MAXIMUM TORQUE:** 569 Nm at 4,800 rpm

**MAXIMUM SPEED:** 170 mph / 274 km/h

**0–60 MPH ACCELERATION:** 5.0 secs

**TRANSMISSION:** 5-speed automatic or 6-speed manual

**LENGTH:** 197¾ in / 5,022 mm

**WIDTH:** 75¾ in / 1,923 mm

**HEIGHT:** 57 in / 1,448 mm

**WHEELBASE:** 76½ in / 1,946 mm

**MANUFACTURE DATE:** 2008–present

**BRAKES:** disc (f and r)

**SUSPENSION:** A-arm (f), 5-link (r)

**WHEELS:** alloy, 20 in

**TIRES:** 245/45 R-20 (f), 255/45 R-20 (r)

The Challenger SRT8 comes with either a five-speed automatic box or a six-speed manual with dual clutch that has been lifted from the Dodge Viper – this is the first time a modern Hemi-engined car has had a manual gearbox option. A limited slip rear diff, a traction-control system, a more direct steering ratio, those upgraded Brembo brakes and a sophisticated multi-link suspension system are all part of the SRT8's comprehensive specification.

On the open road, the SRT8 handles like a dream, while the rorty growl of its Hemi V8 makes just the sort of noises that might be expected of a latter-day muscle car. And its overall performance makes this just as desirable in its own way as the original 1970s Challenger was. No wonder, then, that 4,300 customers placed orders on the very first day the Challenger SRT8 was announced. A year later, the Challenger range was extended to include a second Hemi engine – a 370 bhp 5.7-liter version – and a 250 bhp V6. It means Challenger prices start as low as $23,000.

But if the flagship ST8 is exciting, there's the distinct possibility of more to come. In late 2008, Dodge revealed a Challenger SRT10 Concept with a 600 bhp V10 crammed under its bonnet. Officially, this is just a concept car; unofficially, it could well be ready for production as a 2010 model. It seems the muscle car is enjoying a second coming.

quarter-mile times, and even g-forces (0.88 g on the skid plan) and braking performance from the massive Brembo discs. (For the record, 0–60 mph takes just 110 ft / 33.5 m.)

Also standard is a 13-speaker Kicker audio system with a 322-watt amplifier and 200-watt subwoofer, a satellite radio and a MyGig infotainment system. Dodge asserts that there's seating for five in what it claims is the best-in-class interior space, but in truth, the rear is so cramped that this is best considered a very spacious two-seater.

# Dodge Charger 500 Daytona

**DODGE CHARGER 500 DAYTONA 1969**

**ENGINE:** 6,891 cc V8

**MAXIMUM POWER:** 425 bhp at 5,000 rpm

**MAXIMUM TORQUE:** 640 Nm at 4,000 rpm

**MAXIMUM SPEED:** 200 mph / 322 km/h

**0–60 MPH ACCELERATION:** 5.7 secs

**TRANSMISSION:** 3-speed automatic or 4-speed manual

**LENGTH:** 229¼ in / 5,821 mm

**WIDTH:** 76½ in / 1,946 mm

**HEIGHT:** 53½ in / 1,358 mm

**WHEELBASE:** 117 in / 2,972 mm

**MANUFACTURE DATE:** 1969

**BRAKES:** disc (f), drum (r)

**SUSPENSION:** upper and lower control arm (f), live axle (r)

**WHEELS:** alloy, 14 in

**TIRES:** F70–14 (f and r)

One of the most bizarre and extreme muscle cars of the late 1960s came about because of poor aerodynamics on the track and the fact that Ford was winning too many races. The 1968 Dodge Charger was quick but not quick enough. Quite simply, it generated far too much drag to compete on the banked NASCAR circuits, which the leading cars were lapping at close to 200 mph / 322 km/h.

To improve the car's chances, a closed front nose was fitted to smooth airflow at the front, and the rear window, whose shape had generated a vacuum and therefore loads of drag, was changed to a flush-mounted unit. This was the Charger 500, of which Dodge built just enough to qualify the car for NASCAR.

In a sense, the Charger 500 was a great success, in that it won 18 NASCAR races in the 1969 season. Unfortunately, however, the Ford Torino won 30. Returning to the drawing board, Dodge's aerodynamicists came up with some further tweaks. The nose was extended forwards by 18 in / 457 mm to reduce drag and increase downforce, and a massive rear tail wing was fitted to cut out rear-end lift at high speeds. Overall, the airflow was some 20 per cent more efficient than before, and this was enough to give the car a decisive edge over its Ford and Mercury competitors.

different story, however. The improved airflow made the Charger 500 Daytona decisively quicker than its rivals. So much faster, that US driver Buddy Baker recorded the first ever 200 mph / 322 km/h lap at the Talladega circuit in Alabama in March 1970.

Like its cousin the Plymouth Road Runner Superbird, the Charger 500 Daytona created loads of interest but generated few sales. Dodge had to produce 505 examples in order to race, but many were initially unsold in Dodge dealerships. In later years, the popular TV series *The Dukes of Hazzard* gave the Dodge Charger a massive publicity boost as the dukes' orange 1969 model, dubbed *The General Lee*, allowed them to outrun the sheriff in most episodes.

Today, all Chargers are sought after, with the Daytona – most especially one of the rare 75 Hemi-engined examples – being the most desirable of all. Costing around $3,993 when they were launched, they are valued well into six figures today, and the very finest examples can sell for as much as $750,000.

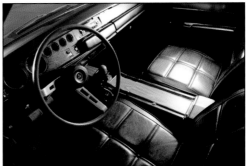

The new model was called the Charger 500 Daytona, and just over 500 examples were built and sold for homologation purposes. In fact, the car wasn't ready to race until very late in the 1969 season, but it made a huge impact on the roads, not least because every one came with red, black or white stripes down the sides bearing the name 'Daytona' in large letters. Another outstanding feature was the headlights, which were hidden in the front nosecone and flipped up when switched on.

The road cars were fitted with GM's 7,210 cc 375 bhp Magnum V8 as standard, though the 6,981 cc Hemi V8 engine was also available, producing 425 bhp at 5,000 rpm and 640 Nm of torque at 4,000 rpm. Transmissions were either four-speed manual or three-speed TorqueFlite automatic. The suspension arrangement was little changed from the standard Charger R/T chassis, with torsion bars at the front and leaf springs at the rear. However, the standard Charger's drum brakes were upgraded for the Daytona, with discs fitted at the front and a brake booster added to the rear drums.

Interestingly, although the road-going 500 Daytona looked quick even when it was standing still, it was actually slower to accelerate than the standard Dodge Charger 500 and had a lower top speed – simply because the new nose and tailfin added some 300 lb / 136 kg to the weight. On the racetrack it was a

# Dodge Viper SRT-10

In the late 1980s, Chrysler was a company desperately in need of a shot in the arm. Its chairman Lee Iacocca had put in place a new model programme, but the new cars aimed at restoring the fortunes of the struggling company wouldn't be ready for launch until at least 1992. What Chrysler needed was something to excite the car-buying public right now. A small team was put together to create something at low cost – Chrysler didn't have much money to throw around then – but with an enormous 'Wow!' factor.

Fortunately, the perfect engine was available. The company had already developed an 8-liter V10 for its largest pick-up truck and this was shoehorned into an outrageously long and low two-seater sports car. The bonnet was enormous, to emphasize the power and potential of its engine, while the sharply cut-off rear resembled the haunches of a crouching beast. Massive side exhausts and enormous air vents completed the package.

In tribute to the Shelby Cobra, which was the initial inspiration for the project, the concept car that was revealed at the 1989 Detroit Motor Show was called the Dodge Viper. It was received with such enthusiasm that Chrysler put a small team of just 85 people to work on turning the Viper into a production car. Their collaboration was so successful that the first customer deliveries began in 1992.

The production car remained very true to the concept in appearance, though a huge amount of work behind the scenes was required. For example, although it would have produced

**DODGE VIPER SRT-10 2008**

**ENGINE:** 8,382 cc V10

**MAXIMUM POWER:** 600 bhp at 6,100 rpm

**MAXIMUM TORQUE:** 760 Nm at 5,000 rpm

**MAXIMUM SPEED:** 193 mph / 311 km/h

**0–60 MPH ACCELERATION:** 3.5 secs

**TRANSMISSION:** 6-speed manual

**LENGTH:** 175½ in / 4,459 mm

**WIDTH:** 75¼ in / 1,911 mm

**HEIGHT:** 47½ in / 1,210 mm

**WHEELBASE:** 98¾ in / 2,510 mm

**MANUFACTURE DATE:** 2008–present

**BRAKES:** disc (f and r)

**SUSPENSION:** double wishbone (f and r)

**WHEELS:** alloy, 18 in (f), 19 in (r)

**TIRES:** 275/35 ZR-18 (f), 345/30 ZR-19 (r)

Viper SRT-10 now produces 600 bhp at 6,100 rpm and 760 Nm of torque at 5,000 rpm thanks to input from both McLaren Automotive and consultant engineers Ricardo in the UK. That monstrous output translates into 0–60 acceleration in 3.5 seconds and a top speed of 193 mph / 311 km/h for the Roadster and 202 mph / 325 km/h for the more aerodynamic Coupé.

Since its initial launch, the Viper has changed a great deal, developing from a fast but relatively unrefined sports car into a truly great supercar, whose performance, handling and speed is at least as good as those of competitors such as the Audi R8, Ford GT and Porsche 911 Turbo. What has not changed is the Viper's 'Bad Boy on the Block' attitude. And all credit to Chrysler for that!

loads of power, the weight of the engine in its cast-iron form would have badly affected the handling of a light sports car. As a result, a new aluminium-alloy version was created with the help of Lamborghini. This 7,990 cc V10 produced 400 bhp but was 100 lb / 50 kg lighter than the original truck engine. It also had lots of torque – 630 Nm at 3,600 rpm – which allowed the six-speed manual transmission to be long-geared to provide fast acceleration and reasonable fuel economy at the same time.

The Dodge Viper's performance was outstanding – 0–60 mph in 4.5 seconds and a top speed of 165 mph / 266 km/h – but its appearance was even more incredible. Here was a genuine supercar, with head-turning presence on the street, that had been conceived and created on a shoestring budget. It was a triumph for Chrysler, not only because of the interest it created but also because it demonstrated that a small team working closely together could achieve great things. Chrysler learnt the lesson: from then on, each new model was created by a dedicated 'Platform Team'.

A hard-topped coupé, the GTS, was added to the range in 1996, and at the same time, the chassis was strengthened, the suspension and brakes were refined and the engine output was boosted to 450 bhp, which pushed the top speed up to 192 mph / 309 km/h. Since then, the Viper and its GTS stablemate have been steadily improved and enhanced. The very latest 2008

# Ferrari Enzo

Back in 1998, Ferrari boss, Luca Cordero di Montezemolo, had a big problem on his hands. The company had a history of producing supercars that set new standards. This started with the 250L in 1963, a road-legal racecar that became Ferrari's first supercar. Next came the GTO, launched in 1984 to massive critical acclaim, then the F40 in 1987 and the F50 in 1995. The company now had to come up with a successor to the fabulous F50, yet how was it going to create something even better than the supercar that had been designed to celebrate Ferrari's 50th birthday?

Montezemolo gave his engineers and the designers at Pininfarina three orders: make the car 'really impressive', employ the most radical technologies, and give it a clear association with the F1 racecars, which at the time were all conquering. Apparently, more than 20 proposals were considered, but the one that was ultimately chosen – and that became the Ferrari Enzo – was an aggressive silhouette with a nose resembling that of an F1 car and a body shape that was determined more by aerodynamic needs than by aesthetics. In short, the Enzo was never meant to look beautiful, just purposeful.

A brand-new V12 engine was commissioned, a 5,998 cc unit producing 660 bhp. Like Ferrari's F1 engine, it had a variable-length induction system and continuously variable exhaust-valve timing – a first for Ferrari. The engine and six-speed gearbox was bolted to the rear of the car's carbon-fibre tub.

Now came the 'radical technologies'. With the Enzo, Ferrari became the world's first manufacturer to integrate all the car's electronic control systems so that they could instantly communicate with each other and allow the central 'brain' to choose the optimum settings in all road conditions.

This connected the suspension (which had adaptive dampers that could be adjusted to provide more comfort or more body control) with the engine, transmission, traction control, ABS, aerodynamics and even the brakes. The brakes were carbon fibre, which produces immense stopping power. As in an F1 car, the driver could adjust the brake balance between front and rear.

The carbon-fibre bodywork was designed to optimize the car's aerodynamic performance. That's why it has a long front overhang and why, under the floor, there's a sophisticated venturi arrangement that speeds up the airflow, thereby increasing the downforce. It's so effective that at speeds over 180 mph /290 km/h, the downforce is more than 1,764 lb / 800 kg. The resulting appearance is far from elegant, but it works.

The Enzo's 0–62 mph acceleration is a tire-shredding 3.6 seconds, it can achieve 0–125 mph in 9.5 seconds and it has a maximum speed of 217 mph / 350 km/h. Like the F1, the Enzo has a 'Launch Control' incorporated into the transmission, which provides the fastest possible start by 'dropping' the clutch at the optimum engine speed.

Launched in 2002 at the Paris Motor Show, the Enzo would inevitably be compared with two other supercars introduced at about the same time: the Porsche Carrera GT and the Mercedes-Benz SLR McLaren. It's possible to argue about which is the best-looking, the most practical or even the best all-rounder. But there's no doubt at all that the Ferrari Enzo is both the quickest and the most technically advanced vehicle in the world.

Ferrari had originally planned to produce just 349 Enzos, at a list price of £450,000, but because of demand from existing F40 and F50 customers, this number was upped to 399. Later, one more car was built, numbered 400, and was auctioned for nearly twice the list price, for the benefit of survivors of the 2004 Tsunami in Southeast Asia.

**FERRARI ENZO 2002**

**ENGINE:** 5,998 cc V12

**MAXIMUM POWER:** 660 bhp at 7,800

**MAXIMUM TORQUE:** 658 at 5,500 rpm

**MAXIMUM SPEED:** 217 mph / 350 km/h

**0–60 MPH ACCELERATION:** 3.6 secs

**TRANSMISSION:** 6-speed semi automatic

**LENGTH:** 185 in / 4,702 mm

**WIDTH:** 80 in / 2,035 mm

**HEIGHT:** 45¼ in / 1,147 mm

**WHEELBASE:** 104¼ in / 2,650 mm

**MANUFACTURE DATE:** 2002–04

**BRAKES:** disc (f and r)

**SUSPENSION:** double wishbone (f and r)

**WHEELS:** alloy, 19 in

**TIRES:** 245/35 ZR-19 (f), 345/35 ZR-19 (r)

# Ferrari F40

'I asked my engineers to build me the best car in the world. And now it is here.' That is how Enzo Ferrari introduced the F40 model, the car launched to celebrate Ferrari's 40th anniversary in 1988. This was a truly special Ferrari, not least because it was the very last launched before the death, that same year, of the company's founder, Enzo himself. It was the very epitome of the 1980s supercar: its styling was aggressive and raw, its performance was head-and-shoulders above any other car of its time, and its handling was so good that only a truly skilled racing driver could extract the very maximum from its awesome potential.

The F40, designed like so many Ferraris by Pininfarina, was not beautiful, yet it looked so right. It certainly wasn't comfortable, yet none of its owners complained about that. And it wasn't particularly sophisticated in its engineering, yet its performance was all that really mattered. A top speed of 202 mph / 325 km/h was truly special back in 1988. The F40 was built just like a racing car, yet Ferrari never officially raced. However, it did provide assistance to privateers who wanted to extract the ultimate performance on the track – and some modified racecars eventually pushed out as much as 700 bhp.

**FERRARI F40 1988**

**ENGINE:** 2,936 cc V8

**MAXIMUM POWER:** 478 bhp at 7,000 rpm

**MAXIMUM TORQUE:** 576 Nm at 4,500 rpm

**MAXIMUM SPEED:** 202 mph / 325 km/h

**0–60 MPH ACCELERATION:** 3.5 secs

**TRANSMISSION:** 5-speed manual

**LENGTH:** 174½ in / 4,430 mm

**WIDTH:** 78 in / 1,980 mm

**HEIGHT:** 44½ in / 1,130 mm

**WHEELBASE:** 96½ in / 2,450 mm

**MANUFACTURE DATE:** 1988–91

**BRAKES:** disc (f and r)

**SUSPENSION:** independent double wishbone (f and r)

**WHEELS:** alloy, 17 in

**TIRES:** 245/40 ZR-17 (f), 335/35 ZR-17 (r)

rear screen were made of plexiglass, and even the seats were made from carbon fibre, all to save weight.

There were few concessions to creature comforts in the cockpit either. There were no carpets, no stereo, and not even any interior panelling – the doors and other panels were simply exposed carbon fibre. The one item that was included was air conditioning, but only because the Middle East was an important market for Ferrari and it realized that this really was essential there.

When it first announced the F40, Ferrari said it would produce just 400. But faced with an order bank that initially exceeded 3,000, the production line was kept rolling, and in the end, more than 1,300 examples were produced between 1988 and 1991. Even today, the F40 still looks fresh. It was conceived as an uncompromising sports car, one that would offer levels of performance previously unheard of in a road car. It was, and remains, a classic Ferrari, and it stands as a homage to the man who created it: the 'Old Man' himself, Enzo Ferrari.

Its suspension closely followed contemporary racing car design, with double wishbones front and rear, coil springs and dampers to ensure adequate braking, which was important, because the F40's performance was truly stunning for its day. It was entirely possible, in dry conditions, to spin the wheels when accelerating in first, second and third gears and, despite the massive tires (335/35 ZR17 at the rear and 245/40 ZR17 at the front), it took a highly skilled driver to balance the massive power delivery with the available grip.

That power came from an engine that was not directly linked to the current Ferrari F1 powerplant, but it was a V8 instead of the usual Ferrari high-revving V12. The F40's V8 was a twin-turbo, twin-turbocharged double overhead cam design that pushed 78 bhp through a five-speed manual transmission to the rear wheels. It achieved 0–60 mph in a tire-shredding 3.8 seconds, 0–100 mph took just 8.2 seconds. It's not certain whether the magic 200 mph / 322 km/h figure was actually achievable, but what was important at the time was that Ferrari claimed it for the F40.

Like the 288 GTO, to which the F40 was the spiritual successor, it had a tubular-steel chassis. But unlike the 288, the F40 made extensive use of Kevlar and carbon-fibre composites on the floorpan, fascia and bulkhead. In addition, its body panels were composed of composite materials, its side windows and

# Ford GT

It all started in 2002, when Ford decided it should make a massive statement to celebrate its forthcoming centenary. And what better way to pay heritage to the past, while at the same time looking confidently to the future, than to create a successor to the legendary 1960s Le Mans-winning GT40?

The concept car, which was unveiled at the 2002 Detroit Auto Show, shared the silhouette of the original GT40 and was obviously inspired by it. Some purists saw it as a weak retro pastiche, but most were enthused by the latter-day supercar project, and in general, it received such a favourable reception that Ford gave it the green light for production. The team with the task of turning what was no more than a show car into a street-legal production was given a deadline: the car had to be ready for the centenary celebrations in June 2003.

The exterior styling might hark back to the 1960s, but underneath, the Ford GT is all 21$^{st}$ century. Its aluminium body sits on an immensely strong aluminium spaceframe chassis. The 5.4-liter supercharged V8 engine is mid-mounted behind the passenger cabin and drives the rear wheels via a six-speed manual transmission and a limited slip differential. The suspension is all independent, with double wishbones front and rear.

On the road, the grip provided by the massive Goodyear Eagle tires is immense, helped in the downforce produced at higher speeds by the venturi tunnel designed into the floorpan. As with the McLaren F1, the Ford GT's designers chose to fit neither traction control nor an electronic stability control system, leaving it to the driver to harness the power of the V8 engine.

And what power! The all-aluminium V8 was already in use in different Ford trucks and SUVs, but for the GT40, a Lysholm supercharger was added, together with revised cylinder heads and hotter high-lift camshafts. The result is 550 bhp and 678 Nm of torque – more than enough to offer 0–60 mph acceleration in 3.7 seconds, 0–100 mph in 7.4 seconds and a top speed of 204 mph / 328 km/h.

Despite its awesome performance, the Ford GT is actually a reasonably practical proposition. Though it can be driven as fast as any Ferrari or Lamborghini, its massive torque and tractability means it can be cruised with ease – it can be left in third gear, for example, all the way from 30 mph / 48 km/h to 120 mph / 93 km/h.

The cabin is larger, more comfortable and more practical than that of the original GT40, which was hampered by being so low – the '40' of its name derived from its height, which was just 40 in / 1,016 mm. Thanks, too, to modern legislation, the latest Ford GT is longer, wider and higher than the original, and this allows more space for the driver and passenger to get comfortable. Like the original, however, the GT has no luggage space.

Ford announced a production run of just 4,500 examples of the GT and was immediately inundated with enquiries and orders. However, although early customers were even willing to pay premiums of $100,000 or more above the list price of $203,599, in the end, only 4,038 were built before production was stopped in 2006.

The Ford GT is one of the great supercars of the 21st century, one that more than achieved the ambitions of its designers to create a car that would combine all the performance, brilliance and image of a Ferrari 360 with the practicality, reliability, build quality and ease of driving of a Honda NSX. It was the perfect 100th birthday present for Ford.

**FORD GT 2003**

**ENGINE:** 5,409 cc V8

**MAXIMUM POWER:** 550 bhp at 6,500 rpm

**MAXIMUM TORQUE:** 678 Nm at 3,750 rpm

**MAXIMUM SPEED:** 204 mph / 328 km/h

**0–60 MPH ACCELERATION:** 3.7 secs

**TRANSMISSION:** 6-speed manual

**LENGTH:** 182¾ in / 4,643 mm

**WIDTH:** 77 in / 1,953 mm

**HEIGHT:** 44¼ in / 1,125 mm

**WHEELBASE:** 106¾ in / 2,710 mm

**MANUFACTURE DATE:** 2003–06

**BRAKES:** disc (f and r)

**SUSPENSION:** upper A-arm and lower L-arm (f and r)

**WHEELS:** alloy, 18 in (f), 19 in (r)

**TIRES:** 235/45 ZR-18 (f), 315/40 ZR-19 (r)

# Gumpert Apollo

The Gumpert Apollo is not pretty, but it's a technological tour de force. It was developed by former Audi Director of Motorsport Roland Gumpert and, perhaps not surprisingly, uses many Audi parts in its construction. Chief among these Audi parts is the twin turbo-charged 4.2-liter V8 that sits at the heart of the Apollo, mated to a six-speed sequential transmission. It's tuned to produce either 650 bhp in the 'base' Apollo, 690 bhp in the sportier Apollo S and an awesome 789 bhp in the Apollo R. Figures for the Apollo S show that peak power comes in at 6,300 rpm and maximum torque is 850 Nm at 4,000 rpm. The sheer volume of power, combined with the relative light weight of the car, gives it a power-to-weight ratio that's superior even to that of the McLaren F1, and its claimed performance is 0–60 mph in three seconds and a top speed of 220 mph / 354 km/h.

The Apollo's design is supercar conventional – like many others, it's a mid-engined, rear-wheel drive two-seater. Underpinning the car is a tubular frame, with either fibreglass body panels or, in the lightweight Apollo R, carbon-fibre panels. Suspension is by double wishbones front and rear with inboard

adjustable dampers. The ventilated disc brakes are also mounted inboard, with six-piston calipers both front and rear.

What's special is the car's aerodynamics. As well as the huge rear spoiler, it has an undertray consisting of two massive venturis extending the whole length of the car, which speed up the airflow under the car the faster it travels. This increase in air speed in turn lowers the pressure, with the result that the Apollo is claimed to have as much downforce as a DTM racecar. In fact, Gumpert goes further, suggesting that if driven at around 200 mph / 322 km/h, the car has so much downforce – some 2,646 lb / 5,833 kg – that it could actually be driven upside down in a tunnel!

And yet despite all this extreme high-tech engineering, the Apollo doesn't require a driving superstar at the wheel. It can be driven gently with little effort, thanks to the relatively light clutch, power-assisted steering and tractable power delivery from the Audi V8. But it's at higher speeds that the Apollo is transformed, and it really needs a racetrack to explore the limits of its astonishing performance. It has massive grip, neck-breaking acceleration and stunning stopping power.

In truth, the Gumpert Apollo is a racing car, just one that has been made street legal and been given a small boot to carry a modicum of luggage. The upward-swinging gullwing doors look sensational, but getting in and out over the wide side pods is far from easy. Once inside, the cabin is reasonably spacious for the driver and passenger, but the four-point harnesses indicate this is a car with serious intent.

Of course, none of this comes cheap. The price of the base Apollo is just over €300,000, with the Apollo S costing €378,000 and the Apollo R no less than €427,000. Gumpert remains a small, highly specialized company, but it plans production of some 30 cars a year. Those numbers won't frighten the likes of Ferrari, Lamborghini or Porsche, but the Apollo's sheer performance and all-round capability might give them something to think about, particularly as it seems there is more to come. Gumpert has already created a hybrid-powered Apollo, which was raced in 2008 at the 24 Hours Nürburgring race. And at the 2009 Geneva Motor Show, it unveiled the 800 bhp Apollo Speed, which has an even more aerodynamic body, lower ride weight, carbon-fibre wheels and a claimed 0–62 mph time of three seconds, 0–124 mph time of 8.9 seconds and a top speed of 224 mph / 360 km/h.

**GUMPERT APOLLO 2005**

**ENGINE:** 4,163 cc V8

**MAXIMUM POWER:** 650–789 bhp at 6,000 rpm

**MAXIMUM TORQUE:** 850 Nm at 4,000 rpm

**MAXIMUM SPEED:** 220 mph / 354 km/h

**0–60 MPH ACCELERATION:** 3.0 secs

**TRANSMISSION:** 6-speed sequential

**LENGTH:** 175½ in / 4,460 mm

**WIDTH:** 78¾ in / 1,998 mm

**HEIGHT:** 44 in / 1,114 mm

**WHEELBASE:** 106¼ in / 2,700 mm

**MANUFACTURE DATE:** 2005–present

**BRAKES:** disc (f and r)

**SUSPENSION:** double wishbone (f and r)

**WHEELS:** alloy, 19 in

**TIRES:** 255/35 ZR-19 (f), 345/35 ZR-19 (r)

# Jaguar XJ220

The outstanding star of the 1988 British Motor Show was a long, low, sleek mid-engined coupé that adorned the Jaguar stand. This was the XJ220, a stunning aluminium jewel powered by a massive V12 engine that produced over 500 bhp.

It featured four-wheel drive, an AP racing twin-plate clutch and a five-speed manual gearbox. It had a bonded-aluminium chassis with aluminium body panels, and the combination of massive power and relatively low weight promised blistering performance. Jaguar officials estimated a top speed of 220 mph / 354 km/h and acceleration from 0 to 60 mph in 3.5 seconds, figures that would have made the XJ220 the fastest car of its generation.

Wealthy enthusiasts queued up to place deposits for the car, even though no price had been mentioned and even though Jaguar insisted this was just a design study. But no-one was surprised when, just one year later, it was officially announced that the XJ220 would go into limited production in a joint venture between Jaguar and Tom Walkinshaw Racing, the company responsible for Jaguar's recent successes at Le Mans.

At the time, the world was in the grip of a speculative supercar boom, with cars such as the Ferrari F40 and Porsche 959 commanding massive premiums over their already elevated list prices. Perhaps swept along on a tide of enthusiasm, Jaguar announced an initial production run of 220 examples, with the provision of increasing this to 350 if demand was high enough, despite an eventual price tag of £403,000. Jaguar collected 350 firm orders in a matter of days, and looked set for a serious commercial success, until the supercar bubble collapsed a few months later, and those who had placed deposits began clamouring to get their money back, claiming they had been misled.

The reason for this was that in place of the V12 and four-wheel drive that had graced the concept car, the production XJ220 had a V6 Turbo engine and two-wheel drive. It was the same engine that had powered the very fast XJR-10 and the Metro 6R4 rally car, and produced 542 bhp at 6,500 rpm – more than enough to offer a top speed of over 200 mph / 322 km/h and acceleration from 0 to 60 mph in 4.0 seconds, but according to the disgruntled potential buyers, it wasn't what had been promised. There was further dismay when, in 1990, JaguarSport launched the XJR-15, which was fitted with the very same V12 that had originally been destined for the XJ220.

In the event, only 280 XJ220s were ever produced, and it took some years before the last of these found a good home. This was a pity, because the XJ220 had real potential. On the test track, it was timed at 217 mph / 349 km/h, so there was no doubting its performance, and indeed until the launch of the McLaren F1 in 1994, the XJ220 could claim to be the world's fastest car. In addition, it was a striking-looking design with impeccable build quality and incorporating the very latest manufacturing technology. It featured a bonded and riveted aluminium body/chassis with aluminium body panels, and though it lacked the concept's four-wheel drive system, it didn't need it for stability purposes, because it was the world's first road car to generate true ground effects. Thanks to a pair of underbody venturis, the XJ220 generated as much as 600 lb / 1,323 kg of downforce at 200 mph / 322 km/h.

Just how effective the XJ220's aerodynamics were can be judged by the car's 1993 win in the Grand Touring class at Le Mans, a track where the long Mulsanne Straight soon reveals any shortcomings of stability at high speeds.

Though Jaguar had created some stunning vehicles in the past – such as the one-off XJ13 – this was the company's first production supercar and it's unfortunate that its arrival coincided with the collapse of the supercar speculation bubble. Nevertheless it was an impressive machine.

**JAGUAR XJ220 1992**

**ENGINE:** 3,498 cc V6

**MAXIMUM POWER:** 542 bhp at 6,500 rpm

**MAXIMUM TORQUE:** 640 Nm at 4,500 rpm

**MAXIMUM SPEED:** 217 mph / 349 km/h

**0–60 MPH ACCELERATION:** 4.0 secs

**TRANSMISSION:** 5-speed manual

**LENGTH:** 191¼ in / 4,860 mm

**WIDTH:** 78¾ in / 2,000 mm

**HEIGHT:** 45¼ in / 1,150 mm

**WHEELBASE:** 104 in / 2,640 mm

**MANUFACTURE DATE:** 1992–94

**BRAKES:** disc (f and r)

**SUSPENSION:** independent wishbone (f and r)

**WHEELS:** alloy, 17 in (f), 18 in (r)

**TIRES:** 255/45 ZR-17 (f), 345/35 ZR-18 (r)

# Koenigsegg CCX

Back in 1994, wealthy Swedish businessman Christian von Koenigsegg had a dream: to create a world-beating road-legal supercar using Formula 1 technology. It's something many have aspired to, but the difference is that Koenigsegg actually achieved it. The first carbon-fibre concept appeared at the

Geneva Motor Show in 2000 and the first Koenigsegg CC 8S customer cars were delivered in 2002.

A new model, the CCR, was announced in 2004, and this gained international fame in 2005, when, at the massive Nardo test track in Southern Italy, it made it into the *Guinness Book of Records* as the fastest production car ever made. It was timed at 241.63 mph / 388.87 km/h as it took the crown from the McLaren F1. The Koenigsegg's record has since been eclipsed by the Bugatti Veyron (253.2 mph / 407.5 km/h), but it was still a massive achievement for what was, at the time, such a small company.

Koenigsegg's big move came in 2006 with the introduction of the CCX, a model designed from scratch to meet all US safety laws and even California's notoriously tough emissions legislation. The starting point was the engine. Previously, Koenigsegg had used Ford Modular V8 racing engines, but for the CCX, it developed and built its own engine at its factory on a military air base in Ängelhom, Sweden. It's a 4,719 cc all-aluminium V8 that has been subjected to a special heat

**KOENIGSEGG CCX 2006**

**ENGINE:** 4,719 cc V8

**MAXIMUM POWER:** 806 bhp at 6,900 rpm

**MAXIMUM TORQUE:** 920 Nm at 5,700 rpm

**MAXIMUM SPEED:** 259 mph / 417 km/h

**0–60 MPH ACCELERATION:** 3.2 secs

**TRANSMISSION:** 6-speed manual

**LENGTH:** 169 in / 4,293 mm

**WIDTH:** 78½ in / 1,996 mm

**HEIGHT:** 44 in / 1,120 mm

**WHEELBASE:** 104¾ in / 2,660 mm

**MANUFACTURE DATE:** 2006–present

**BRAKES:** disc (f and r)

**SUSPENSION:** double wishbone (f and r)

**WHEELS:** alloy, 20 in

**TIRES:** 335/30 ZR-20 (f and r)

a revised model called the CCX Edition, in which power was boosted to 888 bhp and torque to 921 Nm. It also featured a larger adjustable rear wing and a wholly carbon-fibre body.

Koenigsegg also produced an 'environmentally friendly' version of the CCX, the CCX-R, which was converted to run on ethanol biofuel as well as normal petrol. Incredibly, when running on biofuel it produces 1,018 bhp and 1,060 Nm of torque and improves acceleration from 0 to 62 mph to just 2.9 seconds. This is because biofuel has a higher octane value than the petrol sold at pumps and because it also has the effect of cooling the combustion chambers. The Koenigsegg CCX-R is the world's most powerful production car, overtaking the Bugatti Veyron (1,001 bhp).

Only two CCX Edition cars and four CCX-Rs were made, however, as Koenigsegg announced at the 2009 Geneva Motor Show that the company's future would lie in more environmentally sustainable products such as the Quant solar-electric sports car that it previewed at the Show.

treatment that strengthens the aluminium and thus allows thinner and lighter engine block to be employed. With the help of a pair of centrifugal superchargers, it produces 806 bhp at 6,900 rpm and 920 Nm of torque at 5,700 rpm. Dry-sump lubrication is employed so the engine can sit lower in the chassis. This engine is mated to either a six-speed manual or a sequential transmission, driving the rear wheels through a limited slip differential. Unusually, Koenigsegg customers can choose the gear ratios that best suit their driving style.

The CCX's body is slightly larger than that of the earlier CCR and is made from carbon fibre and Kevlar. The doors open by rotating forwards and upwards in an impressive design known as dihedral synchro-helix. There's even an element of practicality about the car in that it has a removable targa top that can be stored under the bonnet. With such massive performance on tap, attention to aerodynamics is crucial. The CCX has a totally flat underside with venturi tunnels at the rear to speed up the airflow and therefore increase the downforce. A rear spoiler is also an option.

According to Koenigsegg, the performance of the CCX is 0–62 mph in 3.2 seconds, 0–124 mph in 9.8 seconds and it has a top speed of 259 mph / 417 km/h. And yet for some, this still wasn't enough, and so in 2008, Koenigsegg created

# Lamborghini Countach

The Lamborghini Countach was probably the most stunning, shocking and ground-shaking design that the motor business has ever experienced. Its styling, when unveiled at the 1971 Geneva Motor Show, looked like something from outer space.

Lamborghini had proved itself a worthy adversary to Ferrari when it introduced its luscious Miura mid-engined supercar in 1966, but this latest model, again the work of stylist Marcello Gandini, abandoned the gentle curves of the Miura in favour of aggressive sharp edges and a wedge profile that no other manufacturer had dared offered before. If this wasn't enough, the Countach also sported outrageous 'scissor' doors and massive vents and scoops, some of which were needed for cooling purposes but all of which contributed to a truly over-the-top design. It was the new kid on the block, it was aggressive and self-confident, and it was determined to be noticed (the show car was painted a vivid yellow).

Three years later, the Countach went into production, by which time some changes had been made. The monocoque chassis of the show car had been replaced by a tubular frame, and the five-liter engine had been supplanted by a four-liter derivative, mainly because the five-liter had proved unreliable due to cooling problems – in fact, it had blown up during testing! But despite this, the production car was still an astonishing achievement.

What had not changed were the eye-catching lines that ran from the front to the back of the wedge-shaped car. Cooling remained an issue, which is why the distinctive vents remained, but it still looked like a car taken off the pages of sci-fi comic: it retained those magnificent scissor doors, guaranteed to draw a crowd whenever the Countach drew up outside a restaurant or theatre.

It also made a statement out on the open road. It had a mid-mounted V12 engine mounted longitudinally, with the gearbox at the front to improve weight distribution. Initially, six Weber carburetors provided the fuel, though later fuel injection was adopted. The original Countach produced 375 bhp at 8,000 rpm and 499 Nm of torque at 5,500 rpm, and achieved 0–60 mph in 5.6 seconds and a top speed of around 170 mph / 274 km/h, though that was a good

way below the 200 mph / 322 km/h that had been hoped
for from the planned five-liter. Incidentally, the Countach never
achieved 200 mph / 322 km/h, even in later years, when, in the
5000 QV model introduced in 1985, its engine was increased
to five liters and power reached 455 bhp – more than the
original prototype. The Countach looked magnificent, but its
aerodynamics were never brilliant, and its coefficient of drag of
around 0.4 meant even the final 25th Anniversary cars could only
manage 190 mph / 306 km/h.

The Countach may have been outrageous, but it remained
in production for 20 years, during which time it evolved and was
improved but it never lost its ability to draw the crowds. It finally
went out of production in 1991, by which time more than 2,000
examples had been built.

The most successful incarnation was the last, known as the
Countach Anniversary, launched in 1988 to mark Lamborghini's
25th anniversary. It was mechanically identical to the 5000 QV
but the body was substantially restyled. By this time, the company
had been bought by Chrysler, which pushed for the addition of
a few modern creature comforts, including air conditioning and
electric windows. In all, 650 examples of this last model were
sold, despite the car being by then close to 20 years old.

# Lamborghini Gallardo

A new chapter at Lamborghini began in 1998, when Volkswagen Group's Audi subsidiary bought the company from Indonesian President Suharto's eldest son, Tommy, who had gained his majority interest in 1993, when he picked up Chrysler's stake in the company. At that time, the Italian supercar company was making only around 200 Diablo cars a year, but Audi had far greater plans for the legendary marque. Its first job in turning round the company was to create a new range of cars, and the first of these, the Murcielago, arrived in 2002. But the Gallardo, which was launched in 2003, is significant as being the first Lamborghini developed wholly under Audi's ownership and

control. It was an instant triumph, successfully marrying Audi's German engineering skills with the heart and soul of the Italian supercar manufacturer.

Like all Lamborghinis, the Gallardo has massive visual presence: this is not a car that is going to go unnoticed on the road. Its aluminium body design is sharp, angular, aggressive and low, with front lights like blades and gaping cooling inlets. The original design was the work of Italdesign-Giugiaro, with final tweaks by Lamborghini's own Styling Center. The aluminium body panels are mounted on a light but immensely strong aluminium spaceframe chassis that features double wishbone suspension front and rear, massive Brembo brakes and Pirelli Pzero tires.

At the heart of the Gallardo is a newly developed V10 engine, whose block and cylinder heads are manufactured by Cosworth, the British engineering company whose engines have won more Formula 1 victories than those of any other supplier. The 5.0-liter V10 produces 500 bhp at 7,800 rpm and 510 Nm of torque at 4,500 rpm. In true racing fashion, it has variable valve timing and dry-sump lubrication, with throttle control performed via a Drive-by-Wire system. The transmission is a six-speed manual unit operated by paddles on the steering wheel, though a Lamborghini e-gear unit is also available, which offers a sequential gearshifting system and the ability to choose between normal, sport and automatic modes.

## LAMBORGHINI GALLARDO 2003

**ENGINE:** 4,961 cc V10

**MAXIMUM POWER:** 500 bhp at 7,800 rpm

**MAXIMUM TORQUE:** 510 Nm at 4,500 rpm

**MAXIMUM SPEED:** 197 mph / 317 km/h

**0–60 MPH ACCELERATION:** 3.9 secs

**TRANSMISSION:** 6-speed manual

**LENGTH:** 169¼ in / 4,300 mm

**WIDTH:** 74¾ in / 1,900 mm

**HEIGHT:** 45¾ in / 1,165 mm

**WHEELBASE:** 100¾ in / 2,560 mm

**MANUFACTURE DATE:** 2003–present

**BRAKES:** disc (f and r)

**SUSPENSION:** double wishbone (f and r)

**WHEELS:** alloy, 19 in

**TIRES:** 235/35 ZR-19 (f), 295/30 ZR-19 (r)

The Gallardo is unusual in supercar territory in that it has a permanent four-wheel drive system that normally distributes the drive 70 per cent to the rear and 30 cent to the front. Viscous couplings change the ratios under hard acceleration, braking or cornering to provide the optimum traction in all road conditions. Special attention was paid to getting the optimum weight distribution of 42 per cent front and 58 per cent rear, reckoned by Lamborghini's engineers to be perfect for a sports car.

The Gallardo's magnificent engine makes it possible for it to accelerate from 0 to 62 mph in only 3.9 seconds and to reach a top speed of 197 mph / 317 km/h. And the combination of the superbly balanced four-wheel-drive system, the fantastically precise steering and the sublime handling means that the performance potential is achievable even by drivers who will never compete at the top levels of motor sport. By supercar standards, the Gallardo is reasonably practical too: its cabin is spacious and comfortable for two, the conventional doors open wide for easy access and there's reasonable luggage storage at the front.

Soon after the launch of the Gallardo, two other models were added to the range: a convertible and a Superleggera, or Superlight, which is not only some 220 lb / 91 kg lighter, but also squeezes an extra 10 bhp out of its V10, giving it even more neck-breaking acceleration. Lamborghini's badge is a raging bull, and it's from this heritage that the Gallardo gets its name – it's a breed of fighting bull. And the car proves that Lamborghini is fighting in the marketplace too: the year after its launch, more than 2,000 Lamborghini Gallardos were sold.

# Lamborghini Murciélago

**LAMBORGHINI MURCIÉLAGO 2002**

**ENGINE:** 6,192 cc V12

**MAXIMUM POWER:** 580 bhp at 7,500 rpm

**MAXIMUM TORQUE:** 650 Nm at 5,400 rpm

**MAXIMUM SPEED:** 205 mph / 330 km/h

**0–60 MPH ACCELERATION:** 3.85 secs

**TRANSMISSION:** 6-speed manual

**LENGTH:** 180¼ in / 4,580 mm

**WIDTH:** 80½ in / 2,045 mm

**HEIGHT:** 44¾ in / 1,135 mm

**WHEELBASE:** 105 in / 2,665 mm

**MANUFACTURE DATE:** 2002–present

**BRAKES:** disc (f and r)

**SUSPENSION:** double wishbone (f and r)

**WHEELS:** alloy, 18 in

**TIRES:** 245/35 ZR-18 (f), 335/30 ZR-18 (r)

When Audi took over Lamborghini in 1998, a Bertone-designed successor to the Diablo was already quite close to production, but was abandoned by the new owners in favour of a design by Audi's chief designer, Luc Donckerwolke.

In 2002, this new model – named the Murciélago – was the subject of one of the most dramatic launches ever staged for a new car. Hundreds of journalists, owners, dealers and VIPs were flown to the slopes of Mount Etna in Sicily, where the car was unveiled in a spectacular *son et lumiére* show that included the eruption of artificial lava flows.

Back in the real world, there was some grumbling about the design of the new supercar, but that came mainly from Lamborghini die-hards, who struggled to accept that a Belgian could create an Italian masterpiece. The Murciélago was more angular than the Diablo it replaced, though it lacked the truly sharp edges of the original Countach. Its wedge-shaped body was created with angular lines at the front combined with more rounded curves elsewhere. Needless to say, the trademark Lamborghini air intakes and outlets were retained, as were the impressive scissors-opening doors.

The chassis was constructed from high-strength steel tubing with some structural elements, such as the floorpan, in carbon fibre. All the external body panels were fashioned from carbon fibre, with the exception of the roof and door panels, which were made from steel. The engine derived from the 30-year-old design that had powered the Countach for so long, but for the Murciélago it was updated with the very latest sophisticated

technology, including electronically controlled variable valve timing, drive by wire throttle, and a variable induction system. It also now had a dry-sump lubrication system, which allowed the engine to be mounted 2 in / 50 mm lower to reduce the center of gravity and improve handling. The capacity was stretched to 6,192 cc and the power output was boosted to 580 bhp at 7,500 rpm and torque to 650 Nm at 5,400 rpm. As for performance, it was as spectacular as the car's appearance – 0–62 mph in 3.85 seconds and a top speed of some 205 mph / 330 km/h.

Just as important as its outright performance was the Murciélago's driveability, which was much improved over that of earlier Lamborghinis. Its smoother torque curve and sophisticated electronic engine management system made it much more tractable in traffic, and its high-speed handling, stability and grip were also greatly improved, thanks to the rigidity of the structure, the lowered center of gravity, improved aerodynamics and superbly tuned suspension.

The Murciélago had an impressively low drag coefficient, though for the sake of stability it has an adjustable rear wing that increases downforce (and inevitably drag) at higher speeds. The rear wing sits completely flush with the bodywork until the car reaches 80 mph / 129 km/h, at which speed it rises to 50 degrees, then at around 135 mph / 217 km/h it rises again to 70 degrees, where it generates enough downforce for the car to remain extremely stable, even at speeds above 186 mph / 299 km/h.

Permanent four-wheel drive was standard, as was a six-speed manual transmission, though a year after the initial launch, a new e-gear sequential gearbox was offered as an option. The layout was typically Lamborghini, with a mid-mounted engine, the transmission mounted in front of the engine, with the rear differential integrated into the engine unit, and a central viscous coupling that adjusts the torque between the front and rear wheels as required to maintain optimum traction.

Lamborghini launched a convertible version of the Murciélago in 2004, and in 2006, introduced the uprated Murciélago LP640, in both hardtop and convertible versions, with a new 6,496 cc V12 engine, producing 640 bhp at 8,000 rpm and 660 Nm of torque at 6,000 rpm. By now, the 0–62 mph acceleration time had dropped to 3.4 seconds, though the official top speed remained at 205 mph / 330 km/h. At the time of its launch, the roadster was billed by Lamborghini as being the fastest convertible on the road.

# Lotus Esprit Turbo

**LOTUS ESPRIT TURBO 1980**

**ENGINE:** 2,174 cc inline 4-cylinder

**MAXIMUM POWER:** 210 bhp at 6,250 rpm

**MAXIMUM TORQUE:** 271 Nm at 4,500 rpm

**MAXIMUM SPEED:** 150 mph / 241 km/h

**0–60 MPH ACCELERATION:** 5.6 secs

**TRANSMISSION:** 5-speed manual

**LENGTH:** 165 in / 4,191 mm

**WIDTH:** 73 in / 1,852 mm

**HEIGHT:** 44 in / 1,118 mm

**WHEELBASE:** 96 in / 2,438 mm

**MANUFACTURE DATE:** 1980–92

**BRAKES:** disc (f and r)

**SUSPENSION:** upper wishbone (f), double transverse link (r)

**WHEELS:** alloy, 15 in

**TIRES:** 195/60 VR-15 (f), 235/60 VR-15 (r)

The origins of the Lotus Esprit – the model that replaced the two-seat mid-engined Lotus Europa – go back as far as 1972, when Giorgio Giugiaro's ItalDesign showed a Silver Car concept based upon a Europa chassis. It was an astonishing, angular, 'folded-paper' design that used straight lines to create a visually stunning wedge shape. Lotus immediately started work on making it a production reality, and the M70 project was born. This in turn evolved into the Lotus Esprit, which was launched at the 1975 Paris Motor Show and went into production the following year.

It was fitted with a Lotus four-cylinder 2.0-liter engine producing 160 bhp, which drove the rear wheels via a five-speed manual transmission that formed part of the rear transaxle. It wasn't a huge amount of horsepower, but as the Esprit weighed less than 2, 205 lb / 1,000 kg and handled better than any previous Lotus model, its actual performance was outstanding. (The official Lotus figures of 6.8 seconds for 0–60 mph acceleration and top speed of 138 mph / 222 km/h may have been exaggerated, however; contemporary roadtests suggest that eight seconds and 133 mph / 214 km/h are nearer the mark.)

But more was to come. In 1980, Lotus held a party in London's Albert Hall, where it revealed a new turbocharged Esprit, resplendent in the colours of the Essex Lotus F1 team livery. Giugiaro had been commissioned to revise the bodywork

of this new Esprit Turbo, which concealed what was practically an all-new car. It had a new backbone chassis-frame, completely revised rear suspension and much improved aerodynamics. Most important was the engine: it was still a four-cylinder unit, now bored out to 2.2 liters, but with the addition of a turbocharger, its peak power was increased to 210 bhp at 6,250 rpm and peak torque 271 Nm at 4,500 rpm. Significantly, the engine was tuned to produce much of its torque low down, so the Esprit Turbo was extremely flexible and didn't suffer excessively from the turbo lag that blighted many early turbocharged cars. Very few other changes were necessary to cope with the extra power, which was a tribute to the original Esprit, but a larger clutch was fitted along with larger brake discs.

At £20,950, the Lotus Esprit Turbo was not cheap, but it was a real supercar. Its 0–60 mph acceleration was now down to 5.6 seconds and the top speed was 150 mph / 241 km/h. Better still, it handled beautifully, had enormous levels of grip and well-weighted steering. No wonder one contemporary road tester described it as 'the perfect driving machine'.

The first 100 cars off the production line all had that same F1-inspired Essex Lotus livery that had been seen on the first Turbo to be revealed. They also all had air conditioning, a sophisticated stereo system and a special scarlet leather interior trim. In 1980, a more usual range of colours was offered, and the price was dropped to £16,917, though the air conditioning and stereo then became optional extras.

The car also received a massive publicity boost that year when it was featured in the James Bond film *For Your Eyes Only*.

(This was the second time the Esprit had found its way into an Bond film: in 1977, a normally aspirated Esprit had appeared in *The Spy Who Love Me*, during which it converted into a submarine.)

In 1986, the Esprit Turbo gained a power boost when the engine compression was raised. These High Compression (Esprit Turbo HC) models put out 215 bhp, but more importantly, the torque was raised to 300 Nm, which made the car even more tractable. The Esprit Turbo continued after 1987 in a far more rounded body designed by Peter Stevens, who went on to design the McLaren F1. For many, however, it's the original Giugiaro/ItalDesign style that remains the real thing.

# Maserati Bora

There was only one star of the 1971 Geneva Motor Show – a stunning new mid-engined supercar on the Maserati stand whose beautiful bodywork had been penned by Giorgetto Giugiaro and whose mechanical design was by Maserati's engineering chief Giulio Alferi. The Maserati Bora was the first car produced by the Italian firm since it had been bought by Citroën in 1968 and it accurately reflected the way supercar design was moving – away from the traditional front-engine and towards the mid-engined concept. De Tomaso had its Mangusta and Lamborghini had its Miura. Now it was Maserati's turn.

The Bora had a steel monocoque with a separate steel rear subframe to which the engine and transmission was mounted. As well as reducing vibrations into the passenger compartment, this layout resulted in a 42:58 weight distribution front to rear, which in turn contributed to good handling characteristics. The steel body panels were produced for Maserati by Officine Padane of Modena in Italy. Though the suspension was conventional – wishbones with coil springs, shock absorbers and anti-roll bars front and rear – this was actually the first time that Maserati had offered fully independent rear suspension. The braking system

was also a first for Maserati, inherited from Citroën and employing high-pressure hydraulics to operate the ventilated disc brakes. Those same hydraulics also powered the clutch, the retractable headlights and, most interestingly, the pedal box, consisting of the clutch, brake and throttle assemblies, which could be moved forward and back in relation to the fixed driver's seat.

The mid-mounted engine was Maserati's 4,719 cc V8 with four Weber carburettors that was longitudinally mounted and drove the rear wheels via a five-speed ZF transaxle. Power output for cars destined for the European market was set at 310 bhp at 6,000 rpm with peak torque of 440 Nm at 4,200 rpm. The Bora's 0–60 mph time is usually quoted as 7.1 seconds, though the British magazine *Autocar* claimed it achieved 6.5 seconds to 60 mph and 15.3 seconds to 100 mph. Top speed was close to 170 mph / 274 km/h, with first gear being good for around 50 mph / 80 km/h, second up to at least 80 mph / 129 km/h, third to 120 mph / 193 km/h, fourth to 147 mph / 237 km/h and fifth to some 168 mph / 270 km/h. US-specification cars had a lower output because of emissions regulations and performance inevitably suffered somewhat.

If the Maserati Bora's performance was in the supercar category, then so were its looks. It was low, sleek and boasted a remarkably large glass area with a wide wraparound front screen and further large glass panels over the engine compartment and the long rear quarters. The stainless-steel roof and A-pillars added contrast to the body colour and were a unique feature of the Bora, whose overall design bore many of the hallmarks of the earlier Ghibli – perhaps no surprise as both were penned by Giugiaro. Also distinctive were the Bora's Campagnolo alloy wheels with their unusual polished stainless-steel hubcaps.

For a supercar, an unusual degree of attention was paid to comfort and luxury. For a start, the passenger cabin was insulated from engine noise by an extra removable carpeted aluminium panel and the rear window between the passengers and the engine was double glazed. The car was fitted with air conditioning and electric windows and the Bora also had a modicum of practicality that its rival lacked, including quite reasonable luggage space in the front boot.

Later on, in 1975, Maserati fitted the Bora with a larger 4.9-liter engine that raised the power output to 320 bhp at 5,500 rpm and increased the peak torque to 454 Nm at 4,000 rpm. By the time the Bora went out of production in 1979, 524 had been built. The Bora was also the basis of the 2+2 Maserati Merak that was sold between 1972 and 1983. The latter was powered by the physically smaller V6 – also used by the Citroën SM – in order to provide space for rudimentary rear seats.

**MASERATI BORA 1973**

**ENGINE:** 4,719 cc V8

**MAXIMUM POWER:** 310 bhp at 6,000 rpm

**MAXIMUM TORQUE:** 440 Nm at 4,200 rpm

**MAXIMUM SPEED:** 170 mph / 274 km/h

**0–60 MPH ACCELERATION:** 7.1 secs

**TRANSMISSION:** 5-speed manual

**LENGTH:** 96 in / 4,328 mm

**WIDTH:** 68 in / 1,730 mm

**HEIGHT:** 44½ in / 1,133 mm

**WHEELBASE:** 102¼ in / 2,596 mm

**MANUFACTURE DATE:** 1971–79

**BRAKES:** disc (f and r)

**SUSPENSION:** independent wishbone (f and r)

**WHEELS:** alloy, 15 in

**TIRES:** 215/70 VR-15

# McLaren F1

**MCLAREN F1 1994**

**ENGINE:** 6,064 cc V12

**MAXIMUM POWER:** 627 bhp at 7,400 rpm

**MAXIMUM TORQUE:** 649 Nm at 5,600 rpm

**MAXIMUM SPEED:** 231 mph / 372 km/h

**0–60 MPH ACCELERATION:** 3.2 secs

**TRANSMISSION:** 6-speed manual

**LENGTH:** 168¾ in / 4,288 mm

**WIDTH:** 76¾ in / 1,820 mm

**HEIGHT:** 45 in / 1,140 mm

**WHEELBASE:** 107 in / 2,718 mm

**MANUFACTURE DATE:** 1994–97

**BRAKES:** disc (f and r)

**SUSPENSION:** double wishbone (f and r)

**WHEELS:** alloy, 17 in

**TIRES:** 235/45 ZR-17 (f), 315/45 ZR-17 (r)

From the very outset, the McLaren F1 was planned to be the greatest supercar ever built. That didn't just mean it would be the fastest, though it certainly was. And it didn't just mean it should be the most expensive and exclusive, though it most certainly was. It meant it should be conceived, designed and engineered absolutely without compromise. So if gold was the best reflector of heat, gold would be used in the engine bay. If supercharging and turbocharging would result in even minute delays between the driver pushing the throttle and the engine responding, then an all-new naturally aspirated engine would be commissioned. And if the strongest and lightest material for the structure of the car was carbon fibre, then that would be specified, whatever the cost and however difficult it made the manufacturing process.

The F1 was conceived by Gordon Murray, a brilliant South African engineer who had made his name at the Brabham Formula 1 team, creating a series of innovative designs that pushed the boundaries of both current technology and current regulations. The design was by Peter Stevens, who worked alongside Murray to create a car that was both elegant and superbly packaged. Both men wanted to avoid aesthetically ugly large spoilers, so to ensure high-speed stability, the F1 was designed to incorporate Formula 1-style ground-effect aerodynamics, which meant that the faster it was driven, the more downforce was applied to the wheels.

Low weight was an obsession for Murray, whose ambition was that the F1 should weigh no more than 2,205 lb / 1,000 kg.

In the event, that was unachievable (it ended up at 2,513 lb / 1,140 kg), but the quest for low weight meant, among other things, that the car had to be extremely compact. To provide decent interior space, Murray specified a central driving position, with passenger seats on either side and just behind the driver. It made getting in and out a bit of a struggle for the driver, but once in place, he or she was perfectly positioned to enjoy an unrivalled driving experience.

Behind the passenger cabin was the mid-mounted six-liter V12 that BMW built to Murray's specifications.

It was a lightweight, all-alloy design, driving the rear wheels via a six-speed manual transmission. Because of the need to save weight, and because Murray wanted this to be a true drivers' car, there was no four-wheel drive, no power assistance for the brakes, no traction control and not even an ABS system. But because the chassis was so finely engineered, and because the aerodynamics were so perfectly tuned, the F1 was more than capable of handling the 627 bhp that the V12 churned out at 7,400 rpm. It was also capable of handling the highest speed any road car had achieved up till then – 231 mph / 372 km/h.

A few cars were built for racing, and the McLaren F1 was extremely successful at Le Mans, winning outright despite having been originally conceived as a road car. But more important was its performance on the road: quite simply, the McLaren F1 remains the greatest supercar ever devised. Performance figures are truly staggering: 0–60 mph in just over 3 seconds, 0–100 mph in 6.5 seconds, 0–125 mph in 9.8 seconds and 0–200 mph in under 30 seconds. The McLaren F1 not only set new standards, it raised the bar so high that it would take years before any other manufacturer produced a car with a higher top speed or better acceleration.

And yet, paradoxically, the F1 was not a commercial success. It was launched in 1992 at a time of economic turmoil, and although the original plan was to sell 350 examples, only around 100 roadgoing cars were delivered before production finally ceased in 1997. The price of £634,500 reflected the 'money no object' style of the development programme, and yet it's estimated that McLaren still lost money on the project.

# Mercedes-Benz SLR McLaren Roadster

The Mercedes-Benz SLR McLaren came about in 2003 when Mercedes-Benz and its Formula 1 partner McLaren decided to combine their experience to create a new supercar for the road. The 'SLR' part of the name is important because it unites the legend of the highly successful SLR racing models of the 1950s with the cutting-edge technology of modern Formula 1 vehicles from the Vodafone–McLaren–Mercedes team.

Stylistic elements such as the arrow-shape tip of the F1 Silver Arrow establish a visual link with the modern racing cars,

while the 1950s SLR legend lives on stylistically in the distinctive lateral louvres, side pipes behind the front wheels and the wide-opening gullwing doors. Mercedes-Benz and McLaren produced a Coupé version of the SLR first in 2004, and the convertible Roadster followed in 2007.

With the exception of the two aluminium engine frames, the body of the SLR Roadster is made entirely from carbon-fibre-reinforced plastic, which offers extremely low weight, incredible strength – and therefore passenger safety in the event of an accident – and a degree of torsional stiffness that no other open-topped car has yet achieved. Its fabric roof can be opened or closed in less than ten seconds to ensure the car remains practicable in all weathers, and the design has been fine-tuned in a wind tunnel to ensure that high-speed handling and aerodynamics are optimized. Interestingly, attention was also paid to aeroacoustics, so, Mercedes claim, it's still possible to carry on a normal conversation at 124 mph / 200 km/h with the top down!

But what the SLR is really all about is performance. Its five-liter AMG V8 supercharged powerplant is positioned front-mid-engine for optimum weight distribution and is mated to an AMG Speedshift R five-speed automatic transmission with

## MERCEDES-BENZ SLR MCLAREN ROADSTER 2007

**ENGINE:** 5,439 cc V8

**MAXIMUM POWER:** 617 bhp at 6,500 rpm

**MAXIMUM TORQUE:** 780 Nm at 3,250–5,000 rpm

**MAXIMUM SPEED:** 201 mph / 323 km/h

**0–60 MPH ACCELERATION:** 3.8 secs

**TRANSMISSION:** 5-speed automatic

**LENGTH:** 183¼ in / 4,656 mm

**WIDTH:** 75 in / 1,908 mm

**HEIGHT:** 49¾ in / 1,261 mm

**WHEELBASE:** 106¼ in / 2,700 mm

**MANUFACTURE DATE:** 2007–present

**BRAKES:** disc (f and r)

**SUSPENSION:** double wishbone (f and r)

**WHEELS:** alloy, 18 in

**TIRES:** 245/40 ZR-18 (f), 295/35 ZR-18 (r)

controls, a starter button that glows red when the key is in, and lots of aluminium and fine leather. Though it shares its basic concept with the Coupé, the SLR Roadster has more than 500 components that are either new or uprated. Obviously the soft top is new, but there are also changes to the boot lid, windscreen, doors, rear wings and roll-over bars.

The Mercedes-Benz SLR Roadster, like the Coupé before it, was produced at McLaren's Formula 1 factory in Woking, England, and it's not just the fastest convertible ever to wear a Mercedes-Benz badge, it's also the most expensive, at an eye-watering £350,000 – a little more than the £333,000 cost of the Coupé. But for the fortunate few, the SLR Roadster is the ultimate stimulation for the senses. It offers all the driving performance, technology and design of the SLR Coupé with the additional joy to be had from open-top motoring, and that makes it a unique supercar.

steering-wheel-mounted paddle shifters. Maximum power is a healthy 617 bhp at 6,500 rpm and its maximum torque of 780 Nm at 3,250 rpm ensures that acceleration is neck-breaking, 3.8 seconds from 0 to 62 mph, while the top speed is 201 mph / 323 km/h. Remarkably, and despite its extra weight, the Roadster is only marginally slower than the Coupé, which can reach a speed of 207 mph / 333 km/h.

To ensure the SLR Roadster stops as well as it goes, it is fitted with an advanced electro-hydraulic braking system that employs carbon-fibre-reinforced lightweight ceramic brakes. A high degree of safety is ensured by unique carbon-fibre crash elements, steel-reinforced A-pillars and two fixed roll-over bars. The comprehensive specification also features adaptive airbags, knee and side airbags as well as seat-belt tensioners and a tire-pressure monitoring system.

The SLR Roadster's styling closely resembles that of the Coupé: it has a long bonnet and short tapered tail, the eye-catching front-opening scissor doors, the massive side vents and the side exhaust pipes, and the active aerodynamics, including a spoiler mounted on the rear air brake. As the spoiler's angle is altered, so the amount of downforce it provides is increased. Inside the cabin there are body-contoured carbon-fibre sports seats, a sport steering wheel with fingertip gearshift

# Mercedes-Benz SLR McLaren Stirling Moss

It has no roof and no windscreen, it's the ultimate SLR, aimed at providing unadulterated high-speed excitement, and it's named after one of the greatest Mercedes-Benz SLR drivers ever. Stirling Moss, with his navigator Denis Jenkinson, won the Mille Miglia in 1955, a race run over normal roads, through towns and villages in central Italy, at an average speed of over 100 mph / 161 km/h. He covered more than 1,000 miles / 1,610 km in 10 hours, 7 minutes and 48 seconds and he still holds the Mille Miglia record.

It was an awesome achievement, and the car that now bears his name is equally incredible. For a start, the SLR Stirling Moss accelerates from 0 to 62 mph in a scorching 3.5 seconds and runs on to a top speed of 217 mph / 349 km/h, powered by a supercharged V8 engine churning out a massive 650 bhp.

According to Mercedes-Benz, the new SLR Stirling Moss unites the character of the current SLR models with the fascination of the SLR of 1955. The core values of both the historical and the present-day SLR models are married with an exciting new design, innovative technology, high-class materials displaying perfect craftsmanship and, above all, a unique driving experience for all the senses. To ensure the lightest possible weight, the entire bodywork is created from carbon fibre. The arrow-shaped design has a strikingly long bonnet and a compactly muscular rear, where two air scoops behind the driver and passenger hide additional roll bars. Powerfully contoured

wings with black-painted ventilation slats provide a reminder of the 300 SLR of the 1950s, and, like the original car, the SLR Stirling Moss has high side skirts. It was these that lead the designers to incorporate dramatic folding swing doors that open forwards.

Inside, the cockpit is reduced to bare essentials, sculpted from carbon fibre and aluminium, and there's an aluminium plate engraved with the signature of Stirling Moss around the gear lever. Fine-quality leather seats are just about the only concession made to creature comforts. This Spartan theme extends even to protection from the elements – there is no roof and there are no side windows, just a pair of wind deflectors a couple of centimeters high to direct the airflow over the heads of the occupants. If the car has to be parked outside, it can be closed by two tonneau covers, which are carried in the boot.

Though it looks radically different to the 'standard' Mercedes-Benz SLR McLaren, this car clearly derives from that model. One common feature is the aerodynamic concept that combines a closed underbody with a diffuser in the rear bumper for maximum possible downforce at the rear, though in the Stirling Moss, this difffuser is much larger than that of the Coupé and Roadster. And when, at the highest speeds, even the downforce generated by the diffuser needs a little help, there's a manually operated airbrake that further increases the contact pressure. It can also be raised during powerful braking at speeds above

75 mph / 121 km/h to ensure maximum stability.

Yet despite the lack of standard creature comforts and the extremely high performance potential of this latest supercar from the Mercedes-Benz stable, the SLR Stirling Moss is not aimed at the racetrack, but rather at 'individuals who have exquisite requirements and nurture very special dreams'. It might be mentioned, too, that this car is also aimed at extremely wealthy individuals, as the price is €750,000. And that it's also aimed

exclusively at existing Mercedes-Benz SLR McLaren customers: they alone will be offered the opportunity to buy one of just 75 examples that are being built. For the fortunate few, this supercar looks likely to become a serious collector's item, because it is planned that it will be the final SLR to be built: these SLR Stirling Moss cars, bearing chassis numbers one to 75, will bring the SLR era to an end.

| MERCEDES-BENZ SLR MCLAREN STIRLING MOSS 2009 |
| --- |
| **ENGINE:** 5,439 cc V8 |
| **MAXIMUM POWER:** 650 bhp at 6,500 rpm |
| **MAXIMUM TORQUE:** 820 Nm at 4,000 rpm |
| **MAXIMUM SPEED:** 217 mph / 349 km/h |
| **0–60 MPH ACCELERATION:** 3.5 secs |
| **TRANSMISSION:** 5-speed automatic |
| **LENGTH:** 189¾ in / 4,820 mm |
| **WIDTH:** 86½ in / 2,194 mm |
| **HEIGHT:** 48 in / 1,220 mm |
| **WHEELBASE:** 106¼ in / 2,700 mm |
| **MANUFACTURE DATE:** 2009–present |
| **BRAKES:** disc (f and r) |
| **SUSPENSION:** double wishbone (f and r) |
| **WHEELS:** alloy, 19in |
| **TIRES:** 255/35 ZR-19 (f), 295/30 ZR-19 (r) |

# Morgan Aero 8

Morgan, the most traditional of all British sports car makers, tends to launch a new model about once every 30 years, so there was a frisson of excitement in the air at the 2000 Geneva Motor Show when chief executive Peter Morgan prepared to unveil the Aero 8. As the wraps came off, there was a stunned silence, because the new car, while clearly a Morgan, had a closed cabin, aerodynamic bodywork and very strange headlights. It polarized opinion: onlookers – and presumably Morgan customers too – either loved it or hated it. It was a design about which it was impossible to be indifferent.

This was a big risk for a small family-owned company like Morgan to take. It had tried once before to persuade its customers into a more modern design. Its Plus Four Plus, launched in 1964, was an elegant coupé with styling rather similar to the MGA. It was far more comfortable than the traditional Morgan, and had far better aerodynamics, but it was a commercial disaster because Morgan's customers simply preferred the older, pre-war design.

The most radical aspect of the Aero 8 lies in its construction. Gone is the traditional Morgan wooden frame, which is replaced by an aluminium alloy chassis with aluminium body panels mounted upon it. At the time, this was not just radical for Morgan, it was also leading the industry: Morgan was using formed aluminium panels significantly earlier than either Aston Martin or Bentley, and its chassis used the same technology that Lotus employed in the Elise.

A further innovation for Morgan was the fully independent suspension with a cantilever upper arm and lower wishbone with inboard coil springs and shocks at the front, and transverse wishbones with cantilever mounted inboard coils springs and shocks at the rear. In the original 2002 version, power came from a BMW-sourced 4,398 cc V8, producing 286 bhp at 5,400 rpm and 440 Nm of torque at 3,600 rpm, mated to a six-speed manual transmission driving the rear wheels. That was more than enough to offer 0–62 mph acceleration in 4.5 seconds and a top speed of just under 160 mph / 256 km/h.

| MORGAN AERO 8 2002 | | WIDTH: 69¾ in / 1,770 mm |
|---|---|---|
| ENGINE: 4,398 cc V8 | | HEIGHT: 47¼ in / 1,200 mm |
| MAXIMUM POWER: 286 mph at 5,400 rpm | | WHEELBASE: 99½ in / 2,525 mm |
| MAXIMUM TORQUE: 440 Nm at 3,600 rpm | | MANUFACTURE DATE: 2000–present |
| MAXIMUM SPEED: 160 mph / 256 km/h | | BRAKES: disc (f and r) |
| 0–62 MPH ACCELERATION: 4.5 secs | | SUSPENSION: independent lower wishbone (f), independent transverse wishbone (r) |
| TRANSMISSION: 6-speed manual | | WHEELS: alloy, 18 in |
| LENGTH: 162¼ in / 4,120 mm | | TIRES: 255/40 ZR-18 |

The Aero 8 is ferociously fast, but the whole car has been designed to cope with this. It has massive disc brakes, all with ABS, electronic brakeforce distribution and drag torque control to prevent lock-up. It has an electro-hydraulic power steering system to provide assistance at low speeds without interfering with the accuracy of the steering at higher velocities. And despite the lack of anti-roll bars, it corners without any body roll, thanks to the Morgan-designed suspension, which offers both a reasonable ride and outstanding grip and poise.

In many ways, the Aero 8 is a great car. The only problem, for some people, were those weird cross-eyed headlamps. This aspect was addressed in 2007, when the front end was redesigned to incorporate more conventional xenon lights. At the same time, some minor changes were made at the rear, including the addition of a small ducktail to improve stability. Then, in 2008, BMW's bigger 4.8-liter V8 was fitted, along with the option of either manual

or automatic transmission. This boosted the power output to 368 bhp and the top speed to 170 mph. While 0–62 mph acceleration for the manual car remains at 4.5 seconds, the auto is actually quicker, recording 4.2 seconds.

Unlike the earlier Morgan Plus Four Plus, the Aero 8 has been a major commercial success for the company: more than 600 examples of the bespoke hand-built sports car have been delivered to customers so far. Interest may have been boosted by the car's successes at Le Mans and in the FIA GT3 European Championship, but the main reason customers add their names to Morgan's long waiting lists is that the Aero 8 provides all the performance of a Porsche 911 in a car that's both instantly recognizable and yet rare.

# Pagani Zonda

Horacio Pagani spent his childhood modelling supercars out of wood and clay and later found himself a job as a junior mechanic at Lamborghini. Specializing in carbon-fibre manufacturing techniques, he found himself working on the development of the Countach Evoluzione, the world's first car with a carbon-fibre chassis. He left in 1988 to set up his own consultancy, which was immediately contracted by Lamborghini to help develop the composites for the Diablo and Countach Anniversary models.

But in the meantime, he started working on his own pet project – the development of a supercar codenamed the 'C8 Project', which Pagani planned to call the Fangio F1 in honour of his motor-racing hero. A major breakthrough came in 1994, when Mercedes-Benz agreed to supply him with its V12 engine, but it took five more years of hard work before the first car was ready to be unveiled at the 1999 Geneva Motor Show. Because Fangio had died by then, the car's name was changed to the C12 Zonda, after a wind that blows in the Andes mountains in South America.

That first Pagani Zonda, like all Zondas since, had its engine mounted behind the passenger cockpit driving the rear wheels. Its AMG-tuned Mercedes V12 produced 542 bhp and provided sparkling performance – a 0–60 mph acceleration time of 3.7 seconds, a 0–100 mph time of 7.5 seconds and a top speed of around 220 mph / 354 km/h, which made it one of the fastest cars in the world. It looked the part, too, thanks to its carbon-fibre bodywork and squat, aerodynamic lines. With a price tag of $320,000, it was never intended to be a mass-produced car, but the company has sold an average of about ten cars a year since.

Because the cars are hand-built, it's relatively easy to make changes to the specification, and Pagani was offering a slightly faster C12 S model by 2001. For the first time, a convertible version of the model was offered, as well as a coupé. In 2002, the output of the engine was dramatically increased with the installation of a new 7,291cc V12, which produced 547 bhp, pushed the top speed up to 224 mph / 360 km/h and reduced the 0–60 mph acceleration to 3.5 seconds. Another model was added to the range in 2004 – the Zonda C12 S Monza. With more than 600 bhp on tap, a lighter body and modified aerodynamics, it offered a whole new level of performance. Next up, in 2005, was the Zonda F, which, again, was available in both roadster and coupé formats and produced in excess of 600 bhp. And yet, astonishingly, there was still more to come.

The 2009 Zonda R produces 750 bhp at 7,500 rpm and 710 Nm of torque at 5,000 rpm from its 5,987 cc dry-sump bi-turbo Mercedes-Benz AMG V12, powering the rear wheel via a six-speed sequential transmission. To help in transmitting so much power to the road, a 12-stage Bosch Motorsport traction-control system is standard, while to ensure adequate stopping power, massive ventilated Brembo brakes are fitted, with six-piston callipers at the front and four-piston callipers at the rear. The suspension system uses double A-arms with forged suspension

**PAGANI ZONDA R 2009**

**ENGINE:** 5,987 cc V12

**MAXIMUM POWER:** 750 bhp at 7,500 rpm

**MAXIMUM TORQUE:** 710 Nm at 5,000 rpm

**MAXIMUM SPEED:** 217 mph / 349 km/h

**0–62 MPH ACCELERATION:** 2.7 secs

**TRANSMISSION:** 6-speed sequential

**LENGTH:** 188 in / 4,775 mm

**WIDTH:** 81 in / 2,055 mm

**HEIGHT:** 45 in / 1,140 mm

**WHEELBASE:** 109½ in / 2,780 mm

**MANUFACTURE DATE:** 2009–present

**BRAKES:** disc (f and r)

**SUSPENSION:** independent double A-arm (f and r)

**WHEELS:** alloy, 19 in (f), 20 in (r)

**TIRES:** 255/35 19 (f), 335/30 20 (r)

arms, pull-rod helical springs and Ohlins adjustable shock absorbers. It has a carbon-titanium chassis and carbon-fibre body panels, and weight-saving extends even to the cabin, where the seats – designed to accommodate the F1 HANS safety device – are also constructed from carbon fibre. If there's any doubt as to the car's motorsport capability, it's also fitted with an integral roll cage. As to performance, according to Zonda, the R's acceleration from 0 to 62 mph is 2.7 seconds – an absolutely incredible achievement. And for good measure, top speed is recorded as over 217 mph. All Zondas have been true supercars, but the Zonda R could be said to be in a league of its own.

# Porsche 911

Ferdinand Porsche was an automotive genius. His CV includes credits for designing the V16 Auto Union P-Wagen racing car in 1934 – one of the legendary Silver Arrows that dominated Grand Prix racing until the outbreak of World War II, the Tiger Tank during hostilities and, perhaps most especially, the Volkswagen Beetle. But he also put his own name to a small, nimble and lightweight sports car that he developed and launched in 1948 with the help of his son Ferry – the Porsche 356.

Like the Beetle, the Porsche 356 had a rear-mounted air-cooled four-cylinder engine, trailing link front suspension, and was constructed on a unitary floorpan and body design. Although the first few bodies were crafted in aluminium, later ones were all made out of steel. Power from the original 1.1-liter overhead-valve engine was just 40 bhp, and yet the Porsche 356 was soon to be found on the racetrack because of its good aerodynamics and handling. It stayed in production until 1965 and its successor followed many of its design and engineering leads.

The new car, the Porsche 901, was shown at the 1963 Frankfurt Motor Show, but failed to make a spectacular impression, not least because its 130 bhp was the same output as that of the final series of 2.0-liter 356 Carreras. Nevertheless,

| PORSCHE 911 2003 | WIDTH: 66.9 in / 1,770 mm |
|---|---|
| ENGINE: 3,596 cc Flat 6 | HEIGHT: 51.2 in / 1,305 mm |
| MAXIMUM POWER: 320 bhp at 6,800 rpm | WHEELBASE: 92½ in / 2,350 mm |
| MAXIMUM TORQUE: 370 Nm at 4,250 rpm | MANUFACTURE DATE: 1964 to present |
| MAXIMUM SPEED: 177 mph / 285 km/h | BRAKES: Discs (f and r) |
| 0-62 MPH ACCELERATION: 5.0 secs | SUSPENSION: Independent MacPherson strut (f), independent trailing arm (r) |
| TRANSMISSION: 6-speed manual or 5-speed Tiptronic | WHEELS: alloy, 17 in (f) 18 in (r) |
| LENGTH: 174.4 in / 4,430 mm | TIRES: 205/50 R 17 (f) 225/40 R 18 (r) |

production started in 1964, the only major change being the car's name, because it transpired that Peugeot held the rights to all three-digit car names with a zero in the middle. Thus it was that the first Porsche 911 came into being, fitted with a 2.0-liter air-cooled flat-six engine with chain driven overhead camshafts producing 128 bhp at 6,200 rpm and 174 Nm of torque. It was basically a two-seater, but because rudimentary rear seats were fitted, it was described as a 2+2. At the time, its performance was truly sporting: 0–60 mph took 8.3 seconds and its top speed was 132 mph / 212 km/h.

Almost immediately after the 911's launch, Porsche started developing the car, and a higher-performance 911 S appeared in 1966, with power up to 158 bhp, torque up to 179 Nm and top speed up to 137 mph / 220 km/h. Interestingly, Porsche also produced a lower-powered version at around that time, using the four-cylinder engine from the 356 in a 911 body and calling it the Porsche 912. Apart from that aberration, the power and performance of the 911 went inexorably upwards over the years – and there were many, many years, because the 911 remains in production to this day, ranking alongside the Chevrolet Corvette and the Nissan Skyline as one of the longest-surviving sports cars in the world.

As an indication of just how far Porsche has traveled since 1964, the very latest 'basic' 911 Carrera produces 345 bhp at 6,500 rpm from its 3,614 six-cylinder boxer engine, which gives it a 0–62 mph acceleration time of 4.9 seconds and a top speed of 180 mph / 290 km/h. But that performance pales into insignificance compared to that of the 911 Turbo, however, which churns out 480 bhp and reaches 62 mph from a standstill in 3.9 seconds and a top speed of 193 mph / 311 km/h. And the Turbo is not even the fastest 911 on the market: the GT2 model produces 530 bhp from its 3,600 cc flat-six, accelerates from 0 to 62 mph in a tire-blistering 3.7 seconds and has a top speed of 204 mph / 328 km/h.

Such performance is a very far cry from that of the original, and in engineering and technical terms, the 1964 and the 2009

911s have nothing whatsoever in common. And yet in terms of their basic shape, design philosophy and sheer charisma, it's abundantly clear that the first and most recent 911s share the same DNA. The Porsche 911 has been one of the most successful racing cars of all time – it has competed at Le Mans every year since 1964, for example, and taken numerous class wins – and one of the most enduring and successful road cars of all time, too. It is one of the automotive world's real classics – and, amazingly, it's still going strong.

# Porsche 911 GT3

**PORSCHE 911 GT3 2006**

**ENGINE:** 3,800 cc flat four-cylinder

**MAXIMUM POWER:** 435 bhp at 7,600 rpm

**MAXIMUM TORQUE:** 430 Nm at 5,500 rpm

**MAXIMUM SPEED:** 194 mph / 312 km/h

**0–62 MPH ACCELERATION:** 4.1 secs

**TRANSMISSION:** 6-speed manual

**LENGTH:** 176 in / 4,465 mm

**WIDTH:** 71¼ in / 1,808 mm

**HEIGHT:** 50½ in / 1,280 mm

**WHEELBASE:** 92¾ in / 2,355 mm

**MANUFACTURE DATE:** 1999–present

**BRAKES:** disc (f and r)

**SUSPENSION:** independent MacPherson strut (f), independent trailing arm (r)

**WHEELS:** alloy, 19 in

**TIRES:** 235/35 ZR19 (f) 305/30 ZR 19 (r)

The latest Porsche 911 GT3, which was unveiled at the 2009 Geneva Motor, is the more recent evolution of what has become, in a very short while, an iconic sports car, one that's road legal but in its element on a track.

The first GT3 was introduced in 1999, based on the 996 model of the Porsche 911, the first of those rear-engined sports cars to be water cooled rather than air cooled. The GT3 differed radically from the standard production car, not least because its engine was a normally aspirated derivative of the turbocharged engine used in the Porsche 962 racing car. It produced 355 bhp (compared to 296 bhp of the standard 911), and thanks to that and its lower weight, it was substantially faster, recording 62 mph from standstill in around five seconds. More was to come in 2004, with a power upgrade to 381 bhp, which enabled the GT3 to reach 60 mph in 4.5 seconds, but the big news came in 2006, when the all-new 997 Porsche 911 was launched. In due course, a GT3 version was introduced, now with 415 bhp on tap and with a 0–62 mph acceleration time of just a fraction over four seconds.

Porsche continued development and introduced a second generation of the Type 997 911 GT3 in 2009. Porsche engineers' intention with this latest GT3 was simple: to offer even higher performance and driving dynamics. Its flat-six engine was increased in capacity to 3.8 liters and tuned to develop 435 bhp at 7,600 rpm, making it one of the world's most powerful naturally aspirated engines. The torque is also increased to 430 Nm at 5,500 rpm. Because this is unashamedly a driver's car, the only transmission that's fitted is Porsche's six-speed manual box, which is a full 66 lb / 30 kg lighter than the double-clutch manual transmission fitted to standard 911 road cars.

According to Porsche's official figures, the latest GT3 has a 0–62 mph acceleration time of 4.1 seconds and a maximum speed of 194 mph / 312 km/h. However, as the company is notorious for understating its cars' performance figures, it is highly probable that the 911 GT3 is capable of yet more, despite the fact that the engine has been made cleaner and easily conforms to EU5 emissions standards. In fact, former racing

driver and Porsche development driver Walter Röhrl claims to have lapped Germany's Nürburgring race track five seconds a lap faster than in the previous model.

So the engineers certainly seem to have succeeded in their first task, that of boosting performance, but what of handling and overall dynamic balance? The car looks very similar to the previous model, but hours in the wind tunnel have resulted in a shape that manages to increases downforce – to 243 lb / 110 kg at 196 mph / 315 km/h – without increasing the drag. The result is far more stability at high speed. Porsche has also managed to induce a slight reduction in understeer and to increase the rear stability by tweaking the suspension system and stiffening the springs and anti-roll bars.

The 911 GT3 is fitted as standard with the Porsche Stability Management (PSM) system, which helps the driver keep control of the car whatever the circumstances. But as this is a barely disguised racer, the driver can choose to deactivate both the Stability Control and Traction Control components in separate steps. This gives the driver absolute control, because, unlike in some other supercars, these functions are not reactivated automatically even under the most extreme conditions, but only when manually switched back on.

Although it can be said that just about all Porsche 911s look the same, the new 'Aerodynamics Package' gives the latest GT3 its own distinctive appearance, enhanced by its new Bi-Xenon headlights, LED rear light clusters, and modified air intakes and outlets. All Porsche 911s are special, but some are quite definitely more special than others. The 911 GT3 is one of them.

# Porsche 959

In 1983, Porsche unveiled a new Group B racing prototype at the Frankfurt Motor Show that looked something like a standard 911 on steroids. Two years later, again at Frankfurt, the company announced that it was putting the car into production as a road car, building just 200 examples for homologation purposes. A further two years later, in 1987, the 959 finally saw the light of day, by which time every one of the 200 was pre-ordered, despite a price tag of $225,000.

The 959 was clearly related to the 911 but it was also very different – longer, lower, wider, and sporting a massive wide tail with an enormous spoiler. With it vents and ducts to control the airflow over the body, it was clear that much work had gone into the aerodynamics, and the end result was a Cd of 0.31. But far more important than that drag co-efficient was the fact that the body created zero lift at higher speeds.

Like the 911, the 959 sported a six-cylinder horizontally opposed Boxer engine, but there the similarity ended. For the 959, Porsche's engineers created a 2.8-liter sequentially turbocharged masterpiece with twin overhead cams and four valves per cylinder. At lower speeds, only the left-hand turbo operated, while when top-end power was needed, the other turbo kicked in, too. This meant that the 959 could be driven around town without sacrificing its performance potential.

And what performance! With 450 bhp on tap, racing up through the six-speed gearbox, the 959 accelerated from 0 to 60 mph in 3.6 seconds, 0–100 mph in 8.8 seconds and on to a top speed of 195 mph / 314 km/h.

To achieve this level of performance, and to allow all of the 450 bhp to be safely transmitted to the road through the massive low-profile tires that Bridgestone created specially for this car, Porsche specified a full-time four-wheel-drive system that allowed the driver to adjust the level of torque transmitted to the front and rear wheels. Most, sensibly, Porsche also left the system in automatic mode and programmed the 959's computers to choose the optimum setting.

The 959's engineers also radically changed the suspension from that of the standard 911. The 959 had double wishbones front and rear, with twin dampers and concentric coil springs at each corner. The dampers were controllable to allow for standard or sports settings to be selected and for the ride height of the 959 to be lowered automatically at higher speeds for aerodynamic stability.

In addition, the 959 was actually sold in two forms, Sport and Comfort. The Sport model had no air conditioning, electric windows or rear seats and so was around 132 lb / 60 kg lighter than the Comfort.

Production started in 1987, though the 959 tested even the genius of Porsche's best engineers. It was so complex and so revolutionary that it proved impossible to build on standard production lines and so Porsche had to create a new facility to build the cars virtually by hand. It was also rumoured at the time that although the $225,000 price tag was enormous by the standards of the day, it actually cost Porsche nearly double that to build each one.

The new 959s were available only to existing Porsche owners, and, to deter speculators, purchasers had to agree not to sell them for at least six months. The car was never homologated for the USA market because Porsche refused to supply four examples for crash-testing purposes, so it could never be driven on public roads there. Wealthy collectors, including Microsoft founder Bill Gates, did import 959s, but not without severe difficulties with the authorities.

In the end, production continued until 1990 – far longer than Porsche had ever anticipated – by which time, 226 examples had been delivered to customers in Europe and perhaps 100 more had been built for racing.

The 959 was truly a one-off, but the lessons learnt in its development soon found their way onto 'standard' 911s. This was most notably evidenced in the launch of the four-wheel-drive Carrera 4 model, and four-wheel drive subsequently became standard on 911 Turbo models.

**PORSCHE 959 1987**

**ENGINE:** 2,849 cc Flat 6

**MAXIMUM POWER:** 450 bhp at 6,500 rpm

**MAXIMUM TORQUE:** 500 Nm at 5,500 rpm

**MAXIMUM SPEED:** 195 mph / 314 km/h

**0–60 MPH ACCELERATION:** 3.6 secs

**TRANSMISSION:** 6-speed manual

**LENGTH:** 167¾ in / 4,260 mm

**WIDTH:** 72½ in / 1,839 mm

**HEIGHT:** 50½ in / 1,280 mm

**WHEELBASE:** 89½ in / 2,271 mm

**MANUFACTURE DATE:** 1987–90

**BRAKES:** disc (f and r)

**SUSPENSION:** independent double wishbone (f and r)

**WHEELS:** alloy, 17 in

**TIRES:** 235/45 VR-17 (f), 255/40 VR-17 (r)

# Porsche Carrera GT

The Porsche Carrera GT – one the finest supercars the company ever made – had a muddled start to its life. The basis of the car lay in a prototype built in preparation for Le Mans in 1999 but later abandoned because, for various reasons, Porsche chose not to compete against the Audi R8. Its engine, meanwhile, can be traced back to a V10 that Porsche designed in secret for the Footwork F1 team in the early 1990s. The two were brought together in a concept car unveiled at the Geneva Motor Show in 2000, where enough people offered to put down deposits to encourage Porsche to sign it off as a limited-edition road car.

From the very outset, the plan was to produce a racing car modified just enough to make it road legal, and at first glance, it was clear that the car's appearance owed more to the design of Porsche racing cars than its road cars. It is aerodynamic and muscular looking, with the mid-engined layout pushing the cockpit towards the front of the car. Large air scoops cool the

## PORSCHE CARRERA GT 2003

**ENGINE:** 5,700 cc V10

**MAXIMUM POWER:** 612 bhp at 8,000 rpm

**MAXIMUM TORQUE:** 590 Nm at 5,750 rpm

**MAXIMUM SPEED:** 205 mph / 330 km/h

**0–62 MPH ACCELERATION:** 3.9 secs

**TRANSMISSION:** 6-speed manual

**LENGTH:** 181½ in / 4,610 mm

**WIDTH:** 75½ in / 1,920 mm

**HEIGHT:** 45¾ in / 1,160 mm

**WHEELBASE:** 107½ in / 2,730 mm

**MANUFACTURE DATE:** 2004–06

**BRAKES:** disc (f and r)

**SUSPENSION:** double wishbone (f and r)

**WHEELS:** alloy, 19 in (f) 20 in (r)

**TIRES:** 265/35 ZR19 (f) 335/30 ZR 20 (r)

instead of the normal Porsche MacPherson struts, provides safer and more consistent handling.

The engine was the same V10 that had been used in the concept car, but its capacity was increased from 5.5 to 5.7 liters. The output was monumental – 612 bhp at 8,000 rpm and 590 Nm of torque at 5,750 rpm – as was the performance: the Carrera GT was good for 0–62 mph acceleration in 3.9 seconds, 0–124 mph in 9.9 seconds and a top speed of 205 mph / 330 km/h. A six-speed manual gearbox designed specially for the Carrera GT was fitted, operated via the world's first ceramic clutch. For good measure, the ventilated disc brakes were also constructed from ceramic materials.

The Porsche Carrera GT really only had one rival when production started in 2004 and that was the Ferrari Enzo. Both offered blistering acceleration and the sort of top speeds that could only ever be attained on a racetrack, but they were very different cars in conception and execution. The Ferrari was an expression of pure automotive emotion while the Porsche was perhaps a little more rational and a little less extrovert. Porsche originally announced it would built a run of 1,500 Carrera GTs but in the end had built only 1,270 by the time production was brought to a halt in 2006.

engine and brakes while providing some raw visual clues to the GT's ultimate potential. Meanwhile, the perforated stainless-steel powerdomes extending back over the engine ensure the mighty powerplant is clearly displayed.

The Carrera GT is essentially an open two-seater, but it was supplied with a pair of lightweight carbon shells weighing just 5¼ lb / 2.4 kg each, creating a roof to provide protection from the elements. Its construction owed much to race technologies, too, as this was the world's first production car to boast a monocoque chassis and modular frame constructed entirely in carbon fibre. Because a top speed of over 200 mph / 322 km/h was envisaged, good aerodynamics were crucial, and to ensure sufficient downforce, the underbody of the Carrera GT contains diffusers and venturis. With the added help of a large rear wing that is deployed when the speed of the car exceeds 75 mph / 121 km/h, the Carrera GT produced some 882 lb / 400 kg of total downforce at its top speed.

Other motorsport elements included lightweight forged magnesium wheels, magnesium and carbon-fibre seats, and a suspension set-up in which the spring/damper units were operated by stainless-steel pushrods and pivot levers attached directly to the chassis structure for absolute rigidity. The basic configuration of double wishbone pushrods front and rear,

# Shelby Mustang GT350

Ford had launched the Mustang in 1964 very successfully. It looked good, it was relatively inexpensive and it sold in huge numbers. The only trouble was that it had been designed for style rather than true performance.

Ford itself started to put this right just a year later, when it offered the Cobra 4.7-liter V8 engine in the Mustang. With 271 bhp available, and with uprated suspension, wider tires and broad stripes, the car's performance was greatly improved.

More interesting, however, was the work of former racing driver Carroll Shelby, the man who had brought Ford together with British sports car company AC to produce the legendary Cobra.

Shelby took a standard Mustang into his workshops in Los Angeles and set about making it perform, handle and brake far better than the original. By working on the manifolds of the 289 Cobra engine and fitting a Holley carburettor, he managed to extract 306 bhp from the sturdy V8. For racing, this was boosted to 360 bhp, and this car, the GT350R, immediately made its mark on the tracks, winning in its class first time out and running away with the SCCA B-Production road-racing series in 1965, 1966 and 1967.

Shelby's Mustang was fitted with a four-speed transmission as standard, though some cars that were built for the rental market through Hertz were fitted with three-speed auto boxes. There were no rear seats because the SCCA B-Production

regulations stipulated a two-seater car. Instead, there was a shelf under the rear window that housed the spare wheel.

The suspension was uprated to cope with the extra power, with wishbones, coil springs, Koni shocks and an anti-roll bar at the front. Ford's live rear axle was retained at the back, along with trailing arms,

| SHELBY MUSTANG GT350 1965 | | WIDTH: 68 ¼ in / 1,732 mm |
| --- | --- | --- |
| ENGINE: 4,727 cc V8 | | HEIGHT: 55 in / 1,397 mm |
| MAXIMUM POWER: 306 bhp at 6,000 rpm | | WHEELBASE: 108 in / 2,743 mm |
| MAXIMUM TORQUE: 446 Nm at 4,200 rpm | | MANUFACTURE DATE: 1965 |
| MAXIMUM SPEED: 149 mph / 240 km/h | | BRAKES: disc (f), drum (r) |
| 0–62 MPH ACCELERATION: 6.5 secs | | SUSPENSION: independent wishbone (f), live axle (r) |
| TRANSMISSION: 4-speed manual | | WHEELS: alloy, 15 in |
| LENGTH: 181½ in / 4,613 mm | | TIRES: 205/60 R-15 (f), 225/60 R-15 (r) |

semi-elliptic leaf springs and Koni shock absorbers. Braking was by discs at the front and drums at the rear. Side exhausts and extravagant stripes completed the visual package. With 306 bhp at 6,000 rpm and a massive 446 Nm of torque at 4,200 rpm on tap, the Shelby Mustang GT350 promised real performance, and it didn't disappoint: it raced from 0 to 60 mph in 6.5 seconds and had a top speed of 149 mph / 240 km/h. The Mustang had become a true performance car, a true 'muscle car'.

By 1967, the Shelby Mustang GT350, which remained in production, was joined by a second model, the GT500. This was fitted with Ford's very latest 7,014 cc V8, known as the Police Interceptor, and with its 355 bhp on tap, it was much quicker than the GT350, accelerating from 0 to 60 mph in around six seconds and with a top speed of over 150 mph / 241 km/h.

For some, this still wasn't enough, and a very few GT500s were converted to produce 425 bhp. It's not certain how many of these were sold, perhaps between 20 and 50, but these 'Shelby

Super Snakes' are both extremely rare and extremely desirable.

Many enthusiasts consider that real Shelby Mustangs were built only until 1967, the year in which production was shifted from Shelby's works in Los Angeles to one of Ford's many factories in Michigan. Certainly, the 1968 model seemed to be far more Ford than Shelby: it was bigger, heavier and significantly more comfortable, with higher trim levels, including power-sapping air conditioning and power steering, which had never been features of the earlier raw street racers that Shelby had designed.

It was clear that Ford wanted to move the Shelby Mustang upmarket, and each year, the finished product moved further away from Carroll Shelby's brilliant original concept.

Today, the Shelby Mustang is one of the most desirable of all muscle cars, and can fetch prices well into six figures at auction. The rarest competition GT350Rs – only 37 were built – have been auctioned at more than $500,000, which is not bad considering that the list price, when new, was $4,547 for the street version and $5,995 for the competition GT350R.

# Toyota 2000GT

Prestige motor manufacturers like Jaguar and Aston Martin pay millions to get their cars featured in the latest James Bond movies. So how did a humble Toyota get star billing in *You Only Live Twice*? Quite simply, the film's producer 'Cubby' Broccoli had seen the Toyota 2000GT when it was the undoubted star of the 1965 Tokyo Motor Show and he reckoned it would make the perfect set of wheels for Bond's Japanese associate Aki. Toyota was so keen to get involved that it went to the trouble of creating a pair of open-topped convertibles especially for the film.

Even without the James Bond publicity, it was clear that the 2000GT was something special. Toyota had been very successfully making mass-market cars for 30 years and felt it was time to make a statement of future intent. It would create a world-class GT car that would not only showcase the company's engineering skills, but would also boost the image of a company that, until then, had been known only for reliable and well-built, but basically plodding and soulless small cars. At the time of its launch, the 2000GT was described admiringly as a 'Japanese E-Type'. Not bad for a car that was originally intended to carry Nissan badges. Bizarrely, the car had been conceived by another Japanese company, Yamaha, on behalf of Nissan. Nissan, however, decided it wasn't right for them, so Yamaha sold the design to Toyota, who made some changes of its own then gave the car pride of place at the Tokyo Show in 1965.

It was beautifully proportioned. Much of the design work had been carried out by Count Albrecht von Goertz, the genius responsible for the earlier BMW 507, and he created the elegant aluminium body that sat on top of a steel backbone chassis with independent suspension in a set-up highly reminiscent of the Lotus Elan. It had sharp and responsive rack-and pinion steering and excellent brakes, thanks to its four-wheel disc brakes – the first time any Japanese production car had boasted such a

**TOYOTA 2000GT 1967**

**ENGINE:** 1,988 cc inline 6-cylinder

**MAXIMUM POWER:** 150 bhp at 6,600 rpm

**MAXIMUM TORQUE:** 175 Nm at 5,000 rpm

**MAXIMUM SPEED:** 131 mph / 211 km/h

**0–60 MPH ACCELERATION:** 10 secs

**TRANSMISSION:** 5-speed manual

**LENGTH:** 164½ in / 4,176 mm

**WIDTH:** 63 in / 1,600 mm

**HEIGHT:** 45¾ in / 1,161 mm

**WHEELBASE:** 91¾ in / 2,329 mm

**MANUFACTURE DATE:** 1967–70

**BRAKES:** disc (f and r)

**SUSPENSION:** independent coil spring (f and r)

**WHEELS:** alloy, 15 in

**TIRES:** 165/41 HR-15 (f and r)

specification. A five-speed manual transmission took the drive via a limited slip differential to the rear wheels. Under the bonnet was a 2.0-liter DOHC in-line six-cylinder engine, fuelled via three Mikuni-Solex side-draft carburettors that produced 150 bhp at 6,600 rpm and 175 Nm of torque at 5,000 rpm, enough to provide 0–60 mph acceleration in 10 seconds and a top speed of 131 mph / 211 km/h, which was highly respectable at the time. Contemporary road tests raved about the 2000GT's performance, and especially its vice-free handling. Its ride, cornering and levels of grip were praised, as was the car's near-perfect balance, thanks to the low center of gravity, 48:52 weight distribution and Lotus-inspired suspension. This truly was the first Japanese car that could challenge the best that Europe and the USA could offer in terms of both style and driving dynamics.

Production of the Toyota 2000GT started in 1967 but came to an end in 1970, by which time only 351 examples had been built. It wasn't the fastest car on the road, but that probably wasn't the reason sales were so hard to come by. More likely, car buyers found it hard to stomach the idea of spending $7,230 on a Japanese car when at that time a Chevy Corvette cost $4,663 and an E-Type Jaguar $5,559. But for those who did choose to buy one, the rewards were high. They not only enjoyed driving one of the most interesting and technically advanced cars of the time, but those that kept hold of it could now be looking at an asset worth between $100,000 and $200,000.

# TVR Griffith

**TVR GRIFFITH 1991**

**ENGINE:** 4,997 cc V8

**MAXIMUM POWER:** 335 bhp at 6,000 rpm

**MAXIMUM TORQUE:** 475 Nm at 4,000 rpm

**MAXIMUM SPEED:** 162 mph / 261 km/h

**0–60 MPH ACCELERATION:** 4.1 secs

**TRANSMISSION:** 5-speed manual

**LENGTH:** 156¼ in / 3,970 mm

**WIDTH:** 68½ in / 1,740 mm

**HEIGHT:** 74 in / 1,880 mm

**WHEELBASE:** 89¾ in / 2,280 mm

**MANUFACTURE DATE:** 1990–2002

**BRAKES:** disc (f and r)

**SUSPENSION:** independent double wishbone (f and r)

**WHEELS:** alloy, 15 in (f), 16 in (r)

**TIRES:** 215/50 ZR-15 (f), 225/50 ZR-16 (r)

The British sports car manufacturer TVR was founded in 1946 by Trevor Wilkinson, who very early on started making two-seaters with glass-reinforced-plastic bodies over tubular-steel chassis. The company's first production car, launched in 1954, was the Grantura, and it was superseded in 1980 by the very angular, wedge-shaped Tasmin. In the meantime, an American dealer had been experimenting with fitting a big-bore AC Cobra engine into his TVR Grantura. His name was Jack Griffith, and when, many years later, TVR first put a big V8 into one of its production cars, it named the car TVR Griffith in his honour.

The car was first unveiled as a prototype at the 1990 British Motor Show, where it was an instant success. It had the appearance of a traditional British sports car, with clear influences of both the Jaguar E-Type and the AC Cobra in its smooth and curvaceous composite body. The style was clean and uncluttered – the door handles and boot catch were concealed to avoid interrupting the fluid design, for example. Its appearance was both aggressive and elegant, and its proportions were near perfect.

The original plan had been to modify the existing chassis of the TVR V8S, but it simply wasn't stiff enough for the performance TVR had in mind for the Griffith, so instead, TVR adapted the much tauter chassis of the TVR Tuscan Racer. All-independent suspension was essential, and TVR chose unequal-length twin wishbones, with coil-over adjustable telescopic shock absorbers with anti-roll bars front and rear. With its wide track and massive tires, the Griffith offered excellent grip and viceless handling in the dry (though it could be more than a handful in the wet) that was well capable of transmitting the V8 engine's power to the road. Reassuringly, the huge ventilated disc brakes front and rear performed as if they had been designed for the racetrack.

At first, TVR used the Rover 3.9-liter V8 engine in the Griffith, though over the years this was uprated to 4.0 liters and later to 4.3 liters. Later still, in 1993, TVR developed its own 5.0-liter version of the Rover V8 – the Griffith 500 – and by this time it was producing 335 bhp at 6,000 rpm and 475 Nm of torque at 4,000 rpm. The power

output was later reduced to 320 bhp to provide smoother idling and to make the car more driveable at lower speeds. Even the earliest Griffiths had a top speed of just under 150 mph / 241 km/h and acceleration from 0 to 60 mph in under five seconds, which made them faster in terms of acceleration than either the Porsche 911 Turbo or the Ferrari Testarossa, two of the Griffith's contemporary competitors. The Griffith 500 was even quicker, taking just 4.1 seconds to accelerate from 0 to 60 mph and continuing to a top speed of 167 mph / 269 km/h.

Quite apart from its out-and-out performance, what was special about the Griffith was its carefully tuned big-bore stainless-steel exhaust system, which did more than just

optimize performance, it also emphasized the magnificent roar of the V8 engine, which became one of the car's hallmarks. The Griffith stayed in production until 2002. The final 100 examples were badged SE (Special Edition), and these had a different fascia and rear lights and new door mirrors, and each was individually numbered.

The Griffith was very successful, despite it being an uncompromising prospect. For those who wanted a little more practicality – a bigger boot and softer, more compliant suspension – TVR developed the Chimaera, a model that was just as fast as the Griffith but a little less brutal. But the Griffith remains, meanwhile, a wonderful, timeless classic.

# Picture Credits

The publisher would like to thank the following for permission to
reproduce the following copyright material:

**BUGATTI AUTOMOBILES S.A.S.**
page 2

**THE CAR PHOTO LIBRARY – WWW.CARPHOTOLIBRARY.CO.UK**
Page 8, 10, 11, 12, 13, 14, 15, 20, 21, 22, 23, 24, 25, 26, 27,
28, 29, 30, 31, 32, 33, 56, 57, 58, 59, 60, 61, 62, 63, 64, 65,
74, 75, 98, 99, 100, 101, 102, 103, 106, 107, 108, 109, 110,
111, 112, 113, 114, 115, 116, 117, 124, 125, 126, 127, 134,
135, 142, 143, 148, 149, 150, 151, 152, 153, 154, 155, 170,
171, 172, 173, 174, 175, 176, 177, 178, 179, 180, 181, 182,
183, 184, 185, 186, 187, 188, 189, 190, 191, 192, 193, 200,
201, 202, 203, 214, 215, 220, 221, 222.
Back jacket page 64, 65 only

**SIMON CLAY PHOTOGRAPHY  - WWW.SIMONCLAY.COM**
Front end papers.
Page 1, 5, 6, 7, 34, 35, 36, 37, 40, 41, 42, 43, 44, 45, 46, 47,
48, 49, 50, 51, 52, 53, 54, 55, 70, 71, 72, 73, 76, 77, 78, 79, 82,
83, 84, 85, 86, 87, 88, 89, 94, 95, 96, 97, 104, 105, 118, 119,
120, 121, 122, 123, 128, 129, 130, 131, 144, 145, 146, 147,
156, 157, 158, 159, 160, 161, 162, 163, 166, 167, 168, 169,
204, 205, 208, 209, 216, 217, 218, 219.
Back end papers.

**NP MEDIA LTD**
Page 16, 17, 18, 19, 38, 39, 66, 67, 68, 69, 80, 81, 90, 91, 92,
93, 132, 133, 136, 137, 138, 139, 140, 141, 164, 165, 194,
195, 196, 197, 198, 199, 206, 207, 210, 211, 212, 213.

# Index